The People Are
Not an Image

The People Are Not an Image

Vernacular Video after the Arab Spring

Peter Snowdon

VERSO
London • New York

First published by Verso 2020
© Peter Snowdon 2020

1 3 5 7 9 10 8 6 4 2

Verso
UK: 6 Meard Street, London W1F 0EG
US: 20 Jay Street, Suite 1010, Brooklyn, NY 11201
versobooks.com

Verso is the imprint of New Left Books

ISBN-13: 978-1-78873-316-8
ISBN-13: 978-1-78873-318-2 (UK EBK)
ISBN-13: 978-1-78873-319-9 (US EBK)

British Library Cataloguing in Publication Data
A catalogue record for this book is available from the British Library

Library of Congress Cataloging-in-Publication Data
Library of Congress Control Number: 2020932070

Typeset in Sabon by MJ & N Gavan, Truro, Cornwall
Printed and bound by CPI Group (UK) Ltd, Croydon CR0 4YY

In memory of
Hani Shukrallah
(1950–2019)
mentor, comrade and—above all—friend

Doubtless Resnais and the Straubs are the greatest political filmmakers in the modern Western cinema. But, bizarrely, their greatness is not the result of the presence of the people in their films: on the contrary, they make great political films because they know how to show us that the people are that which is lacking, that which is not there.

—Gilles Deleuze

I understood it! I finally understood it and I returned to the Square day after day just to make sure that what I was witnessing was not a dream. What I have seen to be the people really were the people, alive and well, and it wasn't just an afternoon uprising that would vanish with the onset of evening. I realized all of a sudden, then and there, that I never really gave the people their right space in my imagination. The people, the collective, are absent in my novels: there are characters, individuals … but none of the novels has the people in it … Until that day, I saw the people only as a handful of stragglers seeking their own individual interests. When Egyptians became themselves the people, our world, the world of the narrators and storytellers of Egypt, completely transformed.

—Ibrahim Shukri Fichere

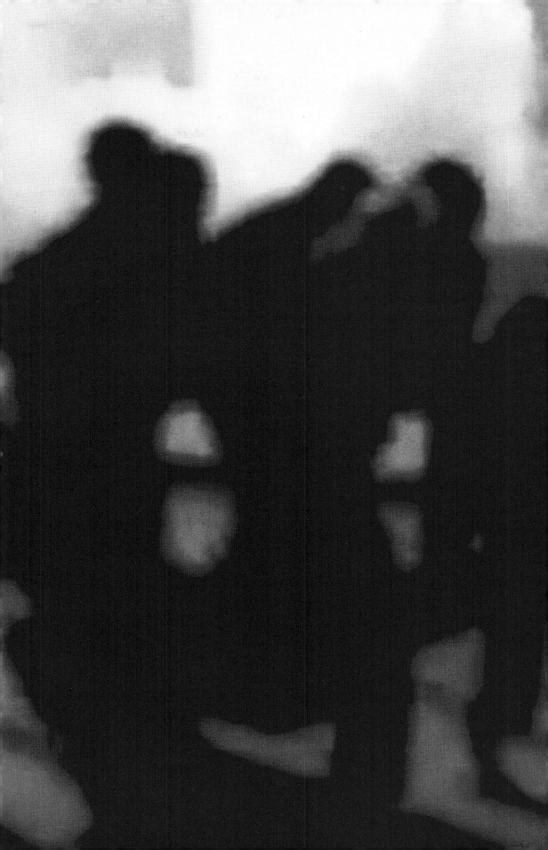

Still frame from video posted to YouTube, February 18, 2011. To view, and for more information, go to vimeo.com/channels/thepeoplearenot, video 0.0.

Contents

Introduction

Video as a Vernacular

Filming in the First-Person Plural

Not the least extraordinary thing about the Arab revolutions of 2010–12 is the fact that they gave rise to an exercise in popular self-documentation on an unprecedented scale. In this, they have an obvious precursor in the Iranian Green Movement of 2009, which might be considered an outlier within the same series, a first tremor announcing the larger earthquake to come.[1]

This ongoing sequence marks the first time since the invention of the cinema that the people have not largely left it to experts, professionals, and outsiders to film their attempts to overthrow an oppressive order, but have instead seen it as part and parcel of their revolutionary action, even as part of their revolutionary duty, to film one another as together they made and unmade history, day in and day out.

For the viewer, the result has been an almost overwhelming proliferation of material, made accessible in quasi-real time through online video-sharing websites. These videos do not simply sit there on YouTube, either, waiting for us to stumble on them: they are

Still frame from video posted to YouTube by 5000zukoo, September 21, 2011. To view, and for more information, go to vimeo.com/channels/thepeoplearenot, video 0.1.

always already in circulation, posted and reposted on Twitter and Facebook, as well as being passed on through more private communications channels, such as e-mail or various messaging apps. They are not static objects waiting to be discovered and analyzed: they are fully subsumed within a much larger dynamic process, in which what matters most is not any specific video itself, so much as the energy (both physical and affective) that they gather and transmit as they travel through the complex online–offline ecosystems these events have carved out across the region and beyond. These videos are, then, not primarily videos, so much as one vector among many for the ongoing work of mutual self-mobilization that makes radical political change possible, or at least, conceivable.

This double character, matching massive volume with high velocity, makes this phenomenon even harder to pin down—if indeed it makes any sense to refer to these videos as a single phenomenon at all. After all, no single viewer, however dedicated, is ever likely to be able to view enough of these videos to establish with reasonable confidence what might constitute any given sample of them as "representative." At the same time, one does not have to watch so many of them before coming across one or more that do not simply *record* events that were (or aspired to be) significant or even exceptional, but that also *produce* an exceptional effect upon the viewer, even when that viewer is remote, unfamiliar with the context, and has little or no prior emotional connection with the content.

In this book, I set out to explore some of the effects produced by certain of these videos and which are specific to them *as video*, however much they may remind us of experiences we have encountered elsewhere, whether offline or in other types of media. And I argue that these effects, and the affects associated with them, are, above all, *political*. More specifically, I suggest that the political work that these videos do—both those that strike us as exceptional and those which we are more inclined to treat as unremarkable, as almost too "ordinary" to merit any specific attention—is effected not simply through the documentation of offline events (demonstrations, occupations, speeches, songs, poems, debates, arguments,

confrontations, acts of State repression, and deaths, to name but a few) and thus through the information about the world "away from keyboard" that they inevitably contain, but is indissolubly bound up with their *aesthetic* properties as video—that is, with those of their properties that are at once *both* sensory *and* formal.

To speak of the aesthetics of these videos, whether singly or as a group, is not to ignore their importance as human documents and/or political gestures, to reduce them to an object of disinterested "appreciation," or to trivialize the very real risks that those who made them took, and often—too often—paid for with their lives. Rather, it is to focus on their nature as *gestures*—that is, as concrete ways of carving out singular blocks of perceptible, sensible space–time, each of which is imprinted with its own specific dynamic character. Alongside the more obvious reasons contained in their subject matter which may have led them to be recorded and subsequently posted on the Internet in the first place, these videos also contain a wealth of information that can neither be mapped without remainder onto their explicit first-order message ("On such and such a date, in such and such a place, such and such an event happened"), nor dismissed as mere "noise." To ignore the formal-kinetic-affective dynamics that traverse them and single them out for us, the viewer, is, I would argue, to ignore that which is most irreplaceable and most valuable about them and so risk misconstruing what they have to tell us about one of the most important recent passages in the history of human emancipation.

If I insist on the sensory and kinetic qualities of these videos, it is because the videos themselves insist on them. They are above all exercises in the concrete, and as such, acts of resistance against the kinds of abstraction that characterize both the practice of government and certain species of intellectual discourse. Their rebelliousness lies, at least in part, in their disdain for legibility, intelligibility, and/or "context." They do not offer etiologies, genealogies, or any other type of rationalization. They do not explain, much less explain away. They are presentations rather than representations. They are committed to appearance as a space of action in and for its own sake, not as something to be decoded or demystified. The strategies of the regime, the arguments of journalists, the

3

blandishments of false friends—these may need to be exposed and unmasked. But while they are aware of the functions of critique and distance, they do not make a fetish of them, for their main work is elsewhere. Their subject is not "them," even as "they" send their troops and riot police in to crush us. Their subject, in both senses of the term, is "us." If they try to articulate anything, to understand anything, it is simply how it has come about that a moment before there was nothing, and now there is a "we."

But to say they try to understand this "we" is also to miss the point. What runs through all these videos, I believe, is this sense of the "we," of the first-person plural, *not* as the thing that is most difficult to understand, but as that which is most immediately given, most obvious, most concrete—as that which cannot be analyzed, but can only be accepted and assumed. In the following pages I will try to add color and texture to that "we" as the subject of video, but on some level, I cannot analyze it or explain it either, without reducing it to what it is not. The whole point of this first-person plural is its originary quality. You can bring together as many "I"s as you like, and you will still never make a "we." For, as Jean-Luc Nancy has proposed, it is "we" who are, not the consequence, but the starting point.[2]

This "we" is not simply a ghostly presence haunting the individual with the camera. This "we" is, in some sense, both the actor of these revolutions and the maker of these videos. It is also their audience, including not only those close to these events, but also those who can only view them from a distance. The progressive convergence of these three categories, though never finally exhausted, represents an ideal limit toward which these videos tend.

This plural, anonymous, impersonal dynamic traverses these videos and the people who make them, shaping them from within. In this way, it is able to resist what Dork Zabunyan has described as "the danger that threatens all the images produced by revolutionary action, and by the periods that follow," namely,

that the figure of the hero may be used to control the memory of these struggles, and deprive these actions of their true power. For their power is the power of the impersonal, which cannot be pinned down, nor reduced to the tranquillizing identification of a single name that excludes all other names.[3]

It is through their insistently first-person plural vision of these revolutions that these videos remind us, more perhaps than any other media, that all the other figures we encounter—figures of the individual, figures of the collective as structure or aggregation —exist only insofar as they emerge provisionally from this "we" and are liable at any moment to be folded back into it.

Video as Common Property

To say "we," however, is not the end of the matter. What is revolutionary in the first-person plural is not simply its grammatical form or some sort of inherent superiority of the first-person "perspective," which might easily collapse into an idealistic (and sentimental) subjectivism. As Jacques Rancière has argued, to say "we" becomes a revolutionary act when the empirical "we"— the limited group of people whose actual coming together makes the existence of such a plural subject plausible—cease to speak only on their own behalf and instead claim to speak on behalf of everyone. In the phrases "we the people" (as in the preamble to the U.S. Constitution), or "we are the people" (as was heard among the demonstrators in Leipzig in 1989), what is revolutionary is neither the "we" nor "the people," but the conjunction of the two.[4] In such a moment, the people ceases to be an abstraction constructed by the State for its own legitimation and becomes instead a concrete lived reality, even if that reality has no substance beyond the refusal of "them"—or indeed, the refusal of abstraction per se, as the form of the process which has created "them" as separate from (and superior to) "us."

This collision of the "we" and "the people" can be heard implicitly in the emblematic phrase of the Arab revolutions,

al-sha'b yurid—the people want. The very fact that "the people" was assumed by the crowds in the street as their own name represented a claim that went far beyond what their simple numbers might have merited alone. (However large those crowds, they were far from ever constituting a numerical majority of the population.) The "we" of these videos then has to be seen and understood in relation to "the people"—that is, to the *third-person* perspective in which the experience and claims of the first person are not simply restated but radically transformed. They are no longer the experience and claims of one person or of the small group of us gathered here this afternoon: they are, as Agustín García Calvo would put it, the experience and the claims of *all of us*.[5]

How do these videos—these visions—affirm and, at the same time, move beyond and outside the first-person singular perspective within which they might seem to be confined, if only for purely material-technical reasons (for how can more than one person hold the same camera at the same time)? This question will form a constant theme throughout this book. For the moment, I want to point to one simple fact: these videos already transcend the perspective of the empirical individual who made them (supposing that they were ever so limited) *at the moment when they are uploaded to the Internet.*

By uploading them, the filmer (or the filmer's intermediary) is not simply "sharing" the videos, in the limited "Web 2.0" sense of the verb. As the Lebanese performer Rabih Mroué has put it in his "non-academic lecture" *The Pixelated Revolution*, these videos are uploaded not as individual expressive statements but *as common property*.[6] Whichever individual may have happened to be standing in such and such a place at such and such a time to make this film, the videos that result from all these countless individual actions belong not to those individuals, considered separately, but to "us." If there is a concept of authorship in play here, it is a collective authorship. The self-evidence with which videos are not only remixed but also downloaded, re-uploaded (with or without acknowledgment of the "original"),

and generally recirculated as if they were words in a common language, rather than specific authored enunciations, is further reinforced by the essential state of *anonymity* in which they exist. As Zabunyan puts it, these images are "impersonal, they have no signature."[7] The fact that we generally do not know, and do not need to know, who made the video cannot be reduced either to a political tactic to evade identification and reprisal or to an accident of the architecture of YouTube at a time when users were still encouraged to use pseudonyms ("handles") rather than their "real names." The desire for *strategic* anonymity (which is undeniable, especially in the case of videos from Syria and Bahrain) appears, through these videos, as entirely continuous with the *experiential* anonymity of the person who made them: the impulse to "escape from visibility" is, as the Invisible Committee puts it, indistinguishable from "the joy of being no one."[8] To upload confirms and extends the experience of filming as, in Giorgio Agamben's terminology, a gesture of *self-destitution*, in terms of both property and identity.[9] The "liberation" of these videos into a larger ecosystem in which their circulation and use cannot be controlled implies consent to what is already obvious: these videos do not and cannot belong (legally) to the person who may happen to have "made" them, because they belong (morally) to all those who make the revolution.

What makes the revolution the revolution, then, is in part the coincidence of these two perspectives, the first-person perspective of "we" and the third-person perspective of "the people," through which that "we" becomes (even if only experimentally and provisionally) "all of us." And it is through this coincidence that the concreteness of our own personal experience is allied with the properly political claims that imply an external point of view—that require us, that is, *to assume a position*, not *within* an existing distribution of places, powers, and competences, but in relation to, and in resistance *against*, that very distribution as a given.

The Demonstration Is the *Dhikr*

The sociologist Mohammed Bamyeh captures very well the interplay of external and internal perspectives that characterizes the lived present of the revolutionary moment:

> Concepts that had been previously unimaginable or abstract became in the revolutionary climate concrete. That which was immeasurable as the manifestation of a collective became felt as the property of the person. One of those concepts, "the people," was used so profusely in ways that suggest that it was felt to be a natural and organic extension of one's own sense of truth and justice. The novelty (as well as rarity and passing nature) of feeling an abstraction as "the people" was evident in how it was used everywhere and without compulsion as a namesake of what everyone assumed to be intuitively true: "the people have decided … ," "the people want … ," "the people will not be humiliated … ," "the will of the people is … ," and so on. These usages were never expressed in terms of any precise mechanisms —i.e. how the people might translate its will into a policy, or even whether a revolutionary committee ought to be formed, somehow, so as to express this peoplehood efficiently. In Tahrir Square, where I spent the majority of my time during the first five weeks of the Egyptian revolution, I saw that peoplehood was usually used to express what were commonly regarded as intuitive propositions about which there existed a presumed social consensus. It was never used to express complex or presumably divisive theories of social order. Even "Islam" was never used then in any way that was synonymous with peoplehood.[10]

The result is a sense of "the people" that is no longer simply a referent for the top–down discourse of the State, but which instead embodies the lived experience of those gathered together in this place. At the same time, the first-person perspective is no longer something irremediably personal to the individual; rather, it is experienced as the indispensable point of access through which they are able to participate in a larger circulation of

revolutionary energy, one which reinforces the perceived necessity of their own particular actions to that larger movement that traverses them:

> In that way, the revolutions drew sustenance, energy, determination, and the will to sacrifice largely out of a broadly distributed moral fire in individual psyches than out of organizational or hierarchical command structures. For "the people" appeared as a macrocosm of the single revolutionary person, who then experienced herself directly as the agent of a grand moment in history.[11]

Bamyeh's analysis here chimes with that of Ayman El-Desouky, who sees in the Egyptian revolution the emergence of a specifically "resonant" form of subjectivity, in which acts of public assembly perform a kind of "mass attunement" between "*placed* subjectivities that are both singular and collective."[12] And like Bamyeh, he sees the possibility of such emergent forms of plurality to be rooted in a consciousness of shared values and practices that distinguish the people from those who would rule over them and which legitimate the claim of the few to speak in the name of all: "When the people speak their own truth, collectively, what they produce is the linguistic, gestured and performed articulations, embodied memories, of their shared knowledge." Such speech is "a collective expressive force that is at once an aesthetic of resonance and an ethic of solidarity."[13]

El-Desouky refers to such "socially-cementing" practices—which are both used to express a set of shared values, and *themselves enact those values* in their rhythmic and resonant forms—as *amāra*, a specifically Egyptian practice of performing collective memory in everyday life. I examine the concept of *amāra* in more detail in chapter 8, where I consider what it may have to tell us specifically about the practice and circulation of video through the online spaces opened up by these revolutions. Here, I want to note how El-Desouky's argument converges with that of Bamyeh in pointing to the Arab revolutions as marked by the emergence into the public realm of "new languages and

new modes of knowing" that were "new to the discourses but older to the realities."[14]

This emergent knowledge is what Bamyeh terms an "anarchist gnosis," which he equates with the ways of living and acting of an autonomous civil society existing largely outside and independent of the State.[15] While some might see this as a radical rupture with the past, Bamyeh interprets it rather as the rediscovery of older values and older ways of living with one another. This leads him to suppose that "some connection between innovation and rootedness must be suspected even where it is emphatically denied":

The traditional systems of multiple loyalties (which integrated in practical and useful ways the multiple resources available through tribal belonging, guild membership, religious order affiliations, urban patronage, and mutual help networks) supplied the sufficient basis of a self-organized civic order for centuries, while insuring that no specific group intruded too much upon another—until the emergence of the modern state. Elements of that old civic order appear to have sustained themselves even after modern, authoritarian states devoted all their resources to magnifying state power over society in the name of enlightenment. Yet, the persistence of elements of the old civic ethics can be evidenced in the revolutionary styles themselves: the spontaneity of the revolutions as an extension of the already familiar spontaneity of everyday life; revolutionary solidarity, out of which emerges the will to sacrifice and combat, as an extension of common, convivial solidarity in neighborhoods and towns; distrust of distant authorities as part of an old, rational and enlightened common attitude, based on the simple thesis that a claim to help or guide is unverifiable in proportion to the power and distance of the authority that makes it; and finally, non-violence as a strategy learned not out of a manual written at Harvard, but as rooted in familiar and old habits of protest and conflict management.[16]

To these participant–observers, the Arab revolutions thus appear in a way similar to that in which the Paris Commune appeared to Marx, namely (in Kristin Ross's phrase) as "a mode of being intensely in the present made possible by mobilizing figures and phrases from the past."[17]

And the interest among both intimate and more distant observers in teasing out these lineages through which the past permeates and *radicalises* the present parallels the way in which Marx went on after 1871 to accelerate his study of Russian communal forms, thus descending "from pure theory to Russian reality" and learning, as he put it, to "not be frightened of the word 'archaic.'"[18]

Specific examples of "Arab realities" through which we can see how the figures of the past were mobilized in order to make the present possible are widespread in the emerging literature on the Arab revolutions. Sahar Keraitim and Samia Mehrez, for example, have argued that

> the vital inspirational and organizational sources for the tactics and strategies of life in Midan al-Tahrir during the initial days of the revolution, and well beyond, was precisely the historic familiarity of the millions of people who came to the *midan* with the extended and elaborate rituals and festivities of the popular *mulid* celebrations … . [For them] the *mulid* spectacle in the Independent Republic of Tahrir became not just a mobilizing factor but a radicalizing one… . Egyptians marshaled and deployed a myriad of specifically familiar cultural rituals, symbols, and performative aspects of the *mulid* to nurture and maintain the utopian space that they gradually constructed in the *midan*, the symbolic site of the birth of their freedom (*tahrir*).[19]

Such phenomena are of course by no means exclusive to Egypt. The French writer Jonathan Littell's account of his visit to the besieged Syrian city of Homs during the winter of 2012 insists on the way in which the nightly gatherings that bound the rebel populations together under the violent onslaught of the regime's forces not only drew on similar traditions of popular celebration

—again, like the *mulid*, associated with Sufism rather than with more mainstream or institutionalized practices of Islam—but that they were explicitly seen by the participants as inspired by these rituals even as they repurposed them. As one of his informants tells him, quite straightforwardly: "The demonstration is a *dhikr*," referring to the central Sufi ritual of praise that involves both song or chanting and rhythmical bodily movement.[20] And as Littell's description shows, it is indeed a *dhikr*, albeit one that has been secularized and in the process turned into a directly revolutionary ritual. Like *mulid al-Tahrir*, and like the Paris Commune that itself referred back to the revolutionary commune of 1792, as well as to older forms of local civic autonomy that had characterized premodern France, the *dhikr* of the Syrian opposition is not just a repetition of a preexisting form, but its *translation*.[21]

The Arab revolutions have thus been marked by a dual phenomenon of vernacularization. On the one hand, they have seen the emergence into public space of a whole range of vernacular practices of everyday life that perform the function of what El-Desouky calls a "cementing social imaginary."[22] The profoundly ethical orientation of these practices serves to give those who recognize themselves in them a sense of their own "profound self-worth that [stands] in sharp contrast to undeserved rule by petty thieves, dour autocrats, and visionless, ineffective functionaries," as Bamyeh puts it.[23] On the other hand, the visibility of these practices has in large part been made possible by the simultaneous emergence of a range of twenty-first-century grassroots vernacular media practices, of which the video practices to be discussed here are exemplary. Connected to these virtual channels, the everyday lived dimension of these revolutions has been able to spill out beyond the immediate confines of the street and the square, evading the censorship and/or ideological distortions of the mainstream and official media. They thus become visible, not only in Cairo or Sana'a or Redeyef or Dera'a, but anywhere there is an Internet connection and a screen (including in the many parts of those countries, and even of those same cities, where these demonstrations must at times have seemed as remote and as exotic as they did to those watching from abroad).

It is this convergence—between concrete practices of living embedded in the customs and idioms of specific places and specific communities and the emerging grassroots media practices that multiply and disseminate them, extending and enlarging their resonance beyond their specific time and place in ways that simultaneously exceed and confirm the limits of the local—that makes it possible, I believe, to speak of the video practices I will be discussing here as themselves genuinely *vernacular*. For what marks them and differentiates them from the vast majority of what elsewhere has been referred to as vernacular online video is not just that they are produced by "amateurs" outside any perspective of institutional recognition or financial gain.[24] If they are vernacular, it is also in this deeper sense that they are an integral part of the wider vernacular life worlds that the Arab revolutions have drawn on in order to lay claim to (and in the process redefine) political agency and the public domain. These videos, that is, are not just documents of vernacular practices that preexist them; nor are they vernacular simply by virtue of their artisanal conditions of production. They *perform* the vernacular in their own forms, too. They *enact* its ethics of solidarity through the rhythms they create and in the patterns of resonance they themselves initiate, and in so doing they *reinvent* and resignify the traditions on which they draw.

The Vernacular Anarchive

My understanding of these videos as vernacular owes much to the writings of those observers of and participants in the Arab revolutions such as Bamyeh, El-Desouky, Keraitim, Mehrez, and Littell, whose familiarity with the practices and histories of everyday life in the region has made them especially alive to this dimension of the people's struggles. But my thinking on this point is also more broadly informed by the work on "vernacular values" carried out by Ivan Illich and his colleagues (especially Gustavo Esteva and Madhu Suri Prakash), starting in the early 1980s.

For Illich, the vernacular was not simply the amateur and the homespun. It was above all the primary domain of people's resistance to the emerging (or invading) State's colonization of their everyday forms of life—to the abstract imperatives of bureaucracy and profit that sought to displace the lived ethic of solidarity that (following E. P. Thompson) he referred to as their "moral economy."[25] His writings on the vernacular resonate strongly with the accounts of the Arab revolutions as civil society's revelation of itself to itself that I have quoted in the previous section. And his discussion of how the printing press, which would later serve as a key tool for the homogenization and standardization of communication, initially functioned in the late fifteenth century as an anarchic grassroots multiplier of unruly vernacular discourses cannot help but recall the ambivalent nature of today's post-Snowden Internet, with its capacity for functioning as both a vector for emancipatory media practices and an instrument of potentially totalitarian control and surveillance.[26]

The vernacular, then—in contradistinction to the artificial construction of a "mother tongue," through which the bureaucrats of the emerging Spanish empire, anticipating the National Security Agency, sought to ensure transparent access to all subversive communications between their increasingly far-flung subjects—is above all the domain of living and *embodied* practices, which are by their very nature *performative*. Instead of an abstract Cartesian space ruled by countable coordinates and populated by arbitrary and measurable objects, vernacular space–time is a polycentric textural and experiential manifold, a palimpsest of dynamic processes each of which is particular to the person or persons who enact it. The kind of world that results is thus radically *recalcitrant to abstract conceptual analysis*, being rooted in the persistence and indeed cultivation of the infra-logical layers of experience that are mobilized by our own concrete gestural–kinesthetic apprehensions, and whose translation into symbolic language inevitably ends up taking the form of poetry and metaphor, rather than rules and calculations. The vernacular enacts an ethics of solidarity, and it does so through

dynamic sensory and aesthetic forms, which are not reducible to discourse but which engage us fully as living bodily creatures.

These vernacular forms are not then simply folkloric fossils from some putative golden age, but what Illich's friend Giorgio Agamben has rightly called (following Plotinus as much as Wittgenstein) "forms-of-life"—forms that are inseparable from the life that is lived through them.[27] Through their contingent singularity, forms-of-life activate the common both as pure potential—the possibility of something new—and as that which is necessarily inappropriable. As such, they are the very deactivation of that division of life into *bios* and *zoē*—that is, the politically recognizable life of the individual and the generic bare life that underlies it—that constitutes the core of modern governmentality, through its implicit generalization of "the state of exception." By rendering that division inoperative, they open the possibility for a new kind of politics, one that can escape the cycle of constitutive violence into which most revolutions fall.[28] For Agamben, such a politics is anticipated in, but not limited by, the "vernacular figures of anomic communities" documented not only by Illich, but also by Pierre Clastres and Christian Sigrist.[29]

It is precisely in this sense that I would suggest that both the videos and video practices produced by the actors of the Arab revolutions should be thought of as "vernacular"—as forms-of-life that open on to new possibilities, and in particular, on to new forms of living together, new forms of what we hold in common. And it is not only the individual videos that collectively constitute a vernacular. Rather, I propose that we should see their forms of online (and offline) circulation and concatenation as equally embodied and performative practices, which open on to equally singular and unexpected constellations and therefore require equally concrete description and analysis.[30]

Such an analysis is much harder to achieve, of course. In some sense, we "have" each individual video, and we can explore and interpret them as much as we like, as I do in the close readings of specific clips that form the core of most of the chapters in this volume. The human and social circuits through which

these videos collectively move and in which they are encoun-
tered, experienced, and further elaborated are, however, much
more difficult to access and pin down. While they may leave
traces—comments on YouTube pages or on Facebook timelines,
for example, as well as data accumulating in Google's databases
beyond our possibilities of access—the information these can
provide about the actual practices of viewing and (re)distrib-
uting online video remains limited and indirect. What would
be required is, rather, detailed ethnographic fieldwork imply-
ing, if not actually spending time with people while they watch,
upload, remix, and generally participate in the active circulation
of videos online, then at the very least extended conversations
with them about what they are doing during that time and how
they think about it when they are no longer doing it. Only in
that way could we begin to follow Zeynep Gambetti's advice, in
her discussion of Occupy Gezi: "One would need to look into
the extensive interstices of this politics of the body, rather than
into macrolevel discourses, to begin deciphering it."[31]

I have learned a lot from ethnographers and from others who
have gone to "the field" specifically to try and understand these
practices, and in particular from recent work by Ulrike Lune
Riboni, Cécile Boëx, Donatella Della Ratta, and Alisa Lebow.[32]
But I am not an ethnographer; I am a filmmaker. My main activ-
ity while I have been working on this book has been watching
and rewatching the many hundreds of hours of online videos
from the Arab revolutions that I collected while making my 2013
feature-length montage film, *The Uprising*.[33] In the course of this
research, I have spent extended periods of time "within" the
online/offline ecosystems through which such videos circulate.
I have read the comments appended to them on their YouTube
pages. I have also read blog posts, tweets, Facebook status
updates, newspaper articles, and academic essays in which they
and the events that they record are discussed. I have met people
who made such videos, sometimes by accident, sometimes on
purpose. I have discussed online video practices at academic con-
ferences, in grassroots media centers, in cafés and in cinemas and
on trains, with my friends in their living rooms, with strangers

I have met on demonstrations, and—over e-mail, Messenger, Skype, and FaceTime—with people I have met and only ever met online. I have had these discussions with Egyptians in Egypt, with Tunisians in Marseille, with Yemenis in New York, and with Syrians in Brussels, as well as with Indonesians, Brazilians, Turks, Algerians, Palestinians, Israelis, North Americans, and Europeans. I have also spent two months in postrevolutionary Egypt, meeting people when I showed my film as a work-in-progress to different audiences in different places. But I have always had these conversations either in the context of friendship or as part of the process of making my film and (subsequently) trying to understand what it was I had done and how it might affect other people. I have not attempted to do the (extremely difficult) work that would enable me to speak with any form of ethnographic authority about the actual practices that constitute the online everyday of YouTube in and around the Arab revolutions, or the emic discourses that surround them.[34]

What I did do, however, in the course of making and showing my film, was to formulate a number of hypotheses about how the videos I was watching may function—both as individual videos and as an online/offline circulation of forms and energies. This book is the outcome of these speculations and of my attempt to situate them in relation not only to a growing body of theoretical and political writing about the occasions and contexts of insurrectionary and revolutionary action within and outside the cinema, but also to my own experience—as a filmmaker seeking to think with a camera in unpredictable times and situations and as a (generally cameraless) rank-and-file participant in various sequences of more (or less) radical protest over the last thirty years. On one level, then, this text can be read as an indirect, almost cryptic memoir of the multilayered experience of editing my film with my friend and collaborator Bruno Tracq—an experience that was discursive, affective, and embodied in roughly equal proportions. (The embodied dimension of film *editing*—as opposed to film making—is rarely talked about, yet crucially determines the outcome of such work.) However, I have tried to approach the arguments I make here as if my film did not exist

and to ensure that they can be understood, and accepted or contested, in their own right, without any reference to or knowledge of my creative work. This book is an attempt to think through some of the issues that might emerge for *anyone* who seeks to take these videos seriously, both as aesthetic forms and as political gestures. It is less a continuation of my film work than a *displacement* of certain energies that it had released and which could not be fully worked through in a cinematic (nondiscursive) form.

In the second part of this book, I describe in some detail my sense of how these videos from the Arab revolutions may circulate online and offline and how in doing so they become not just traces of the singular bodies that made them but also in some sense themselves a *body* of work. For now, in order to avoid either prejudging this complex issue, or speaking of YouTube as if it were one single unified system delivering a set of largely homogenized experiences rather than an open-ended series of overlapping, partly constrained yet also partly plastic and malleable practices, I will refer to the video corpus produced by the Arab revolutionaries as they filmed their revolutions as "the vernacular *anarchive*."

I do so partly to distinguish my proposal here from the multiple understandings of the archive and its place in Western thought initiated by the seminal essays of Foucault and Derrida.[35] But I am also, at a less reflective level, simply allergic to a term that would seem to consign these videos to the past, when they remain—at least for me, and until very recently—resolutely of and in the present. Even today, the accounts which they have opened are in no way closed, though the way forward may be difficult to see through the brutal fog of war, neo-authoritarianism, and—in the most "fortunate" cases—parliamentary spectacle.[36]

As Dork Zabunyan puts it, these images are an attempt "to tear a fragment of reality" out of a context that has become unlivable:

> Before they become an archive in their own right, these images from the "Arab Spring" have a dual function, to put it schematically ...

they serve as weapons in the present and, whether deliberately or not, as forces for the future ... [37]

The Tunisian film critic Tahar Chikhaoui makes a similar point when he describes the cameraphone videos made during the Tunisian revolution as the invention of a "pragmatics of the gaze," in which seeing becomes a way of acting. And he goes on to say:

> To be clear, these are not works of cinema, creative works, but they offer us the prototype of another kind of image. While the distance [that characterized earlier forms of moving image] has not been entirely and definitively abolished, the gap between the screen and the audience has shifted, now it is extremely slight, and mobile. Like this revolution that will lead, whatever its outcome in the short term, to the transformation of political and social structures in the longer term, these images of the revolution show us what the cinema of the future will be based on.[38]

For Chikhaoui, these videos are not documents of the past, nor are they themselves subject to any existing audiovisual codes. They are the prefiguration not only of different ways of living, and different ways of doing politics, but also of different ways of making images, and of joining them together, whose full implications we are a long way from being able to grasp.

The "object" I wish to construct here, then, is very definitely *not* an archive in the sense of a repository of the past, whether that past takes the form of literal documents, allegorical monuments, or somewhat more abstract discursive formations. It is rather a living space, one that is totally porous and plastic to its users, that is constantly being shaped and reshaped by each gesture that contributes to it, each video that is added to it, each comment that is appended. While in standard usage the term "archive" is clearly linked to the idea of written documentation, its etymology refers more generally to a form of rule or governance (Gr. *arkhē*) rather than to any specific technology of storage. On both these levels, the term seems largely

inappropriate.[39] I therefore adopt the term "anarchive," by analogy with the term "anarchy" (also formed from the same Greek root), which designates not chaos but a form of order independent of any ruler, any hierarchy, or any institutionalized government.[40]

The term "vernacular," then, should be understood as applying not only to the *content* of the anarchive, but above all to its *form*. The anarchive is vernacular precisely in that it has, and can have, no central card index, no Dewey Decimal Classification System, no hierarchical ordering. And yet it is more than just an unstructured mass of random material, of which each element would be animated solely by the narcissistic search to distinguish itself from all its peers. Indeed, it might be more useful, and more accurate, to think of the Arab revolutionaries' subversive reconfiguration of their algorithmic online database of choice as a sort of "Occupy YouTube" by anticipation. Starting in early 2011, the videomakers from the region effectively established what might variously be recognized as a "space of anarchy" (Mohammed Bamyeh), a "temporary autonomous zone" (Hakim Bey), or—more precisely, I shall argue—what the review *Tiqqun* has called a "zone of offensive opacity" within the YouTube database, parallel to those which they and their comrades were establishing at the same time in the physical world, and of which Tahrir Square in Cairo was long the luminous (if also sometimes distracting and misleading) emblem.[41] This online zone was only temporary, in the sense that at some point the YouTube of algorithms would inevitably reassert itself and begin to erode its collective identity—erasing its borders, burying most of its contents, and reducing what remained visible to a more "representative" and more "relevant" subset. Nevertheless, for as long as it persisted, it could be called autonomous because it represented a use of YouTube that has been enabled but not foreseen by the website's inventors, and which subverted more than it realized the liberal vision of social media as a forum for individualistic self-expression with its correspondingly decentralized (and inoffensive) forms of collaboration.

In seeking to understand better, then, how the videos from the Arab revolutions enact forms of video that are at once and indissolubly political, ethical, and aesthetic, in ways which earlier practices and theories of online video had barely anticipated, I will consider not only how these videos exist as singular forms created in specific times and places, but also how they organize themselves collectively, so to speak. For it is also through their collective rhythms and patterns of circulation that they reimagine what online video is or might be.

Still frame from video posted to YouTube by feb tub, February 14, 2011. To view, and for more information, go to vimeo.com/channels/thepeoplearenot, video 3.

I

The Body of the People

1

A Happy Man

—No one helped us! We won our freedom for ourselves! The
 Tunisian people made their own freedom! The Tunisian
 people made their own freedom!
—He is so brave! So brave ...
—How great are the Tunisian people! Long live the Tunisian
 people! Long live free Tunisia! Long live Tunisia the great!
 Avenue Bourguiba, Tunis, Tunisia, January 14, 2011

Still frame from video posted to YouTube by rideaudur, January 17,
2011. To view, and for more information, go to vimeo.com/channels/thepeo-
plearenot, video 1.

TRANSCRIPT

(English translation based on original Arabic and French dialogue.)

Curtains are drawn back, camera advances toward the street below.

ABDENNACER
No one helped us! We won our freedom for ourselves! The Tunisian people made their own freedom! The Tunisian people made their own freedom!

WOMAN 1
(in French) He is so brave! So brave …

ABDENNACER
How great are the Tunisian people! Long live the Tunisian people! Long live free Tunisia! Long live Tunisia the great!

WOMAN 1
(in French) He is so brave!

ABDENNACER
Long live the free men of Tunisia! Long live free Tunisia! Long live Tunisia the Great!

Sound of women weeping, off.

ABDENNACER
O free men of Tunisia, you are free! There is no criminal called Ben Ali any more!

Cell phone rings.

ABDENNACER
The criminal Ben Ali has run away! He ran away from the Tunisian people! Ben Ali the thief! Ben Ali the dog! Don't be afraid, lift up your heads! Don't be afraid of anyone! We are free! The Tunisian people are free! The Tunisian people will never die! O Great People of Tunisia! Long live free Tunisia! Glory to our martyrs! Freedom for the Tunisians!

WOMAN 1

(switching into Arabic) How many people died that this day might come!

ABDENNACER

You, Tunisians, who have been excluded! You, Tunisians, in the prisons! You, Tunisians, who were made to feel inferior! You, Tunisians, who were oppressed! You, Tunisians, who were afflicted! You, Tunisians, whose property was stolen! Breathe the air of freedom! The Tunisian people have given us this freedom! Long live the people of Tunisia! Long live the great nation of Tunisia!

Camera withdraws slightly inside as the two men in the street walk toward the other side of the avenue.

WOMAN 2

(speaking into phone) Hello? Hello? Listen! Listen! There are three guys out on Avenue Bourguiba.

WOMAN 1

There they are! The three of them are over there!

WOMAN 2

We can hear his voice from here, it's giving us goose bumps.

A third (?) woman weeps, as the second woman moves back into the interior of the apartment, still talking.

WOMAN 3

(coming into picture and leaning out of window while talking on phone) Greetings! How are you?

WOMAN 2

(returning) Listen! Listen! There's a happy man talking in the street! You've no idea what that feels like! Listen! Listen!

Sound of weeping.

CUT TO

Top shot of pavement below.

ABDENNACER
Glory to the martyrs! We owe it to each and every martyr, to each drop of their blood, yesterday and today! Tunisia is free! Yesterday, we still had the cars and the ululations that Ben Ali paid for![1]

OTHER MAN
Where have the hire cars gone?

ABDENNACER
Where have the hire cars gone?

WOMAN 1
They aren't there any more!

WOMAN 2
What about the police?

WOMAN 3
They're not doing anything.

ABDENNACER
Long live freedom! Here in the avenue, I celebrate freedom!

WOMEN
(in chorus) Tunisia belongs to us!

Ululations, several voices.

CUT TO
The camera is back inside, framing the window.

POLICE *(in the street below, invisible)*
Close your windows! Close all your windows!

Camera moves, framing buildings opposite, leaving the street hors-champ.

WOMAN 1
The policeman said to close the windows. Come on now, don't fool around, do as he tells you. Stop now, they've gone.

WOMAN 3
But I'm not filming! I'm just doing a bit of video …

You Have No Idea What This Feels Like

In this short clip, we hear more than we see a man walking up and down along a main artery ("the avenue," as he calls it) of a North African city. As he walks, he improvises a poetic panegyric in honor of the people of his country and the freedom they have won for themselves. Yet the people of whom and to whom he speaks are nowhere to be seen. Indeed, as the clip progresses, it may seem that he is less assuming their existence than trying to conjure them into being. His entire performance seems designed either to make appear that which does not yet exist or to prevent or defer the disappearance of that which had briefly and provisionally emerged—or perhaps some combination of the two.

Nowhere is this hesitation between the actual, the potential, and the past more poignantly felt than in the complex use of alternating pronouns to figure "the people" whom he celebrates. Sometimes he identifies with or includes himself in "the people" ("We won our freedom ourselves!"); sometimes he excludes himself from the people by objectifying them as independent of himself or any other external party ("The Tunisian people made their own freedom!"); and sometimes he addresses himself directly *to* the Tunisian people despite their apparent absence. The fact that when he does so for the first time, he resorts to a kind of tautology ("O free men of Tunisia, you are free!") suggests not only an elation that at times outruns the spontaneous verbal imagination, but also a real, if disguised, uncertainty as to whether those who are already free really are free, or whether they do not need to claim their freedom again (and again) in order to be sure of it.

Read in this way, the performance that lies at the heart of this video could be seen as less an act of certainty and completion than as a sign of the people's persistent failure to emerge fully, even in this the hour of their triumph. The apparent emptiness of the street around this improvised orator would thus function as an ironic counterpoint to his triumphant words: as if the Tunisian people had chosen the moment of their greatest victory simply to disappear under cover of darkness. Yet, as he

tries to populate the night with the shadows of a people whose existence he has glimpsed only for it to escape him, his solitude is both underscored and disrupted by the presence of the camerawoman who made this video and her companions, and in particular by their complex reactions of withdrawal from and participation in the drama unfolding below their window.

This distance between the people at the window and the man in the street who proclaims the people is underscored by the interjections from the audience to which we, the viewers of the video, are party, but of which its protagonist knows nothing (as yet). As the man in the street below invokes the people of Tunisia, one of the women watching tells a friend over her cell phone: "There are three guys out on Avenue Bourguiba" And a few moments later, she both singularizes and amplifies her claim: "There's a happy man talking in the street. You have no idea what that feels like!" This scene is received as, in some sense, a miracle—but one that initially moves the women at the window as spectators rather than participants.

Yet, while the happy man's performance of his happiness may be more complex and ambivalent than it first appears, it nevertheless remains a moment of great joy. It is *not* undermined by the apparent absence of the people it invokes, to which it lays claim, and which it seeks to encourage into a more permanent existence than the fulgurations of that day's events might in themselves seem capable of sustaining.

If this is so, perhaps it is because there are more people present in this video than just the three men in the street and the three women watching them from their window.[2] And we are given a clue to the nature of this multiple presence very early on, when the first woman murmurs: "How many people died that this day might come!" The people who make it true that the people exist are not exclusively, or even primarily, the living people who are or are not out in the street tonight. They are the people who have given their lives, not just over the past weeks but over the many preceding decades—who have paid the price of refusing to submit to the sequence of authoritarian regimes that have ruled the country since before it ceased to be a French

colony. The really existing people of Tunisia, those who are most obviously and most irreversibly free, are not those who are sheltering indoors, watching emotionally and nervously from their windows: they are the martyrs of the pre- and postindependence regimes and of the uprising that had begun three weeks earlier, on December 18, 2010.[3]

Switch Off the Camera!

Of course, there is a very simple and pragmatic explanation for why the (living) people of Tunisia are absent from this video. This clip was shot on the evening of January 14, 2011, the night that President Zineddine Ben Ali first dissolved his government and then fled the country. After a day of demonstrations and clashes with riot police outside the Ministry of the Interior (also situated on "the avenue"—that is, Avenue Bourguiba in the capital Tunis—only a stone's throw away from this scene), the news that the regime had fallen began to spread. Prime Minister Mohamed Ghannouchi was named interim president in line with article 56 of the constitution and with the support of the army. While Ben Ali himself succeeded in leaving the country, many members of his family were arrested as they attempted to flee. A nationwide state of emergency was declared, which included a curfew from 5 p.m. to 7 a.m., a ban on all public assemblies and demonstrations, and instructions to the police to open fire on anyone suspected of contravening these orders. In these circumstances, it is hardly surprising that very few people are out on the streets. The mood of that night must have been a bizarre mixture of elation, confusion, and deep anxiety. This also explains the very specific resonance of the first woman's opening remarks in French: "How brave he is! How brave!" The man celebrating freedom in the avenue—to give him his full name in "civilian life," the barrister Mohammed Abdennacer Aouini—was doing so in open defiance of the curfew, within earshot of the Ministry of the Interior, and thus at some real risk to his own life.[4]

The event recorded in this video was one of the first to emerge from these revolutions through the YouTube ecosystem and capture the wider popular imagination not only in Tunisia, but across the region and beyond. I am phrasing this carefully, because anecdotal evidence suggests that it was not this particular video but in fact an alternative take of the same event, shot by Abdennacer's friend who was beside him in the street (one of the three men referred to by the woman at the window in her commentary), which actually went "viral" in January 2011.[5] In fact, it did not so much go viral as mainstream: extracts from it were shown on a quasi-permanent loop on many Arab satellite channels over the weeks following the fall of the Ben Ali regime. But the emotional power of the video discussed here seems to me incomparably greater than that of its better known companion piece. Whereas the street-level video simply *records* Abdennacer's performance somewhat flatly, this video shot from a window high-up on Avenue Bourguiba *dramatizes* it in a way that reinforces and deepens the complexity and ambivalence of the scene.

It achieves this, I would argue, in three main ways:

- By filming Abdennacer from such a distance that he is barely a figure—indeed, we can hardly see him most of the time, and when we can see him, he is just a small dot of white—it emphasizes both the fact that it is his *voice* which is important to us, not his physical appearance, and the "fact" of his solitude, despite his repeated invocations to the people. Framing a large fragment of basically empty street, reducing the three people in it to almost indiscernible marks, this video thus, by its "choice" of camera position, opens up a huge gap between the people whom Abdennacer invokes and his own situation as he strides up and down the avenue, isolated and vulnerable.
- By placing the viewer not just at a distance, but with and among the three women in their apartment (whom we also hardly ever see, but whose very different voices and bodies we can hear and sense, as they comment, relate, discuss, weep, and celebrate), it reinforces the sense of distance that

separates those who have obediently stayed at home from Abdennacer, who has risked his life to go out into the street. The women's reactions also dramatize before us, and so allow us to recognize, a number of different possible reactions to Abdennacer's act of bravery. One senses that one of the women (the oldest of the three?) is more diffident, more cautious, in her response, whereas the younger ones are more impulsive and more easily swept up on the wave of their emotions. In this way, we not only experience Abdennacer's words through the effect they have on the women (their effect on both their words and on their bodies as they move about excitedly or shake as they shed tears). We also experience the possibility of a range of reactions to what he is saying, reflecting the differences between people's individual temperaments. There may be no "people" down in the avenue, but there is already the microcosm of a people up here in this room with us. And that people is not a unified mass, but a choreography of singular bodies that is also a series of embodied points of view, which, while they coexist, do not necessarily coincide.

- The form of the video itself further reinforces this sense of dramatization or even theatricalization. It opens with the curtain at the window being swept aside and closes with the window being closed again, on the insistence of the senior of the three women. Within the body of the video, there are basically only two shots: a near-vertical top shot down onto the sidewalk below and another at a slightly shallower angle taking in the sidewalk on the opposite side of the street, and also—when it pulls back—allowing us to see in silhouette the woman who has gone to the window to recount the events to a friend with whom she is on the phone. However, the way in which the clip moves back and forward between these two camera angles, and the way in which the cuts (presumably done in camera) model our perception of time and space, are tantamount to a conscious manipulation of effect. Together, they work to produce a mounting sense of tension. First, we witness the scene going on in the street below. Then we

withdraw a little to consider the effect it is having on the three women as viewers and thus by analogy on us, the audience of the film. Then we go back to a more direct engagement. And it is at this moment that the women emerge suddenly from their reserve and break down the invisible barrier that separates the scene outside from its audience, to provide a collective response to Abdennacer's individual call. Then, just as suddenly (or so it seems), the police appear out of nowhere (in fact, from out of an ellipsis that separates the last two shots), and everything is closed down: the window must be shut, the camera must be switched off.

Tunisia Belongs to Us!

The progression I have just described embodies two separate but related movements that are central to the nature of the vernacular anarchive as a whole. We see the *audience* of the unfolding drama move from passive spectatorship to active participation as, unable to resist the call of Abdennacer's voice, they take the risk of speaking out, of transgressing the boundary between private and public space. And in doing so, the *people* whom he invokes cease to be an absent phantom (as when they were present "only" as the ghosts of the martyrs), a mere projection, whether past memory or future potential (what Canetti called an "invisible crowd").[6] The Tunisian people are suddenly embodied there in the night air with him, in the three women's voices as they ring out in response to his call. With their impulsive, self-certain first-person claim on *all* this land ("Tunisia belongs to us!")—not just the small fragment imprecisely lit up under the sodium lamps here, tonight—their response answers his invocation with a confidence that is partly a function of the fact that it is a sudden irruption, and *not* a lengthy litany whose repetitions may seem to betray an underlying doubt. It is enough for the women to state it once, and its truth shines through, self-evident. The people are no longer absent or lacking. They are here. And we—the viewers—we are not looking at them. We are among them, we are one of them.[7]

Of course, the video does not end on this note of supreme certainty. With the benefit (or obstacle) of hindsight, it is all too tempting to read the final intervention of the police—closing down the party, insisting that the windows be shut, declaring that "there is nothing to see"—as an anticipation of the counterrevolution that was to follow even those of the Arab revolutions that seemed, for a while, the most successful in translating social insurrection into political change.[8] And it would be possible to construct an interpretation of these three minutes that casts these events in an almost wholly negative light. In such a reading, while the curtains open to reveal a scene of celebration, the one man who is celebrating is deluding himself. The people he invokes are nowhere to be seen, they are dead, or they have chosen out of cowardice to stay home. And when the police appear, those who had at one moment dared to think they might rebel simply submit once again and do as they are told.

Still, I am not sure that this reading is correct. Remember how the clip ends—with the third woman's self-deprecating reference to her film as "only a bit of video." This remark can be read on a number of levels. On the one hand, it is an ironic attempt to deny her own artistry, which only serves to highlight the formal complexity of the short film she *has* made and suggests that she is at least the equal in her own "art" of the (professional) orator Abdennacer. On the other hand, it is also an act of implicit resistance to her elder relative's insistence that she stop filming, that she stop taking risks for the revolution. Denying that what she is doing is a "film" is a way of suggesting that she doesn't need to stop filming, because she never started (though it is exactly at that moment that she does in fact switch her camera off). Thus, she ends her film by marking her persistent, and unrepentant, insubordination, even as she complies not with the police's orders but with her relative's plea for her to play it safe.[9]

The Subject of the People

In *Cinéma 2*, Gilles Deleuze famously adopted a phrase he attributed to Paul Klee: "The people are missing." For Deleuze, these words encapsulate what he saw as the strength of the best political films produced since World War II.[10] While mainstream cinema in both the United States and Europe continued to present an increasingly wooden and unconvincing image of the people as a single unified mass, directors such as Jean-Marie Straub and Danièle Huillet, or Alain Resnais, showed us instead the *absence* of the people as a possible subject of any contemporary (Western) history. At the same time, though, Deleuze pointed to an alternative mode of political subjectivity that he glimpsed outside, or on the internal margins of, the West. In both the direct cinema of Pierre Perrault and Jean Rouch and the Third Cinema of Glauber Rocha, Lino Brocka, Yılmaz Güney, and Ousmane Sembène, the people are not so much missing (or lacking) as they are "yet to come." In the context of the nation-building projects that accompanied the Third World independence struggles in particular, the possibility of a people could not be relegated to a rapidly receding past. The people that was emerging through these struggles belonged rather to a future that was perceived as both imminent and increasingly inevitable. If they were absent, it was not because they had been retired from history but because they were still in the process of being born.

Deleuze's binary oppositions in his *Cinéma* books, and his division of film history into two distinct periods characterized by phenomenologically distinct forms of image, have been criticized, notably by Jacques Rancière. In a seminal article, Rancière uses a close reading of Bresson's *Au hasard Balthasar* (1966) to demonstrate how the very possibility of the time-image in fact requires the persistence of the movement-image of the classical cinema that had preceded it *within* those works that are most characteristic of cinematographic "modernity."[11] However, we should perhaps also remember that Deleuze opened his *Cinéma* diptych on the first page of *L'Image-Mouvement* by asserting that these volumes constitute not a history but a natural history,

a vast essay in classification.[12] And Dork Zabunyan has argued that the transition between the movement-image and the time-image should in fact be understood as *nonlinear* in nature, in line with the priority Deleuze accorded to processes of becoming over any merely chronological history.[13]

Deleuze's writings on "the people who are missing" would appear to depend particularly heavily on the prior division of film history into two successive blocks and so to be susceptible to Rancière's critique. Yet again, it is clear that for Deleuze himself, the absence of the people was never an absolute historical caesura, something given once and for all. In his 1987 lecture on the act of creation at the Fémis, the French film school, he qualified his position in *L'image-temps* in these terms:

> What is the relationship between the struggles of men and the work of art? For me, their relationship is at once the closest possible kind of relationship, and also the most mysterious. This is exactly what Paul Klee meant when he said, "You know, the people are missing." The people are missing, *and at the same time, they are not missing.*[14]

In maintaining this paradox, Deleuze anticipates Georges Didi-Huberman's recent proposal toward the end of *Survivance des lucioles*, his meditation on (and against) a celebrated essay by Pasolini, that while the people themselves may indeed exist only as an alternation, an intermittence (figured here by the gleams given off by fireflies in the Mediterranean night), yet there is still something that is constant, indestructible even: and that is the *desire* that the people should exist.[15]

It is hard to imagine a film that more aptly fits this conception of the people as intermittence, as that which is simultaneously present and absent and that exists only through our desire for it, than this short fragment from Tunisia. These three minutes that are not a film, that are "just a bit of video," provide a statement about the Arab revolutions, their emancipatory potential, and the almost overwhelming obstacles that they have faced, that is as complex, as ironic, and as poignant as

any feature-length movie that I know. And they do this, not from the point of view of the individual artist—not, that is, from the point of view of the orator Abdennacer Aouini down in the avenue, who remains oblivious right until the last moment of the presence of the women who are watching him from their window—but *from the point of view of the people themselves.*

From down in the avenue, the people remain invisible. Cloaked in darkness or hidden behind closed doors, they are resolutely *hors-champ.*[16] Yet despite this absence, in this video shot from the window of these women's apartment, the people *do* in fact appear. And they do so in such a way that we know that they are not just "yet to come" but were in some sense there all along, even before they take voice and declare themselves in public.[17] But when they appear to us they do so not as a figure or an object seen from a safe distance that can be identified, represented, and reified, but as a multiplicity of voices, bodies, points of view, which yet seem to be traversed by a single *subject*—a presence, in short, that is too close to us, too complex, too physical, too real, too irrevocable, for us to see it or ever pin it down.

Video as Performance

The People as Performance

Abdennacer Aouini's invocation of the "people" is not, of course, an isolated incident. Indeed, one of the main consequences of the Arab revolutions has been, perhaps, to revive the sense for both participants and observers (both within the region and outside it) that the word "the people" once again corresponded to something real and was not merely an antiquated term, irrevocably tarnished by its association with the manipulative rhetorics of nationalist, socialist, or liberal authoritarianisms and their conveniently essentializing attitudes toward identity, race, and class. This revival of the term was at least in part accomplished by

Still frame from video posted to YouTube by IxLovexBahrain, February 25, 2011. To view, and for more information, go to vimeo.com/channels/thepeoplearenot, video 2.

the emblematic anaphora of the revolutions, *al-sha'b yurid ...* ("the people want"), whose circulation in the streets was rivaled only by its travels outside the region, where it rapidly came to function as the dominant unifying slogan of these movements, enabling observers to group together and summarize what might in many other ways have appeared as highly differentiated events. The simplicity of the phrase and the apparent direct-ness of its translation—the precise yet malleable resonances of other "peoples" that it conjures for us, depending on where we are standing when we hear it—should in itself give us pause. Commenting on the full original slogan, *al-sha'b yurid isqat al-nizam* (the people demand the downfall of the regime), Samia Mehrez wrote:

> What did it really mean for Egyptians, whose entire uprising con-tinues to resound in colloquial Egyptian Arabic, to borrow this slogan in formal Arabic from the Tunisians? What affinities lay behind this borrowing? What poetics of resistance are written into it that conjoin these region-wide uprisings? What did it mean for people on the street to refer to themselves as "*al-sha'b*" (the people), a word that had been emptied of its signification through decades of abuse by the regime? Why was it significant for the people to will, want, demand (*yurid*), when that will had been denied, compromised, and eradicated for decades on end? And what exactly was meant by the word "*nizam*"? Was this a reference to a "regime," a "system," or an "order"? And which *nizam*: local, global, or both? How does this initial chant and slogan translate itself *horizontally*, over time, as the people con-tinue to invest it with new signification, indeed new translations of power relations between *al-sha'b* and *al-nizam*?[1]

The term *al-sha'b*, as it appears both within this phrase and without it, requires "thick," context-rich translations that are sensitive to the specific moment and urgency of each particular use.[2] Yet those contexts that are so necessary are themselves dif-ficult to pin down, because they are not only complex but also inherently *mobile*. Indeed, a large part of the value of the term

comes precisely from the fact that it is has been extracted from a language (classical Arabic) that has (as Niloofar Haeri has put it) "no native speakers," and which, in part perhaps because of that, is able to circulate *across* countless borders—not only of dialect and register, but also of geography and social class—that would arrest more colloquial formulations.[3]

How then can we get closer to what is at stake in this (re-) emergent sense of "the people," both in each of their particular instantiations and in their circulation between those different moments and different uses? Mehrez offers an important point of entry, I think, when she points to the crucial role not only of words, but of bodies and spaces, in determining both the course of the Arab revolutions and the ways in which they have, singly and collectively, resonated far beyond the immediate perimeter of their direct action, however significant that already was:

> One of the most remarkable accomplishments of the various uprisings in the Arab World since January 2011 has been the remarkable transformation of the relationship between people, their bodies, and space; a transformation that has enabled sustained mass convergence, conversation, and agency for new publics whose access to and participation in public space has for decades been controlled by oppressive, authoritarian regimes. Like other uprisings and revolutionary moments whose histories have first been written in great public spaces—from the Place de la Concorde during the French Revolution to the Occupy movements around the world today—people in the Arab world have reclaimed the right to be together as empowered bodies in public space exercising their right to linguistic, symbolic, and performative freedom despite the enormous price in human life that continues to be paid ... This newfound power of ownership of one's space, one's body, and one's language is, in and of itself, a revolution.[4]

What Mehrez confronts us with here is the dynamic convergence of space, body, and language, not as independent variables, but each of them jointly and severally constituting the condition

of the others. The physical occupation of space by insurgent bodies, and the equally physical occupation of discourse by insurgent utterances, are not simply parallel or analogous to one another. Each requires the other in order to become fully effective and fully affecting. The freedoms that are exercised, then, are not simply linguistic and symbolic; they are also and above all, as Mehrez specifies, *performative*.

As we saw in chapter 1 (in connection with the video of Abdennacer Aouini), it is the triangular tension between space, the body, and language (here as voice) that creates the field within which "the people" can emerge. And that field is above all a field of performance. On January 14, 2011, Aouini did not simply "talk about" the people as if they already existed: he *performed* them, conjuring them into existence through a properly *mimetic* and quasi-magical act of poetic invocation.[5]

The people then is not simply an actor; it is also that which is enacted. Elliott Colla has described this emergent quality very well:

> As revolutionaries have testified … it was the collective act of stating that the people wanted something that created the sense there was a social actor by that name. For many Egyptian activists, it was this locutionary event that proved there was an Egyptian people capable of revolutionary action in the first place.[6]

Judith Butler's recent work on the performative nature of political enunciation confirms and extends Colla's insight. As she argues, "the people" who proclaim themselves as the grammatical subject of phrases such as "We, the people" or "The people want …" should not be understood as a singular, pre-existing, and substantial essence, however "progressively" defined, but rather as a performative, plural, conflictual, and self-constituting event:

> Someone says "we" at the same time as someone else, a group says it together, and in this way, they seek to constitute themselves as "the people." Seen in this way, as a speech act, "we, the

comes precisely from the fact that it is has been extracted from a language (classical Arabic) that has (as Niloofar Haeri has put it) "no native speakers," and which, in part perhaps because of that, is able to circulate *across* countless borders—not only of dialect and register, but also of geography and social class—that would arrest more colloquial formulations.[3]

How then can we get closer to what is at stake in this (re-) emergent sense of "the people," both in each of their particular instantiations and in their circulation between those different moments and different uses? Mehrez offers an important point of entry, I think, when she points to the crucial role not only of words, but of bodies and spaces, in determining both the course of the Arab revolutions and the ways in which they have, singly and collectively, resonated far beyond the immediate perimeter of their direct action, however significant that already was:

> One of the most remarkable accomplishments of the various uprisings in the Arab World since January 2011 has been the remarkable transformation of the relationship between people, their bodies, and space; a transformation that has enabled sustained mass convergence, conversation, and agency for new publics whose access to and participation in public space has for decades been controlled by oppressive, authoritarian regimes. Like other uprisings and revolutionary moments whose histories have first been written in great public spaces—from the Place de la Concorde during the French Revolution to the Occupy movements around the world today—people in the Arab world have reclaimed the right to be together as empowered bodies in public space exercising their right to linguistic, symbolic, and performative freedom despite the enormous price in human life that continues to be paid ... This newfound power of ownership of one's space, one's body, and one's language is, in and of itself, a revolution.[4]

What Mehrez confronts us with here is the dynamic convergence of space, body, and language, not as independent variables, but each of them jointly and severally constituting the condition

of the others. The physical occupation of space by insurgent bodies, and the equally physical occupation of discourse by insurgent utterances, are not simply parallel or analogous to one another. Each requires the other in order to become fully effective and fully affecting. The freedoms that are exercised, then, are not simply linguistic and symbolic; they are also and above all, as Mehrez specifies, *performative*.

As we saw in chapter 1 (in connection with the video of Abdennacer Aouini), it is the triangular tension between space, the body, and language (here as voice) that creates the field within which "the people" can emerge. And that field is above all a field of performance. On January 14, 2011, Aouini did not simply "talk about" the people as if they already existed: he *performed* them, conjuring them into existence through a properly *mimetic* and quasi-magical act of poetic invocation.[5]

The people then is not simply an actor; it is also that which is enacted. Elliott Colla has described this emergent quality very well:

> As revolutionaries have testified ... it was the collective act of stating that the people wanted something that created the sense there was a social actor by that name. For many Egyptian activists, it was this locutionary event that proved there was an Egyptian people capable of revolutionary action in the first place.[6]

Judith Butler's recent work on the performative nature of political enunciation confirms and extends Colla's insight. As she argues, "the people" who proclaim themselves as the grammatical subject of phrases such as "We, the people" or "The people want ..." should not be understood as a singular, pre-existing, and substantial essence, however "progressively" defined, but rather as a performative, plural, conflictual, and self-constituting event:

> Someone says "we" at the same time as someone else, a group says it together, and in this way, they seek to constitute themselves as "the people." Seen in this way, as a speech act, "we, the

people," is an enunciation that seeks to produce the social collective that it names. It does not describe it, it seeks to bring it into existence. It is, therefore, a sort of linguistic act of self-creation which is at work here, an action that resembles a kind of magic, or which would at least seek to have us believe in the magical powers of the performative.[7]

The political meaning of the "people" who are invoked in such moments can therefore not be given in advance, but exists only as the projected outcome of the process which such a declaration initiates, without any guarantee of being able to see it through.

When and where popular sovereignty—the self-legislative power of the people—is "declared" or, rather, "declares itself," it is not exactly at a single instance, but instead in a series of speech acts or what I would suggest are *performative enactments* that are not restrictively verbal.[8]

"We, the people" neither presupposes, nor produces, a unity. It founds or institutes a series of debates on the nature of the people, and what the people want.[9]

Butler goes further than Colla, however, in contesting the primacy of language as the mode of this performance. Following Hannah Arendt, she sees the inaugural moment of the event that constitutes the "self-disclosure" of the people as physical, not linguistic. It is the coming together of *bodies*, whether in a single time and place, or distributed and yet connected, that not only makes this collective self-enunciation possible, but in some sense, already *is* the claim that, simply through their physical presence or attention to one another, "the people" may be said to have come into existence.

Although we often think that the declarative speech act by which "we the people" consolidates its popular sovereignty is one that issues from such an assembly, it is perhaps more appropriate to say that *the assembly is already speaking before it utters any*

45

words, that by coming together it is *already* an enactment of a popular will; that enactment signifies quite differently from the way a single and unified subject declares its will through a vocalized proposition. The "we" voiced in language is already enacted by the gathering of bodies, their gestures and movements, their vocalizations, and their ways of acting in concert.[10]

Throughout her recent work on "a performative theory of assembly," Butler seeks to build on Arendt's theory, set out at length in *The Human Condition*, of politics as founded on a "space of appearance."[11] But Butler refuses to follow Arendt in distinguishing between *bios* and *zoē*—between the public realm of politics and the private realm that is the proper place of the body as body, and where the tasks of "bare life" (Agamben), of the reproduction and nurturing of the community, are carried out.[12] This division serves to inscribe the subordination of those who are not fully citizens (women, children, slaves) into the classical model of politics that Arendt seeks to reactualize. But for Butler, the speech through which citizens disclose themselves to one another can never be separated from the vulnerability of the bodies through which it is enunciated—from their private "needs," their weakness, dependency, and fragility. Arendt's thinking here supposes a division of labor between the "given body" and the "active body" that belies the almost anarchist inflection of some of her proposals and defines the public realm as indelibly masculine and hierarchical, while brushing its dependency on *other* bodies under the textual carpet. This division threatens to undermine the more radically democratic strains in Arendt's thought, by making it impossible to account for and respond to those who are excluded from the public realm, but on whose labor the existence of that realm depends. For Butler, however, there can never be a "pure" space of politics that does not depend upon the physical space of our immediate bodily needs for its appearance. Politics, for Arendt, is transcendence of that dependency; for Butler, it is acceptance of the body and its vulnerability as inseparable from the form-of-life through which our deepest political aspirations may be realized.[13]

Butler's people are still a performance, then—just not the kind of glorious, quasi-divine performance that Arendt, with her fixation on the politics of the Greek polis and Republican Rome, had in mind. The bodies whose gathering is enough to already *speak* the people are the same everyday bodies that suffer and labor, that give life and have it taken from them. And it is precisely through the self-disclosure of their mutual vulnerability, not its concealment or repression, that the kind of energy can be released that makes possible the downfall of the regime.[14]

Between the Street and the Screen

So "the people" of the Arab revolutions, as Abdennacer Aouini recited them into being on the night of January 14, 2011, on Avenue Bourguiba and as I will use the term in this book, is a performance. And, just as important for my purposes here, the videos which they produce and post online are *part of that performance*—part of that process of constituting themselves as a collective subject and negotiating exactly what such a form of subjectivity may be and can do. *For making and watching images, films, and videos are themselves bodily actions, bodily gestures.*
 As Butler puts it:

What bodies are doing on the street when they are demonstrating, is linked fundamentally to what communication devices and technologies are doing when they "report" on what is happening in the street. These are different actions, but they both require bodily actions. The one exercise of freedom is linked to the other exercise, which means that both are ways of exercising rights, and that jointly they bring a space of appearance into being and secure its transposability. Although some may wager that the exercise of rights now takes place quite at the expense of bodies on the street, that twitter and other virtual technologies have led to a disembodiment of the public sphere, I disagree. The media requires those bodies on the street to have an event, even as the street requires the media to exist in a global arena. But under conditions when those

with cameras or internet capacities are imprisoned or tortured or deported, then the use of the technology effectively implicates the body. Not only must someone's hand tap and send, but someone's body is on the line if that tapping and sending gets traced. In other words, localization is hardly overcome through the use of a media that potentially transmits globally. And if this conjuncture of street and media constitutes a very contemporary version of the public sphere, then bodies on the line have to be thought as both there and here, now and then, transported and stationary, with very different political consequences following from those two modalities of space and time.[15]

However so distributed—and we will return often in what follows to the question of how bodies in the street and bodies online are both "on the line," yet in different ways and with very different consequences—these images through which the people's energy circulates beyond the immediate space and time of their performance form part of that performance and of its wider resonance, however so conceived. And they contribute, not simply to the diffusion of that event, but also to its localization, to its boundedness.

Again, as Butler puts it:

When the scene does travel, it is both there and here, and if it were not spanning both locations—indeed, multiple locations—it would not be the scene that it is. Its locality is not denied by the fact that the scene is communicated beyond itself, and so constituted in a global media; it depends on that mediation to take place as the event that it is. This means that the local must be recast outside itself in order to be established as local, and this means that it is only through a certain globalizing media that the local can be established, and that something can really happen there.[16]

That the "remediation" of the event is not additional to the event, but is part of what constitutes it as the event that it is, is not simply an empirical consequence of the ubiquity of uncontrollable cameras in public spaces in the twenty-first century. It is

implicit in the Arendtian conception of public space as essentially a "space of appearance." What makes my gesture—any gesture—political is that it is explicitly and deliberately performed for and before others.

Butler glosses it in this way:

> For politics to take place, the body must appear. I appear to others, and they appear to me, which means that some space between us allows each to appear. We are not simply visual phenomena for each other—our voices must be registered, and so we must be heard; rather, who we are, bodily, is already a way of being "for" the other, appearing in ways that we cannot see, being a body for another in a way that I cannot be for myself, and so dispossessed, perspectivally, by our very sociality. I must appear to others in ways for which I cannot give an account, and in this way my body establishes a perspective that I cannot inhabit. This is an important point because it is not the case that the body only establishes my own perspective; it is also that which displaces that perspective, and makes that displacement into a necessity. This happens most clearly when we think about bodies that act together. No one body establishes the space of appearance, but this action, this performative exercise happens only "between" bodies, in a space that constitutes the gap between my own body and another's. In this way, my body does not act alone, when it acts politically. Indeed, the action emerged from the "between."[17]

This space that is "between," this space in which action emerges, encompasses all the "betweens" that are implicated in any given space: not just those between the people who are physically present in that locality, but also the "betweens" that exist between the bodies that are present here and those that are present elsewhere, and which are linked together by the images and sounds that reverberate between them, through the intermediary (Deleuze would say, the "intercessor") that is the camera.

The formal standard Arabic of "*al-sha'b yurid ...*" helped bring into existence revolutions that were specifically Tunisian, Egyptian, Yemeni, Bahraini, Libyan, and Syrian by repurposing

the lingua franca of the institutional Arab world—the language of bureaucracy, elite literature, and state television—as a point of contact between them, while simultaneously embedding it in dialectal frames that were incommensurable and sometimes mutually unintelligible. In the same way, the images that circulated from one country to another (and beyond them to countries that are other-than-Arab and to people who may chance on them without having the slightest idea of what is happening in them or what is being said through them) serve both to open those "local" happenings out onto other spaces and other times and to confirm them in their concrete, unrepeatable specificity.

This may sound somewhat abstract. Consider, then, for a moment the way in which the video of Abdennacer Aouini discussed in the previous chapter entwines together different temporalities and different places. We can distinguish, I suggest, at least four different locations in space and/or time within the event that this video unfolds, which are at once distinct from one another, yet connected:

- The street itself, where the three men pace up and down and Aouini recites his praise song for the Tunisian people;
- the apartment above, with its window which gives onto the street from which the three women can observe what is happening below, without themselves being observed;
- the video that is being made by one of the women, which she is probably monitoring, if not actually watching on her cameraphone's screen as she makes it, and which she will later upload to the Internet, thus linking this scene to countless, unforeseeable other places and other times; and,
- the conversations which are being conducted by mobile phone inside the apartment—one of which at one point plays an important role in the video, while the others are played out more indistinctly in the background—and which link the scene to other places and people around the city, or across the country, or even abroad, who are then able to imagine the scene, elsewhere yet simultaneously, through the narration that is being given of it.

In addition, we know from the alternate take discussed in the previous chapter that Aouini's performance was also filmed by his friend below. And through this second video, we also know that at one point Aouini interrupted his recitation long enough to conduct a nontrivial phone conversation with a friend of his own. Both these last two connections are present within the block of space–time recorded by the first video, though not in such a way as to be perceptible within that video itself.

This scene is thus connected in a number of overlapping ways to countless other spaces and other scenes elsewhere, before we even begin to try and count the ways in which it will later be remediated and recirculated online. What happens in the street is observed from the apartment above in real time. It is also commented on in real time by mobile phone to at least two (and possibly more) other points in space. And then, there is the video recording being made, which not only reconfigures the event differently for the person making it as they film, but also projects the event forward in time, toward those who will potentially watch it later, when it is circulated either locally, by hand (so to speak—but also literally) as the phone it was recorded on is passed around, or by MMS, or by being uploaded (as was in fact the case) to the Internet, and eventually (though this may not have been foreseeable at the time) being picked up by satellite TV channels. The further away these secondary scenes move from the original scene, the more diverse, and the less predictable, these connections and their consequences become.

The different threads that connect this single "event" to so many different places and times are thus uncountably complex. But when we are watching this video, what is most striking about them is the way that they are deftly and intricately woven back into the scene itself, as it plays out before us, in such a way, indeed, that if we remove any one of them, the scene as we know it from this video would begin to erode and collapse. The different kinds of "betweenness" that these relationships enact are crucial in particular to the affective resonance that the scene develops as it unfolds. The viewer of the video feels the different ways in which filming this scene, or narrating it to one

another, or over a mobile phone, alter and extend its emotional texture for the women who are watching it—how these "mediating" gestures contribute to the build-up of tension that finally explodes in the present of the pro-filmic as the ululations that suddenly make these women a part of what they had hitherto "merely" observed. Without these betweennesses—without the spaces to which Butler refers, in which action (and thus emotion) can emerge—there is, in the final analysis, no event to move us, or those who were present to it. In other words, what might too easily be dismissed as the "remediation" of an "original" event is *not* an operation supplemental to the event but *is integral to the texture and dramatic structure of the event itself.*

One of the remarkable things, then, about the videos in the vernacular anarchive is that, far from being raw documents of original events which, by the time we see the video, have definitively receded into an irretrievable past, they are explicitly or implicitly complex constellations of time and space, in which the place and time at which the video was made is only one of the places and times that go to constitute it as what it is. In other words, like the self-constitution of the people, the events that *are* these videos are not single moments in time, of which we who were not there are condemned to know only the ghostly, partial, and imperfect reflection, but complex open-ended series of actions and decisions, including our own decision to watch this video, whoever and wherever we may be. And it is this distributed structure of the video-event—at once there and here, in the past and in the present, singular (in the act of its making and its unique dynamic form) and plural (in its origins and its consequences, its audiences and its transformations)—that makes it not an inert object, but a *distributor of energy.*

The people as performance is therefore always dependent on the specific place and time of its production and on the particular character of the individual consciousnesses that are present there and in which it reverberates. But it is also at least partly configured by all the *other* times and places that are invoked around it, if only by those multiple moments and spaces in which we and others like us will come to watch it on a screen.

The present that is recorded, then, is always a present whose resonance is augmented and expanded by technology. And the people that is thus performed is therefore not simply present to itself, in however complex a way, but is always already redistributed through time and space. This redistribution is not an afterthought or an add-on. And it operates even in the absence of every camera and every telephone. That is, it is not a function of contemporary media technologies, but a consequence of the fact that we live at least one important part of our lives in the open, in public, and for others.

By deciding to be part of "the people," by choosing to appear with and before others, I commit myself both to the concrete, finite limitations of my own perspective and to an existence beyond my consciousness and control, opened for me by the perspectives of others, and open on to possibilities that I can neither predict nor preempt. These possibilities are determined partly by the perspectives of those who are there around me, whom I can reach out and touch, and partly by the perspectives of those who are elsewhere, and whom I may never meet, but who may still be touched through the part of me that reaches out to them through these sounds and images.

3

Seeing as the People

Whether such zones are condemned to be suppressed militarily really does not matter. What matters, each time, is to preserve a sure escape route. And then re-aggregate.

Elsewhere.

Later.

—Tiqqun

Still frame from video posted to YouTube by feb tub, February 14, 2011. To view, and for more information, go to vimeo.com/channels/thepeoplearenot, video 3.

The Kinesthetic Image

Watching the videos that fill the vernacular anarchive, one is struck again and again by this ambiguous and ambivalent quality of the people's presence. Everywhere invoked, everywhere felt, they yet fail to cohere, coalesce, and stabilize into a single, intelligible image.

This is partly an effect of the quality of those images themselves —their pixelated, chaotic, carnivalesque mobility, that is constantly undoing their attempts to represent or "capture" the reality (or perhaps, more accurately, the emotion, the sensation, the affect) they are chasing after—and partly an effect of their very proliferation. No sooner do we seem to grasp an image of "the people" assembled in a single space and time—something along the lines of those famous top-shots of Tahrir Square that served as the visual backdrop for the predominantly verbal-discursive revolutions presented by Al Jazeera and other TV channels—than they are off again, springing up to left and right, occupying a hundred squares or a thousand, rather than one; marching down a myriad of streets, not just one main boulevard; chanting scores of contradictory, contrapuntal slogans; constantly dispersing in front of us only to reform just round the next corner; always on the verge of visibility, but somehow never quite within our sight.

Nor is this problem restricted to the collective. The same ambivalence and instability afflicts the individual. While there are some videos in which the camera manages to focus on one specific person and what they are doing or saying long enough for them to emerge before us in their particularity and individual density, in most of the videos we encounter only glimpses, shards or fragments of human specificity, which somehow fail to add up to what we might conventionally expect to meet when we meet a "person." It is as if, in the intensity of the revolutionary event, the individual had been temporarily dissolved or disbanded in order to throw herself into the movement, while that movement is in turn constantly emerging from the individuals it traverses only to dissolve back again immediately into

some simpler, more molecular subcollective form of agitation. In these videos, then, we seem to be faced with a plurality that is held in tension between two poles, neither of which is able to subsume it—between "the people" on the one hand, and "the individual" on the other.

But that is not to say that these videos are not rooted in anything. On the contrary: however much their attempts to represent either a political event or an individual expression may seem to be undermined on all sides, each and every one of them inscribes a singularity that, once noticed, cannot be eliminated or forgotten. This is the singularity of the human body that is holding the camera.

For in all these videos—or at least, in (almost) all the ones I will be discussing—there is always a flesh-and-blood person holding the camera that is filming. And, as a general rule, the filmer does nothing to conceal or erase the signs not only of her presence, but also of her physical and emotional involvement in the event the camera is documenting. If all the videos that make up the vernacular anarchive share one thing, it is the unignorable fact that the camera they are made by is supported by a singular human body and that that human body does not stand outside the action (except in a most literal, and always provisional, way), but is filming, morally if not physically, from *within it*.

As Ulrike Lune Riboni has argued, these videos are made by people who are essentially *participants* in the events they are recording.[1] And the ways in which they handle their cameras are, in general, of a piece with the way in which the people around them handle themselves. If they run, the filmer runs. If they duck to avoid a sniper's bullets, the filmer ducks down too. If they are elated, or terrified, or angry, or amused, then the filmer, like any other person present, shares in that emotion to some greater or lesser extent.

The state of the camera is thus mimetically bound up with the situation in which the filmer finds herself and with the states of the people around her—not as a straightforward one-for-one mirroring or involuntary replication, but as a creative

bodily response to their movements, a resonant corporeal dia-
logue with their emotions and affects, a mutual and imaginative
exchange of properties.[2] And in the film she makes, these states
of emotion and the actions that bear them are present twice
over. They are there in the visual and aural information that
we can see and hear *in* the video, and which represents a world
in some sense separate from the filmer—which shows us how
others are moving and being moved. But they are also there in
the haptic (tactile–kinesthetic) properties of the moving images
she makes, which are often (though not always) the result of a
direct physical connection between the camera that is recording
and the filmer's living body.[3]

Through this physical contiguity, which is also a form of bodily
intimacy, the resulting video takes on an almost seismographic
quality. The immediate causal relationship between the hand
that holds the camera, the way the camera moves, and the way
these movements are translated into the images we see played
back encourages us to read everything which is *not* motivated
by the event that the video seeks to represent as an indexical
registration of the filmer's physical, mental, emotional, and/or
nervous state at the time the shot was taken. They become what
Riboni terms, in an interesting coinage, "bodymages."[4]

A famous passage in Chris Marker's *Le fond de l'air est
rouge* (1977), his retrospective compendium film that sought to
sum up a decade of left-wing struggle around the world, offers
an interpretation of such imagery which refuses more mysti-
cal or metaphysical constructions in favor of straightforward
empirical–subjective explanation: "If the images shake, it's
because the hand of the cameraman was shaking," we are told.[5]
Yet even if we agree with this interpretation of such moments,
the link between the camera's agitation and the filmer's emotion
is far from simple and straightforward. We cannot *directly* per-
ceive in the quality of the camera's shakiness anything like "how
it felt to be there" or even "how this particular person who
was there felt." The images that we receive are the result of an
unplanned convergence of disparate intentions and affordances.
They are recorded by the filmer intentionally but in part (and

often largely) without her conscious control. And the combi-
nation of the intentional, the unconscious, the machinic, and
the aleatory stands in the way of any confidence in our ability
to reduce them to a direct psychological or physiological tran-
script.[6] By their very nature, they are complex documents and
often deeply ambiguous. At best, we need to learn the particular
dialect they speak. At worst, we need to learn to live with the
forms of opacity and contradiction they generate and which are
irreducible to any rational or pragmatic interpretation.

This ambiguity can be traced in part to the way these videos
tend to embody a constitutive tension on two different levels
simultaneously:

- Firstly, there is a tension between, on the one hand, the atti-
 tude and emotion of the filmer, and on the other hand, those
 of the people around her who figure in her images, and whose
 state may not be at all points identical with her own state (just
 as that collective may itself be composed of a plurality of dis-
 cordant or disjunctive perspectives, rather than constituting a
 single unanimous point of view). The former are registered in
 part through the tactile–kinesthetic dimension of the images
 but also through other traces of the intimacy between filmer
 and camera (such as spoken commentary intended only for
 the viewer-who-is-yet-to-come or the sounds and noises made
 by the filmer's own body, as well as, less directly, certain
 quasi-instinctual aspects of the choices made, such as where
 to point the camera, how quickly to move (with) it, and so
 forth. Of course, one may suppose that, in the great majority
 of cases, it is the sensation of participating in a *shared* emo-
 tional state that motivates, beyond any documentary impulse,
 the decision to film now, and here, and in this way. But then
 again, this "sensation" may in some cases be less a response
 to an affective state that is already circulating, and more a
 desire to bring about the experience it anticipates—including
 through the act of filming itself.
- Secondly, there is the tension between, on the one hand, our
 desire to read some or all of the tactile–kinesthetic properties of

the images, and in particular what we might call their "haptic shadings"—the movements, shakes, blurs, defocussings, and mis-scalings that disfigure the image's "attempt" at photo-realistic representation—as straightforwardly transparent not only to the gestures and behavior of the filmer, but also to her physical, mental, and emotional state of being in that moment; and, on the other hand, our awareness that, beyond any contingent difficulties of establishing a reliable correspondence between identifiable features of the image and the behavior of the body behind it, the actual role performed by *the camera* in relation both to the material situation in which it finds itself, and to the subjective experience of the camera user, remains to a significant extent uninterpretable and opaque.

From the point of view of the sociologist of social movements, the political theorist of revolution, or the scholar of "the Arab world" who may wish to extract information or "data" from these videos, who hopes to interpret them "correctly" or even exhaustively, such forms of complexity and opacity are at best an irritating obstacle, at worst an intolerable moral hazard. This may help explain why so much of the academic work that has been done on these videos to date deals with them mainly at the aggregate or statistical level and avoids as much as possible any detailed analysis of their content, let alone their form.[7] But from the point of view that I adopt here, these complexities and obscurities are not an obstacle to thinking; they are the very *matter* through which the dialectics of form and content are played out. And so they are precisely that which needs to be thought through, if we are to take the full measure of these videos' implications for the politics of our present.

Filming Like a Boss

To explore some of the claims I have made about embodiment, subjectivity, and plastic form more closely, let us consider a video that is as simple as it is striking; a video in which the

content seems to so far dominate or command the form that there should be almost nothing to say about that form *as* form.

On February 14, 2011, thousands of people gathered at different points throughout the kingdom of Bahrain in response to calls for a "Day of Rage," inspired by the recent revolutions in Tunisia and Egypt. (The date was also chosen to coincide with the tenth anniversary of the publication of the National Action Charter, a blueprint for change issued by Hamad bin Isa Al Khalifa shortly after he took power, and whose promises of constitutional reform and economic participation were rapidly reneged upon.)[8] In the village of Diraz (whose Wikipedia entry remains limited to a list of the village's most famous mosques and *matam*s,[9] despite the important role it has played in the ongoing contestation of the regime in recent years), around one hundred people gathered at a traffic intersection, where they were soon dispersed by police firing tear gas. The video I want to discuss shows us the moment at around 2:30 p.m. that afternoon when the police arrive to remove the demonstrators, and their response as almost all of them, including the cameraperson, flee in panic.[10]

Of course, on one level, this video seems almost too simple to require comment. When it starts, the camera is framing the demonstrators frontally as they wave banners and chant slogans, panning roughly back and forward as if to make sure that the full extent of the crowd has been recorded, even though its wide shot is not wide enough to allow the framing of the entire group from a single angle. Then, for no immediately audible or visible reason, the camera makes a long pan that stretches all the way around to the left, and on the other side of the space that is thus opened up—the green expanse of grass at the center of a roundabout—we can see in the distance a low, black line that is at once somewhat difficult to read and yet immediately recognizable as "the police."

As the voices of the crowd suddenly grow together into a single confused cry of anger and alarm, and as cars continue to navigate around the intersection apparently unconcerned, we gradually become aware that the police have begun to move (to

run) toward the crowd—that is, toward us. At the same time, the cameraperson is walking to the left, and while, in fact, I understand that she is distancing herself from the demonstration (or at least, from what the beginning of the video suggested was most or all of the demonstration), to begin with, at least, it feels as though she is moving into, not away from, the police's line of advance.

The police split into two groups, and as one peels off toward the left (where possibly another group of demonstrators were gathered, although we cannot see them), the other heads directly for the camera. As if finally understanding what is happening, the cameraperson begins to retreat, moving quite slowly and continuing to film. And as she does so, the police open fire, aiming their tear gas canisters at the tarmac in front of the filmer and to her right, where the demonstrators stand.[11] We see the plumes of white smoke that are released, and sometimes we catch a glimpse of a canister as it ricochets and spins along the surface of the ground. But mostly, we hear the detonations. The police fire (by my count) twenty-three rounds in just over ten seconds. People begin to scream. The cameraperson continues to track backward, and her pace increases, but the camera itself remains focused on the police as they begin to fill the roadway, even as the frame starts to rock uncontrollably from side to side.

Soon, the filmer is running backward: but she continues to film *forward*. In the admiring words of one commenter on the English-language YouTube re-up of this video:

"This dude is managing to run away and still film the police LIKE A FUCKING BOSS."[12]

A flock of birds traverses the blue sky, as if put up by the sound of the attack. Then there is a momentary lull, and we can see that the demonstration has been reduced to a solitary figure who remains standing there, undaunted and completely alone, waving the Bahraini flag. The filmer, however, continues to run on. Her camera makes a full 360-degree circular pan, and as it does, we can see how other demonstrators are running too, beside her, or just behind, or just ahead. We catch a glimpse of the narrow shopping street she is running into. And when the

camera finally comes back to its original angle, we can see how the police continue to run after them, even if they have temporarily stopped firing.

The path of the filmer takes her into a sort of deep urban gulley, dominated by the shade cast by a tall building to the right of the main axis. As she continues, the video descends into even greater confusion. A few more tear gas rounds are fired; a woman screams; the camera, no longer able to maintain the horizontal, picks up random, oblique fragments of the cars it passes, of tarmac, buildings, sky. We hear glass being smashed; cars start to honk their horns—whether in solidarity, or in warning, or alarm, it is not clear. The filmer runs on a little further. When she turns back to look again, what is happening behind her is also far from clear. Another car sounds its horn, almost right beside her. And the more the camera stares into the distance, the less we are able to make out in the density of the street's shadows the forms of the police (though if we pause the image we can see that they are there and continue to give chase).

And then, right there, in the midst of her flight, in this moment of false calm, as the camera continues to shake and the filmer continues to run on, the video, abruptly, and for no particular reason, stops.

Subjectivity as Interruption

On the face of it, this video is totally transparent to its occasion. A person is filming a small demonstration. The police arrive to violently disperse the demonstrators, and that violence and the ensuing dispersion are registered straightforwardly. That is, form appears to follow content, and anything that is "unusual" in terms of the final video can be motivated (explained) in terms of what we can infer was happening while it was being filmed.

Thus, the video starts with relatively stable images of the collective of which the filmer is a part, even as she stands back just far enough to almost fit it within her frame. After the police charge begins, these stable, legible images are replaced with the

chaotic fragments produced by the camera of a person who has taken to their heels and is being chased down the street, apparently alone, and who is no longer paying much (or perhaps any) attention to what is caught within the frame. And while the filmer is not in fact the only person being chased down that street, once they have begun to flee, the other protesters more or less disappear from view, at least as anything resembling a collective. When we see them again, it is as scattered, isolated individuals, generally plunged into shadow by the high-contrast lighting, who loom into the camera's visual field for a few seconds only to disappear again.

So on one level, this video records the breaking up of a collective and its reduction to single isolated bodies, each of which then runs for its own life. And the "proof" of this description is in the way that the filmer herself ends up alone, separated from her peers, and still searching for a safe refuge that seems to be nowhere in sight. Meanwhile, the "instrument" that effects this breaking up—the police—is not figured in the video as a collective like the demonstrators, who are shown at the outset as a relatively complex yet still legible structure in which individual, personal differences are to some degree preserved, Instead, they appear to function as a single plasma-like mass, whose component parts are not only identical but struggle to separate themselves out long enough to be seen as independent of the whole, and that is thus capable of moving and morphing without ever losing its unity and continuity.

However, to read the video in this way is already to "stabilize" it. What is most remarkable about this video is not the way in which form mimics content—or better, represents content to and for us—so much as those points at which form and content can in fact be seen to part company, to the point that they appear to be operating almost independently of one another.

Consider, for instance, the way in which the soundtrack does or does not coincide with what we see in the image. In this respect, we can distinguish three distinct phases in this short video:

- In the first phase (0:00 to 0:23), the sound is entirely generated from within the space of the image. We see the demonstration, and we also hear the demonstration: the chants, the whistling, the general brouhaha of a lively assembly out to contest something or someone.[13]
- In the second phase (0:23 to 0:42, roughly), the sound is first of all entirely "off": we continue to hear the protesters, though the sound is now somewhat muffled (because off axis), while we turn to look across the roundabout toward the police. And as the police begin to move toward the demonstration, we still do not hear them: instead, they appear to advance noiselessly even as they begin to run. It is only when they open fire that we finally hear a sound that is once again related to what we are seeing and to the police who are now the main actor within the frame. It is as if the police have no recognizably "human" noises associated with them, however close they come to us— no voices, no footsteps. Instead, the only sound through which they are present in this video is the sound of their weapons.
- In the third phase (0:42 until the end), something rather different happens. Instead of the soundtrack being dominated either by the sound from within the image, or by that coming from the dramaturgical *hors-champ*, the main sonic continuity is provided by the low bass rumble generated by the friction of air against the microphone as the filmer runs, and runs. This "wind noise" (which does not resemble any noise the wind usually makes to human ears, which is itself an experience specific, if not to video, then to the audio[visual] technologies that not only record it, but also produce it) dominates the last half of the video, but it does not dominate it completely. Instead it is regularly punctuated (punctured) by specific dramatic noises relating to the continuing action—the crowd screaming, the footsteps of the filmer as she negotiates a pile of debris in the street, the sound of glass breaking, a woman's cry, a car horn. In general, we do not see the sources of these sounds, at least not at the same time as we hear them. Yet they serve to create a kind of rhythm in this second half of the film that without them would be almost entirely lacking.

In this last section, the image track descends into a kind of chaos. But to associate that chaos with the isolation of an "individual" seems to me to be at best a partial interpretation. True, occasionally a single figure looms into the field of the camera's vision, only to disappear again. But it is not easy to use this surfeit of tactile–kinesthetic "information"—noises produced by friction/collision, noises that evocatively reference all-too-tangible events (breaking glass, shards of debris being trodden underfoot), the wild jerky movement of the camera itself, and even the blocky haptic play of pixels that generates strange tonal modulations in the sheer blue sky—to build up any sense of an identifiable individual human being *behind* the camera, even if we think of the individual who is filming as, above all, a body.

Consider the question of how the camera moves through space. On the one hand, we know that the camera is carried by the filmer and that the filmer is running. Yet although the filmer is moving more or less continuously from 0:30 onwards, we only *hear* her moving at three points in the video: around 0:55, around 1:05, and again more faintly at 1:15, and each time for a few seconds only. Each time the sound of what I take to be the filmer's footsteps emerges briefly from the surrounding chaos of the soundtrack, only to disappear into it again.

The effect of this intermittence is curious. Because the sound of footsteps occupies so little time out of the whole sequence, I would suggest we tend to hear the passages where there are no footsteps, not as if the footsteps were still there but drowned out by the other noises, but rather as if the footsteps themselves had *ceased to exist*. The body of the filmer, rather than an insistent presence throughout the video, is noticeable instead by its extended "absences." It is as if the filmer were struggling not only to avoid being beaten or arrested by the cops, but also simply to exist as a biological individual with her own pair of feet, her own independent means of locomotion. Instead, she seems to be carried along by a violent wave of movement that compresses and crushes not only herself, but also the other demonstrators around her. Reduced to particles propelled by this jagged, chaotic flux (due perhaps to the combination of rapid camera movement

with a fast shutter speed), they surface only briefly and intermittently, and then not as themselves, but as rough-edged fragments of what a human being might have been or might still be.

The other sounds that punctuate the second half of the video function, I would argue, in an analogous way: that is, precisely to *interrupt* any sense we might have of the continuous identity of anything—cars, glass bottles, demonstrations, or persons, both collectively and individually. Indeed, if anyone has a body that is continuous and persistent in this video, it is not the filmer herself, but her camera; and not the camera lens, so much, as the microphone that is part and parcel of this audiovisual equipment. For it is the continuous if fluctuating wind noise produced by the motion of the camera(phone?) through space that provides the nearest thing we have in these last forty seconds to a consistent and coherent sensory continuum.

So while there is a minimal sense of continuity, both visual and aural, running the whole length of this video, by virtue of its nature as a single unedited shot, the way in which both the sound and image tracks reduce the world around them to a kind of violently irregular tessellation of time and space tends to undermine our sense that this continuity might be grounded in anything as coherent and clearly delimited as a single, persisting, human body. When we look at these images for the kinesthetic cues they contain, these cues refer us back not so much to the singularity of the filmer's experience, the uniqueness of her perspective, even in its unconscious and embodied dimensions, as to the difficulty of holding a body—any body—together, when it is constantly being invaded, not only by the blunt instrument that is the police, but also by the sharp-edged shards and splinters of all the other bodies, human, and other-than-human, that have been set into motion round about it.

Together with Others

In this brief video from Bahrain, then, we can begin to see how in even the apparently simplest videos, the aesthetic properties

may contribute decisively to the elaboration of a *politics*—how the form of the video can articulate a political discourse that is at least as fundamental as its content.

On one level, of course, the video refers to the violent dispersal of *this* particular demonstration that took place on February 14, 2011, in Diraz, in which we see a provisional collective reduced to its constituent members, who once again find themselves alone before the discretionary projection of power of the security forces. And such a reading is not only relevant and important, but doubtless points us toward part of what those who were present that day may have experienced, including the filmer of the video.

However, when we look more closely at how these images and sounds work, we can see that on another level, the chaos that engulfs them in the second half of the video does not necessarily produce the cameraperson as an isolated individual, as the narrative outlined above would lead us to expect. Rather, it projects her into a movement in which the point of view of the video, in its very abstraction and illegibility—the haptic overload, so to speak, generated by and through a strategy of tactile-kinesthetic excess (what Deleuze, in his essay on the paintings of Francis Bacon, called, appropriately enough in the context of handheld video, "the violent insubordination of the hand")[14]— is marked not simply as one point of view among many, but as *porous to the plurality of the world that surrounds it*—including to the part of that plurality that might be experienced (and quite rightly so) as violence.

What we see and hear in the second part of the video, then, is *not* what it felt like for the filmer to "be there," in some clearly defined and identifiable place, so much as what it might feel like to find one's self—if one had a "self"—reduced to a fragment spinning in a vortex of fragments, one's body broken up and interrupted, its surviving elements provisionally figured as just one or more parts among many other parts. The difference between the experience produced by the video, and the experience we may suppose was that of the person who made it, is marked perhaps most obviously by the way in which a large part

of the video is shot *looking backward while running forward*—a perspective that is totally foreign to the practical morphology of the human body. For while we can easily imagine how this point of view may have been obtained in the video, we cannot easily imagine how we could have had the experience it proposes, or anything closely analogous to it, without the intervention of the foreign body that is the camera.

In short, the tactile–kinesthetic dimension of this imagery and its haptic overflow introduce us to a realm in which representation and reference are displaced and disfigured. In this space, conventional objectification of the world—including of the subject position of the filmer—is no longer able to function univocally, but is instead contested from within the video by the production of a series of noncoincident non-Cartesian/non-Euclidean spaces, which invite other readings and other narratives.

We could see this space (or these spaces) as intrinsically infra-subjective and thus recalcitrant as much to the collective as to the individual. Or we could see it as instead exposing one aspect of the grounds of that "betweenness" that Butler identifies as the space in which political action emerges, as an insight into a form of plurality—an "anarchist interval," perhaps—that precedes and makes possible any recognizably political form of collective organization and any recognizably subjective form of individual experience.[15] By referring us back to a space that cannot be mastered by vision, but which we must *feel* our way through (through touch, movement, and the somatic senses of proprioception, kinesthesia, and the vestibular system, that provide us with our fundamental infra-subjective sense of location and orientation in the world), such moments confront us not with a kind of extreme isolation so much as with the raw material out of which other forms of togetherness—other than those imposed by the administration of bare life—can be built.

In developing her concept of haptic visuality in film, Laura Marks has described how haptic imagery "does not reinforce the position of the individual viewer as figuration does" but instead invites the viewer "to take part in a dispersed subjectivity." In

this way, it facilitates the emergence of a self that is no longer the fundamentally isolated self of the optical regime of modernity, but "a self that is deeply interconnected with others."[16] And Bodil Marie Stavning Thomsen has similarly argued that in Nagieb Khaja's documentary film *My Afghanistan*, compiled from footage shot by inhabitants of Helmand Province in Afghanistan using cell phones that had been smuggled into them by the filmmaker, it is "due to [the] haptic traces of the camerawork" that "it becomes evident that the cameraman or woman is also part of a community."[17] One of the functions of the haptic in film and video, then, is not to refer us back to any simple sense of a personal or individual self as the center of sensation, but rather to dissolve the boundaries between self and other by invoking "sensuous dispositions that exceed anything we might posit as a subjectively felt body–space with a distinct interiority and exteriority."[18] By making explicit the haptic dimension of everyday experience, such videos function as implicit testimony to the truth of Jean-Luc Nancy's claim: "A 'we,' even if it is not pronounced, is the condition of possibility of every 'I.'"[19] This "we" that "is not pronounced" is, as Butler has shown, above all the first-person plural of our bodies.

It is in this sense that it would be misleading to read this video as primarily an assertion that the filmer, as an individual, was there in this place, on that day, when these things happened. What is important is not the fact of her presence—whether as a narcissistic/spectacular exercise in self-publicity or as a selfless/purely specular witness to these events. What is important about the quality of her being there was her being there *together with others*, as part of the collective that there came into being. And her participation in that collective is as important in defining where she stands to frame the group when she briefly stands outside them at the beginning—and that is, not far enough away to completely encompass them or objectify them in a single image —as it is in defining how she continues to film when she runs. For when she runs, what the camera records is not her own personal experience of fear, or speed, or disorientation, or exhaustion, so much as *the dissolution of experience itself into a kaleidoscope*

of intensities, in which the independent, self-standing presence of both the filmer and the world around her is thoroughly punctuated by the unpredictable rhythm of their mutual absences, opacities, and hesitations.

By fragmenting and interrupting both the space through which she runs and the objects and persons that can provisionally be found within it, the camera does not so much isolate us within her single perspective as it maintains the filmer within the possibility of a collective, imagined now not as a unified block but as a scattered plurality, a variant on that "dispersed subjectivity" to which Marks refers. The fact that this particular kind of dispersion is angular, uncomfortable, and that its outcome is uncertain does not undermine its essentially plural, and pluralizing, nature. As Butler says, "interdependency ... is not the same as social harmony... . [T]here is no way to dissociate dependency from aggression once and for all."[20] Yet even in the midst of all this confusion and terror, the filmer never films as though she was filming (only) for herself and *as* herself. She always films for the group and as a member of the group.

To borrow the terminology of the anthropologist James Scott, we might say that optical imagery is paradigmatically a way of "seeing like a State," even when the person who is filming demands or offers some acknowledgment that they remain, in and of themselves, an embodied individual, in opposition to the abstract disembodied perspective of governmentality.[21] And this is so precisely because the "opposition" of "individuals" is one of the main figures anticipated and induced—made intelligible and possible—by the objective space of the State itself. To film as though the space "between" (which Butler identifies as the space of politics) can be reduced to the measurable, quantifiable difference (or distance) that can be drawn between individuals and groups—between *this* individual over here and *that* group over there—is effectively to "see like a State," even if one is not, or does not think of oneself as, one of the State's affiliates. And to see like a State is to view both individuals and groups from *the perspective of the police*. But if this video from Bahrain refuses one thing, both literally and metaphorically, it is the

perspective of the police—that perspective from which society can be divided up without remainder and so rendered entirely legible and intelligible.[22]

From the point of view of the State and its police, the events recorded in this video would, effectively, be restricted to the narrative from which we started, which enacts the dispersal of the collective, its (re-)atomization, and its reduction to its constituent parts, without any remainder. For that is precisely what the police here have, through their intervention, set out to achieve. But to film as the person who made this video does—with a willingness to sacrifice optical clarity for the sake of fidelity not to one body (her own), but to the plural body of the collective and its multiple and potentially contradictory affects—is to accept that part of opacity that is always present, both within us and without us, and which cannot be eliminated. For it is that opacity of both the individual and the collective body which makes another kind of politics possible.

Watching this video, and other videos like it, we begin to unlearn the optics of the State that we have internalized. We begin to know what it might mean *to see like (and as) the people.*

4

What Day Is It?

—*What are you doing?*
—*We're filming.*
—*Is this really the right time?*

Homs, Syria, December 22, 2011

Still frame from video posted to YouTube by jojomomo29, December 23, 2011. To view, and for more information, go to vimeo.com/channels/thepeoplearenot, video 4.

TRANSCRIPT

(English translation based on original Arabic dialogue.)

A street. The camera is angled up toward the top of the surrounding buildings and the sky. It moves from side to side, as if searching for something. Throughout the entire clip, we will hardly get more than a glimpse of all the people whose voices we will hear.

WOMAN
Let's take cover in a building! Let's take cover in a building!

MAN
There's nowhere to hide, aunt. Nowhere.

ADNAN
We're here filming ... Yes?

MAN
They're firing mortars at us!

ADNAN laughs.

ADNAN
Where's my dad?

The camera swings through 180 degrees, surveying the buildings on either side, as if his father might be hidden in them.

MAN
Peace be upon you.

A rapid burst of automatic weapon fire, followed by the sound of a mortar impact. The camera swings back up into the sky, as ADNAN sets off down the street. At the far end, we can see the minaret of a mosque. The mortar fire comes in sporadic bursts, interleaved with periods of quiet.

MAN
Keep down! Keep down!

ADNAN crouches as they move along the pavement. The bodies of some of his companions come briefly into view ahead.

ADNAN
It's Friday … the Friday of the Protocol …

He moves out into the street itself, and laughs at the absurdity of what he is saying.

ADNAN
… the Protocol of Death! What day of the month is it?

MAN
What?

ADNAN
What's the date today?

MAN
I don't know.

ADNAN
What's the day of the month? I want to document it.

Increasingly irritated, he still gets no answer.

ADNAN
In the name of God, what's the date?

ADNAN'S FATHER (?)
I don't know what date it is!

Suddenly, a round of automatic fire, louder than before, causes the camera to shake as ADNAN and the people around him dodge for cover. After a moment's pause, ADNAN runs back on to the sidewalk and takes cover behind a parked car.

A car alarm has been set off by the firing.

MAN *(in distance)*
God is greater! God is greater![1]

ADNAN
The Friday of … of the Protocol of Death.

ADNAN'S FATHER
God's curse on his religion …

MAN
Shhh! Be quiet! Be quiet!

ANOTHER
Hi! What are you doing?

ADNAN
We are filming.

MAN
Is this really the right time to be doing this?!

ANOTHER
It's okay, *hajj*.² It's okay. Let's show this to the dogs of the Arab
League!

ADNAN'S FATHER
Damn the Arab League!

ADNAN
This film is dedicated to the Arab League!

The men around them start to call on everyone to retreat.

MAN
Guys, we have to turn back!

ANOTHER
Those whose houses are on the other side, what will they do?

MAN
Some of them can get out that way.

ANOTHER
But that's not safe!

ADNAN'S FATHER
Adnan, which way shall we go? Which way shall we go?

They both begin to laugh.

MAN *(at top of his voice)*
God is greater!

ADNAN *(shouting too)*
Takbir!³

ADNAN'S FATHER
Adnan! Adnan! Which way shall we go?

ADNAN *(serious)*
It's the Friday of the Protocol of Death. We are at Qebaa Mosque, in the Insha'at and Tawzi' Igbari neighborhoods, Homs. Won't anybody tell me what day of the month it is!

ADNAN'S FATHER
This is no joke, we're completely exposed here.

As the camera tilts down toward the ground, ADNAN says gently:

ADNAN
Don't be afraid, Dad.

Where's My Dad?

The subject of the videos that make up the vernacular anar-chive depends upon, but is not reducible to, the singular body that holds the camera. The implicit point of view that these videos embody is that of a "we" as much as of an "I." As Mohammed Bamyeh puts it, in the present of the revolution, "[the] subject feels like an agent of revolution because he is not an 'individual,' but a particular expression of the general will, and a personal condensation of 'the people.'"[4] The revolution-ary experiences herself, not abstractly or metaphorically, but *directly* as the agent of the collective historical will.[5] And that is partly because, as Andrea Khalil puts it in her study of the North African crowds of 2010–12, "The person, essentially, was already constituted as a peopled space; thus, being in a crowd is becoming human, becoming oneself."[6] What Jean-Luc Nancy would call the "singular-plural" nature of this experience is exposed by these videos on a number of levels. As we saw in the previous chapter, the dynamic tactile–kinesthetic form of the video and the haptic propensities of the handheld camera tend to dissolve the boundaries of the individual subject, opening it up onto forms of plurality that have no specific assignation. This openness is not just a quality of an individual experience but can also be seen in the ways in which filmers may jointly (and provisionally) inhabit a shared space and time of filming, even if these ways are difficult to describe or pin down. This produces moments in which, in Thomsen's phrase, "it becomes evident that the cameraman or woman is also part of a community."[7] In this chapter, I wish to consider a video in which the presence of that community, and their implication in the subject of revo-lutionary video, is made even more explicit than in those I have discussed so far.

This video was shot, as it is itself at some pains to tell us, on the Friday of the Protocol of Death, that is, on December 22, 2011, in Homs, Syria. On the previous Monday, a protocol had been signed in Cairo between the Syrian regime and the Arab League under which the League was to dispatch observers to

supervise a supposed cessation of violence. The Friday of the Protocol of Death was called to protest the murder by the Assad regime of (according to opposition sources) 250 people during the forty-eight hours that followed the signing of this text.[8]

The video starts in medias res and in a state of some confusion. The street is full of people who have left their houses as they flee a violent mortar attack on their neighborhood (subsequently identified as the Insha'at district, close to the Qeba Mosque, whose minarets are visible throughout much of the tape). The young man with the camera greets the people he meets, declares to the camera that he is filming, then breaks off to "reassure" an older woman ("Aunt") that there is no point trying to take shelter indoors. At the same time, he is searching for his father from whom he seems to have become separated. The video thus begins in a state of chaos not so far removed from that in which the Bahraini video discussed in the previous chapter ended: if these people are moving less rapidly, that is not because their situation is less dangerous—on the contrary—but because it is perhaps unclear to them in which direction, if any, safety may lie.

Throughout the video, the filmer—whose name is Adnan—tries repeatedly to "document" the date, in line with a standard evidentiary protocol adopted by Syrian revolutionary videos from the second half of 2011 onward, doubtless under the impetus of the communications services of the Free Syrian Army.[9] But even as he does this, his camera is documenting something rather different from the focus of his conscious efforts. While he wants to memorialize the precise place and date of this vicious attack on an unarmed civilian population, the sounds and images are busy registering a highly disjointed version of the spaces that make up this one particular street, as dramatized by the nervous hand that holds it, the consistently low angle of the images, and the equally low angle of the afternoon light.

The result is a video that engages the viewer's body forcefully and directly, even as it fails to provide much information as to what exactly is going on around the cameraman. We don't know exactly what Adnan thought he was doing with his

camera. We may assume he was holding his phone in whatever way he could, given that he had to keep his eyes on the street, not the screen, and given the deadly situation he was confronted with, and the people he met along the way and had to deal with, and whatever else he may have needed to do with his hands as well (carry belongings, steady himself on rough ground, remain in physical contact with his father once the two had found one another again). A large part of the humor of this video comes, of course, from the mock heroics of his attempt to maintain everyday conventions of civility and citizen–journalist accuracy even as he runs for his life through a war zone. Automatic weapons fire sits cheek by jowl with everyday gestures of familiarity and politeness, and the attempt to save one's life is experienced and presented as less imminent tragedy than absurd—and almost domestic—farce.

Still, the low angle of the camera reflects more than just postural convenience and an almost avant-garde visual happenstance. By largely excluding not only the ground they tread on but also the other bodies that have come together here, by relegating them off screen, this video obliges us to *imagine* those bodies, just as we have to imagine the impacts of the shots and explosions that we hear but never see.[10] In doing so, it creates a powerful sense of an immediate, bodily community—the community of those who have been thrown together in this street as they try to escape the attack, some of whom seem to know one another well, some of whom would seem to be complete strangers to each other. And it does so by appealing directly to our own bodily imaginations as embodied spectators—our own tactile–kinesthetic memories of walking streets, and handling cell phones, and being surprised, if not by gunfire, then by the afternoon light.

The community that we encounter in this video exists as two main formations. There is the larger group of "everyone" who is there in the street and who find themselves not only dodging bullets and other forms of deadly projectile, but also engaging in the debate (which commences at about 1:35) as to which is the best way out and what will happen to the people who are

cut off from that route. Meanwhile, within that larger group, there is also the smaller group that assembles around Adnan's camera, consisting of Adnan, his father, and the acquaintance who takes shelter with them at around 1:15 when they hunker down behind the nearest car and who questions not only what Adnan is doing, but also whether this is really "the right time" to be doing it.

These communities are held together *physically* by the shared precarity of their predicament but also *dialogically*—through the larger debate over how the people on the other side of the street will be able to escape and through the narrower discussion over whether filming is an appropriate activity when one's life is at such immediate risk. The dialogical nature of these people's being together is made further explicit by Adnan's semi-ironic cry of "*Takbir!*," the Arabic formula through which Muslims call on other Muslims to respond by pronouncing the phrase "*Allahu akbar.*" (The fact that Adnan calls out "*Takbir*" after the cry of "*Allahu akbar*" has gone up, not before it, and that his call generates no response, only adds to the sense that he is operating, whether as citizen journalist, or as potential leader of his own subgroup, in a state of slight desynchronization from the scene around him.) On one level, then, what this video documents is less the bombardment of the neighborhood than the conscious persistence in everyday activities—videomaking, dialogical forms of conversation, joking, and banter—in the face of such extreme duress that their simple everydayness becomes, in itself, an expression of political resistance.

The whole video is shot through with this dialogical texture, of which the question-and-answer structure noted above is perhaps the most prominent feature. But the provisional community of the street is also held together, more paradoxically, by its very *invisibility*.

In retrospect, it seems no accident that the video should begin with a question: Adnan's "*Abi wainu?*" ("Where's my dad?"). After all, this is not just a question for Adnan—it's a question for the spectator, too, because we cannot see either Adnan or his father. Of course, the answer for Adnan is to pan his camera

through 180 degrees and head off up the street in the opposite direction, until he is reunited with his dad. But that option is not open to us, the spectators, even though all our imaginative energy is directed toward conjuring these others to whom Adnan speaks, whom he cares for, and with whom he argues. We never meet Adnan's father (though we maybe get a glimpse of him as an anonymous fleeting figure at around thirty seconds in). We are with these men, but we are not able to set eyes on them. They remain, for us, hidden in plain sight.

As in the Tunisian video discussed in chapter 1, which was made by one woman filming from within a group of three whose presence to one another and to the camera was felt more than it was seen, the camera here seems not to belong exclusively to Adnan but to his being-together with his father and with the neighbor they run into and take shelter with. Adnan is filming for himself, but he is also filming for the others and as a way of being with them. And the decisions about what to do with the camera, and where to move as they run, are not taken by Adnan as an isolated individual but together with the others, even though that togetherness is at times more conflictual than unanimous. As a result, the physical inflections of the camerawork, the tactile–kinesthetic dynamic that it receives and imparts, reflect not only Adnan's personal experiences, actions, choices, and nonchoices but also (to borrow a phrase from theater-maker Keith Johnstone) the "kinetic dance" that links his body to the bodies of his father and their friend with whom he is running, and—less directly, but no less important—to the larger community that they move among, and of which they are just one small part.[11]

If these images function so powerfully at the tactile-kinetic level, it is in part because they are less concerned with showing us what is happening than with invoking a series of powerful, but noncoincident, *hors-champs*, all of which depend on the low angle in one way or another. There is the *hors-champ* of the bodies of Adnan and his friends and neighbors, conveyed through the movement of the camera itself and through their voices. There is the *hors-champ* of the enemy and of imminent death, conveyed by the noise of live fire and which we project

onto the large sunlit expanses of the walls opposite, which I keep scanning each time I watch the video in the hope or fear of seeing a bullet ricochet off the stone or a mortar strike the second floor, though I never do. And then there is the *hors-champ* of the way out of this death trap which the men are looking for and which does not seem to correspond to any particular place in the geography of the visual; as they run toward the mosque, I am thinking: are they running away from danger or toward it? And this *hors-champ* seems to be figured, in my field of vision, by the blue sky, both for its vast emptiness, and for its inaccessibility.

It is here then, I would suggest, in this moment of utter confusion, slapstick chaos, and impending death, that we actually *meet* Butler's "people"—that self-constituting, performative, conflictual, and provisional plurality, that is above all a decision made by bodies to meet together, to stay together, and sometimes to separate in order to meet again. We meet them in this street in Tawzi' Igbari just as or more surely than we can see them in any wide shot of Tahrir Square, or Change Square, or Pearl Roundabout. These bodies that surround the camera, influencing its every movement without ever appearing before it as an image, just *are* the people whom we heard Abdennacer Aouini invoking in their absence on Avenue Bourguiba on the night Ben Ali fled Tunisia.

And by watching this video, we too are making the decision, frame after frame, not to look at them, but to look *for* them—to locate them, to care for them, and to try and accompany them to safety.

We join them in looking for the way out which they cannot find and which the video cannot show us. Of course, we do not run the same risks as they do. But by placing us in a position where we are even less able than they are to orient ourselves, to identify where the threat is coming from and which route might enable them to escape it, this video makes its viewers intensely *active* in ways which are at once different from and related to those which must have characterized the actions of its protagonists. And in doing so, it offers us a space in which we are

impelled to ask ourselves what we risk in our own lives, and what we might be willing to risk, in order to be with others.

The Dogs of the Arab League

There is "a people" present, then, both in this video and in the community of those who form around it to watch it online, to laugh at it (and *with* those who made it), and to disagree over what it means, both politically and linguistically.

The linguistic dimension of this dissensus is significant and merits some consideration. I first came across this video when a Syrian friend sent me the link to it with a message saying (I paraphrase): "You must see this, it's hilarious, everybody's talking about it!" For a brief moment in December 2011, Adnan's video was an Internet sensation, at least in one corner of the Arabic-speaking world, rapidly clocking up around 30,000 views on YouTube, together with more than one hundred comments. This degree of interest is all the more remarkable when you consider that the conversation that we hear in the video—and on which a large part of its appeal depends—is conducted in a broad Homsi dialect that is largely incomprehensible not only to non-Syrians but also to many Syrians who are not themselves from that part of the country.

A large part of those 30,000 views presumably are due to the almost 20,000 people who also watched a re-upped version of the soundtrack only, accompanied by a slideshow transcription/translation of the dialogue in Modern Standard Arabic against a neutral black background.[12] Both the fact that this subtitled radio mix was produced so quickly (it was posted online the very same day as the original) and the fact that it was needed at all tell us something about the way such a video may generate not a single unified audience, but a concatenation of multiple related audiences which, if they often overlap, do not exactly coincide.

Yet despite the impenetrability of their local dialect, the actors of this video do not hesitate to address themselves directly to that emblematic instance of pan-Arabism that is the Arab League.

Beyond the intentional comedy of dedicating this video of their death run to the international bureaucracy that is just then claiming, and failing, to protect them, surely there is another, perhaps less intentional, irony in delivering their message through a form of Arabic which most of the representatives of that organization would probably find unintelligible.

But I think there is something more going on here than just black comedy. Even as it demonstrates performatively, and at great personal risk, the uselessness of appealing or dedicating anything *to* the Arab League, this video indirectly reaffirms the vocation of even the most anonymous people, and even the most vernacular forms of speech, to speak *in the place of* the Arab League—to speak not only to and for all Syrians, but to and for all Arabs. In some sense, its acute, self-limiting particularity just *is* its universalism, what makes it resonate in open-ended and unexpected ways.

In this sense, it is the physical fact of speaking that matters here, as much as what is said. As Judith Butler puts it, the words that are pronounced by the people "do not have to be pronounced in unison, *or in the same language,* in order to constitute 'a people.'"[13] In other words, just as the performance that enacts the people arises in the spaces between people, and between spaces, so it can occur *between languages, and between dialects of the same language.* Each language, each dialect, each mode of speech involved, thus becomes the occasion of the others' necessary exteriority—an enactment of the heteroglossia inherent in any nonimperial form of internationalism.

It follows that the politics of a video such as this cannot be reduced either to the opacity of its localism or to its ironic quotation of pan-Arab tropes. But neither does it simply reinstate some larger transnational public sphere of the transparently discursive kind that has, following Habermas, been ideologically associated with the nation–state. Indeed, its primary political function is not linguistic at all. Instead, it inscribes the collective physically, even as it enacts it through the aesthetic (sensory) forms that it embodies and through the bodily gestures and movements of which those forms are, in part, the trace.

In doing so, it effectively disables and displaces the Arab League, along with all the ossified forms of pan-Arab nationalism with which its history has been intertwined, including—by implication—the diluted Baathist version that the Assad regime had purported to represent.[14] And in doing so, it replaces them, not with some sort of narrower Syrian nationalism, or even with a Homsi localism that might defy all larger and more universal constructions, so much as with the particular concrete forms-of-life that are embodied in the words and actions of Adnan and his father and their friends, on this particular day, in this particular place. In this respect, Adnan's desperate and ultimately failed attempt to specify the precise date on which this video is being performed/recorded points us to the fact that what this video inscribes is not some specific geometric point in the abstract map of space and time that underpins the State and its many avatars (including, doubtless, many facets of the Syrian opposition), but the *singularity* of *this* place and *this* moment: the time whose *rhythm* exists only in the space between that street and the screen on which I watch this video—the place that exists only at the intersection of, on the one hand, the possible and impossible paths that the people in the street take as they look for some way out, and on the other, the paths taken by my eyes as they search these images for signs that would make the choices these people are making minimally identifiable, intelligible.[15]

The Vernacular as Destituent Power

The inability, or unwillingness, of the Arab revolutions to produce any organization that was able to take power or impose a specific postrevolutionary political program has bewildered many commentators, including some of those most sympathetic to their aims. As Mohammed Bamyeh writes: "Not represented in organizations or by leaders, the revolutions had to remain radical, in the sense that nothing sustained each other than a simple and obvious radical posture, setting people, united but

unrepresented, against the regime."[16] This pure "negativity" has most often been seen as a weakness. But as Bamyeh points out, this may be to miss the point:

> Successful revolutions are those that usher in a legacy of cultural transformation, and not just those that topple systems of governance ... the immediate politics of the revolution tends to be expressed either as partisan dynamics in their narrow form or as constitutional attitudes in their more general form. Neither points in any clear way to the potential cultural achievements of the revolution. Those can be seen more clearly only many years after the revolution, because cultural change follows patterns unlike those of political or regime change, and because cultural change is, in the final analysis, *a change in a way of seeing*, and not to procedures of ruling a state or techniques of administering social order.[17]

The Arab revolutions did *not* seize control of the State in order to remodel society from the top down. What they *did* achieve was not simply the recovery, but the *reinvention* of a plurality of forms of civic life that were felt to be at risk from the increasing encroachments and corruption of the State and which were themselves not only a critique of the values and practices of the ruling regimes, but their effective *suspension* or deactivation, at least for a period of time and in certain spaces. The daily texture of these revolutions was above all the performative and prefigurative enactment of other ways of being together and caring for one another, in which the distinction between means and ends (on which conventional assessments of political efficacy rest) became in many ways tenuous, even as they remained focused on the goal of securing the dictator's exit.[18] Through this convergence of a purely "negative" program at the level of discourse, reduced to a common opposition to "the regime" in all its senses, with the proliferation of positive gestures that enact an ethics of solidarity at the level of praxis, the Arab revolutions not only exemplify Agustín García Calvo's definition of the people as "nothing more than a negation," but

also anticipate Giorgio Agamben's reflections on the need to invent forms of *destituent* power, not in analysis or theory but through concrete practical acting together.[19]

In her work on assembly, Judith Butler sees the performative power of the people as a *constituent* power, occupying an "anarchist interval" that is destined to give way once again to institutionalized forms of constituted power, though hopefully ones that are more humane and more just than their predecessors. For Agamben, however, what is at stake in these moments is their capacity not only to unseat all constituted powers, but also to effect their own self-destitution—*the self-destitution of the people itself* as an entity that might one day pretend to take those powers' place. This is not an act of angelic renunciation before the messy exigencies of practical politics, but the *only* way in which a revolutionary movement can prevent the capture of its energy by the circular logic of sovereignty that leads to the endless reproduction of violence and oppression:

> if revolutions and insurrections correspond to constituent power, that is, a violence that establishes and constitutes the new law, in order to think a destituent power we have to imagine completely other strategies, whose definition is the task of the coming politics. A power that was only just overthrown by violence will rise again in another form, in the incessant, inevitable dialectic between constituent power and constituted power, violence which makes the law and violence that preserves it.[20]

To call for such an all-encompassing practice of destitution is not to exit practical politics for an abstract utopia. On the contrary: as Mohammed Bamyeh would put it, it is to exit governance and return to politics.[21] For Agamben, the only way that such a destitution can be achieved is through the revival, or the invention, of a *form-of-life*—that is, a life "in which the single ways, acts and processes of living are never simply *facts*, but always and above all *possibilities* of life, always and above all potentiality [*potenza*]." He recognizes such forms-of-life

in the "vernacular figures of anomic communities" as they appear in the work of Ivan Illich, Pierre Clastres, and Christian Sigrist and which are continued by the countless "spaces of anarchy" (Bamyeh) that persist and flourish within and around the field of administered life.[22] Nineteenth-century anarchism, twentieth-century European thought, and certain recent artistic avant-gardes can be seen as having approximated this insight, only to have failed to achieve the result that they sought: "The destitution of power and of its works is an arduous task, because it is first of all and only in a form-of-life that it can be carried out. Only a form-of-life is constitutively destituent."[23] Destituent power is, therefore, not a space emptied of power, but a space that is fully inhabited by human beings. It is a space in which, instead of seeing like a state, we are able again to see like the people. That is, it is a *vernacular* space.

As the Invisible Committee put it, in a passage inspired directly by Agamben's concept of revolution as destitution:

> ... in order to bring about the destitution of the practice of government, it is not enough to criticize this anthropology and its so-called "realism" [the normative egotism of liberal thought]. It has to be grasped *from the outside*. Another plane of perception must be affirmed. For we ourselves act *upon another plane*. And from this relative exteriority where we live, where we try to build, we have acquired this conviction: the question of how to govern can only be posed on the basis of a vacuum that in most cases has had to be deliberately *created*. Authority needs to have been sufficiently separated from the world, it needs to have created enough empty space around the individual, or inside the individual, for it to be possible then to ask how one is going to assemble all these disparate elements that are no longer bound together by anything, how the separate units can be reunited *as separate units*. Power creates a vacuum. The vacuum calls for power. To exit the paradigm of government, we have to reimagine politics on the basis of the opposite hypothesis. There is no such thing as a vacuum: everything is inhabited ...[24]

Magically, impossibly, this video from Homs combines in a single shot these two opposing movements. It bears witness to the action of power that seeks to create a vacuum over which it can rule—first, by evacuating it of all its inhabitants, and later by reducing all the buildings that had once structured it to rubble. And at the same time, it not only records but *is itself* the destituent power of the people in action, not as an abstract or theoretical program, but precisely in their obstinate refusal of the abstracting force of military power and the governmental perspectives that it serves.

The simple everyday words and actions performed by Adnan and his friends as they run for their lives do not merely act out a precarious black comedy or make a mockery of the pretentions of the Arab League—and behind the Arab League, of all other institutions that might claim to embody an "international order"—to offer them appropriate and effective protection. Beyond these more obvious gestures, they are above all engaged in refusing—actively, constantly, vividly—the reduction of their lives to "bare life," to that life which can be taken without any crime being committed and which for Agamben is the unacknowledged basis of all regimes of sovereignty, whether authoritarian or democratic. By re-inscribing in the streets of their neighborhood the convivial everyday practices that bind them together, even as the regime seems intent on reducing those streets to a wasteland, both morally and physically, they enact a counterpower whose goal is not to recreate some "better" form of government, but to wrest back passages, moments, places, from the abstract space–time of governance per se and to reclaim them for truly human ways of living (and of speaking)—ways predicated not on our separation from one another but on our being-together.[25]

What we see in this video, and in so many other videos in the vernacular anarchive, is a people that composes itself not as an essence, defined by a language or a history held in common, nor by some explicit and rational type of "social contract," but as a sequence of vernacular gestures, gestures that remain within the reach and scope of each person and his or her neighbors and

which—in themselves—represent not the assertion of a sovereignty, but the destitution of all forms of sovereignty, including that of "the people" themselves, and not only of "the people," but also of the (individual) "person." (And it is perhaps this consciousness of their claim as precisely a claim *not* to take power, whether over themselves or others, that generates the self-deprecating sense of humor that is also a key characteristic found throughout the anarchive.)

As Agustín García Calvo has put it:

> what can be in real contradiction with the dominance of the Capital-State are by no means the Persons or the Groups of Persons and their mutual Personal Solidarity: the only thing that can really contradict it is that which remains alive of the impersonal and uncountable people, that which survives below the level of these Persons who believe they know what they are doing and who are convinced of the future to which they have been condemned; that which remains alive and keeps on reasoning in all of us, given that "all of us" is precisely the opposite of the Majority.[26]

It is through these concrete bodily (and linguistic) gestures that the emerging and provisional communities that inhabit these videos take form before our ears and eyes, and it is through them, and the gestures they imprint on the videos themselves, that their passage through these spaces is able to resonate with the bodies of those who sit at home watching them, whether they are sitting one hundred meters or 1,000 miles away. It is through the very specificity of these gestures, their concrete rhythmical-dialogical presence *as video*, that they come to speak not for, but *to*, that in each of us which is "all of us."

These videos, then, do not "document" or "describe" the new forms of community and collectivity that began to emerge in the Arab world in 2010–11 (or the old forms of community that inspired and informed them). They simply *are* those forms of community and collectivity in action, and in the process of being enacted, and of refusing those strategies that would enable

their capture by a regime of *representation*. In doing so, they allow us to hear the Arab nation in all its vernacular plurality, its divergences and its dissonances, beyond Orientalist folklore, modernist rationalization, or pan-Islamic utopia. And it is that dissonance and that heterogeneity—all those physical and linguistic accidents that remind us of the unpredictability of the terrain which separates us from and unites us with one another—more than any simple slogan or million-man march, that have, for brief periods over the last three years, given people both within and beyond the region a sense that our weakness and our isolation, *as* people, does not have to be forever.

5

The Death
of Ali Talha

—They're going to be killed!
—God is greater.

Souq al-Juma'a, Tripoli, Libya,
February 25, 2011

Still frame from video posted to YouTube by 17thFebRevolution, February 27, 2011. To view, and for more information, go to vimeo.com/channels/thepeoplearenot, video 5.

The War against the Image

The videos we have considered in the preceding chapters are characterized by the kinetic–kinesthetic–haptic imagery that traverses them and the very special kind of vitality—at once fragile and irrepressible—which such imagery, and the sounds that go with it, seem destined to convey. Yet in order to ensure that this energy can continue to circulate, they are obliged to conjure a precarious truce with the violently hostile world into which they find themselves thrust. Their dynamism exists only under the constant threat of interruption, whether by order of the security forces, by a stray (or well-aimed) bullet, or by the filmer's own abrupt decision to switch off the tape. Their capacity to evoke a singularity that lies beyond conventional notions of the individual, while remaining rooted in the experience of one particular human body, seems owed, at least in part, to a heightened sense of that body's vulnerability, its mortality, its finitude. Indeed, this vulnerability is the most obvious thing that they hold in common with the other bodies that are gathered around them in revolt. As the Algerians chanted during their short-lived but extraordinary insurrection in 2001: "You cannot kill us, we are already dead!"[1] That is: we are *all of us* already dead. You cannot divide us against ourselves by pitting the physically dead against the biologically still living, by trying to separate those who still have something to lose from those who do not.[2]

The filmers of the Arab revolution had everything to lose, too. They risked their lives by being in the street, and they raised the stakes even further by taking out their cameraphones. It is perhaps then no surprise that they made and circulated a large number of videos in which they recorded and memorialized the deaths of their comrades, those who were killed around them or beside them. Through their conscientious efforts, the vernacular anarchive is filled with the images of these martyrs, captured in the moments that immediately preceded and/or followed their deaths, often with a brutal, almost unbearable rawness.

These images serve, among other things, to remind us that the living bodies to whose proximity the flow of haptic–kinesthetic

images has habituated us do *not* exist only in the immediacy and continuity of the first-person perspective that shapes our discovery of them. They are also bodies that have exteriors, that are made of skin and flesh and blood and bones, and are thus exposed not only to the gaze of the State and its police, but also to a whole range of objects that those forces may project at them and which are lethally harder and less capable of spontaneous discrimination or generosity than they are. Nothing could be further from the conventional imagery of the Muslim martyr's remains as "a holy corpse that remains beautiful" than these images' insistence on the misshapen, broken materiality to which the dead are inevitably reduced.[3]

Perhaps the most brutal, and the most haunting, of these videos are those in which it is the filmer herself who is shot and dies (or would appear to die) while filming. Such footage is, of course, a recurrent trope of documentary film, at least since Patricio Guzmán included the footage that the Argentine cameraman Leonardo Henrichsen was filming when he was shot dead at the end of *The Insurrection of the Bourgeoisie* (1975), the first part of his film sequence, *The Battle of Chile*, that chronicles the last year of Salvador Allende's democratically elected government.

The characteristic features of such footage—the sound of the fatal gunshot, the vacillation of the image, the alarmed voices of those nearby, then the collapse of vision as the cameraperson falls to the ground, as a result of which the image itself is plunged into an involuntary semi-obscurity or arbitrary abstraction— can be found in many of the videos of such a moment that exist in the vernacular anarchive.

Thus, in one example, a filmer in Syria is apparently murdered by regime soldiers who fire on him from a tank that he has decided to film as it traverses his neighborhood.[4] This particular video goes even further, however, into the sense of futility and helplessness that such footage usually induces in the viewer. Due to the fact that the anonymous filmer's cameraphone— unlike Henrichsen's Eclair 16—is set up to continue recording even when the filmer's intention (and the pressure of his fingers on screen or button) have been withdrawn, the major part of

this video—more than three of its three and a half minutes—occurs *after* the death of the filmer, not before. As his friend (we presume) stoops over him and repeatedly implores him (in vain) to pronounce the *shahada* (the Muslim declaration of faith), the camera continues to frame an obscurely random fragment of his environment while in the background we hear a voice reciting the Qur'an, whose source (a radio or TV broadcast? a recording?) is unclear. The strongly haptic quality of the whole video, flattened by the low resolution image into what is more a quasi-abstract texture than a "picture" of anything, is further intensified by the involuntary absenting of the filmer, as if his death might find a rough and somewhat hackneyed equivalent in the final withdrawal of representation itself.[5]

The videos I have considered in the preceding chapters derive a large part of their aesthetic and affective force from the tension between the perspective of the camera, through which the scene is presented to us, and the perspective of the filmer, that we imagine may sometimes and in some ways coincide with that of the camera, and sometimes not, but which in the end we can only imagine. While we may try to make these two points of view converge, the detailed gestures of any video in the anarchive are constantly splitting them apart again, reminding us of the aporia of identification. In this deeply unsettling video, however, those perspectives seem to have been definitively severed, but not in the way we would wish: the camera continues to perceive the world, however poorly and haphazardly, even after the filmer is dead and unable any longer to see or hear anything. If other videos encourage our identification with the camera as an eye that is even more alive and more dynamic than the physical person who carries it and handles it, this video reveals the threat that hangs over that desire. The camera, here, *is* in fact more "alive" than the filmer. But this fact cannot console us, for all it does is underline how complete the finality of his human death must be.[6]

In his "nonacademic" lecture *The Pixelated Revolution*, the Lebanese artist and performer Rabih Mroué undertakes a detailed exploration of the YouTube videos produced by the

Syrian revolution, and in particular those videos in which the filmers film—or appear to film—their own death. As numerous as such videos are, they strike Mroué as, at first sight, inexplicable. Having shown several such clips to the audience, he poses the conundrum that they represent in this way:

Why do they keep on filming even though they watch with their eyes how the guns are lifted towards their lenses in order to shoot them? I ask these questions because every time I watch this video and other similar videos, I can see that the cameraman could have escaped if he wanted to. He had enough time to run away before the sniper shot him. But instead, he kept filming. Why? Is it because his eye has become an optical prosthesis and is no longer an eye that feels, remembers, forgets, invents some points, and skips some others? I assume that the eye sees more than it can read, analyze, understand, and interpret. For example, when the eye sees the sniper lifting the gun towards it in order to shoot and kill, the eye keeps on watching without really understanding that it might be witnessing its own death. Because, by watching what is going on through a mediator—the little screen of a mobile phone—the eye sees the event as isolated from the real, as if it belongs to the realm of fiction. So, the Syrian cameraman will be watching the sniper directing his rifle towards him as if it is happening inside a film and he is only a spectator. This is why he won't feel the danger of the gun and won't run away. Because, as we know, in films the bullet will lose its way and go out of the film. I mean it will not make a hole in the screen and hit any of the spectators. It will always remain there, in the virtual world, the fictional one. This is why the Syrian cameraman believes that he will not be killed: his death is happening outside the image. It seems that it is a war against the image itself.[7]

Ulrike Lune Riboni has also described the cameraphone as a prosthesis—but one which intensifies involvement rather than annulling it, thus establishing a link to certain moments in the technical–aesthetic history of direct cinema. Citing Anne-Marie Duguet's description of working with the Paluche, a tiny video

camera invented by Jean-Pierre Beauviala in the 1980s (which anticipated the freedom and gestural quality of today's cameraphones), Riboni offers her own description of the videos produced by the revolutionaries in Tunisia and Egypt:

> Framing has been separated from the eye since the production of the first still cameras with LCD screens, and the cameraphone continues this experience. The phone is an extension of the body, absorbing or exaggerating its movements, its stumbling, its dynamism. The tool becomes a prosthetic eye, the filmer stretches out her arm to grasp what the eye cannot see.[8]

This description can be compared with Beauviala's own description of the Paluche, in the course of a conversation with Jean-Luc Godard, who had tried working with the new camera and rejected it:

> ... you know that for me the PALUCHE is an extension of the body towards people and things, it's the hand's very gesture, its quivering, its emotion; it's a centering of a SUBJECT that has nothing to do with the frame of the cinema ... [9]

For Riboni and Beauviala, the effect is to turn vision into a properly haptic intervention in the world; for Mroué the result is the opposite. The camera does not reconnect the filmer to the rest of her sensorium and, through it, to what is going on around her; it isolates her both from the context of her seeing and from the rest of her senses, reducing her to a pure eye. The filmer is able to film her own death just because she is already less a filmer than she is a member of the audience. It is as if she were already in another space, safely removed from the scene that is being played out on the screen. It is this *other* video—the one we watch, not the one we make—that dominates the filmer's consciousness, until she forgets that she is still a real body, acting and perceiving in a real world, where a bullet can still strike her dead.

Mroué's interpretation is persuasive on its own terms, above all within the dramatic context of his performance. However,

there is still another mystery hidden within this mystery. The real question is not why the filmer fails to take evasive action even when it is obvious that she is in the sights of the sniper, but rather *why she is filming the sniper in the first place.*

After all, these images have no forensic or legal value. While we can see in the distance a form, sometimes clad in military khaki, sometimes not, wielding a gun, the mere fact of recording this is not of any *use* to anyone. There is no tribunal before which such evidence can be brought. And even if there was, this evidence is no real evidence: indeed, the many accusations that specific footage has been faked, while pernicious, still have some purchase just because they are not intrinsically implausible.[10] And even when the footage can be "authenticated," it is still as a rule impossible to make out from such images as these the identity of a specific person who could be held responsible for the crime —or, in most cases, even to establish with any degree of certainty to which "side" of the conflict the perpetrator belongs. For none of the cameraphone videos I have seen which seek to film snipers or other murderers has the minimum optical clarity which allowed the identification of Corporal Héctor Bustamante Gómez as he appeared brandishing his revolver in Henrichsen's footage and which later led to his being charged with the cameraman's murder (even if it took a seven-year investigation by Chilean documentarian Ernesto Carmona to make the case against him stick).[11]

Why, then, does the filmer film her would-be murderer? I would suggest that what is happening here is not the rational act of a "citizen journalist" determined to bring a repressive regime to justice, if not through due legal process, then at least before the court of public opinion. The filmer films the sniper in the building opposite, and the moment in which they lift their gun to take aim at the filmer herself, because she feels a kind of *equivalence* between these two gestures. More than that: she feels that the camera is *stronger* than the gun. By not only capturing the sniper's image but also imitating his gesture as she does so and turning it back against him, she feels that she is acquiring and exercising a kind of *mimetic power* over him.

This equivalence of the gun and the camera is most chillingly evoked by another video, also from Syria.[12] As the security forces sweep through the main street of a town, intimidating people into returning home, the filmer heckles them, insisting that "the world must see"—specifically, that the world must see the massacre that Assad's forces have just committed in Dera'a. After riffing on this theme for some time while the soldiers pass by, more or less impervious to his distress, he ends up screaming at them: "Shoot me! Shoot me!" It is as if, in his desperation, he wants to provoke them into producing an image of *his* death, so that at least there will be some evidence of their murderousness. The ultimate function of the camera is not to "shoot" the enemy but to force the enemy to shoot back. Fortunately, before his adversaries can succumb to his taunting and raise their weapons against him, his friends are able to come and drag him away.

This power that the camera promises, or threatens, to let us wield over others may or may not be an illusion. (Mroué himself expresses doubts as to whether these filmers are actually filming their own death, or whether they do not in fact survive "outside" the film which only *seems* to represent their demise.) As moderns, we assume that simply taking someone's photograph will neither kill them, nor disable their weapons. Despite that, the filming of the sniper does still seem to function less as a rational, material strategy of "documentation" than as an act of symbolic violence by the filmer—a preemptive *counterstrike* against the person whose image is being shot.

After all, the sniper's bullet is only effective in the here and now of the space in which they and their target are physically co-present. But the video that records their gestures and defies them will continue to circulate long after both the sniper and the filmer are no longer here. It immortalizes not the person who films it, but the shame of the person who is filmed. Such an image, of course, can only be made by someone who puts her body on the line and who may or may not be wary of the exact risks she is running. But in return, it enacts a kind of power over the person who is pictured that is absolute and unconditioned. Whether he lives or dies, in this moment of his being pictured

the sniper is judged forever. To film him is not just an act of morbid curiosity or amateur surveillance. It enacts, albeit by anticipation, the judgment of the people—a judgment that is peremptory and without appeal.

The Sea Is Just a Suspicion

The Libyan uprising broke out in Benghazi on February 15, 2011, and the Day of Rage on February 17 saw protests spread to many other cities, including the capital, Tripoli. On February 25 several thousand protesters gathered after Friday prayers in the district of Tajura to the east of the capital, from where they set off to march toward the town center. As they passed through the Souq al-Juma'a neighborhood later that afternoon, they were ambushed by state security forces, including snipers posted on the roofs of surrounding buildings. Different estimates put the death toll for the afternoon at between ten and twenty-five, with many more seriously wounded.

The march from Tajura followed a week of constant clashes during which the security forces had tried and failed to establish control over the neighborhood, and its brutal repression marked, perhaps, the end of residents' initial hopes that they might see Mu'ammar Gaddafi depart as quickly as Zineddine Ben Ali and Hosni Mubarak had before him. By March 1, most of the people of Tripoli had abandoned overt public protest and were looking for other ways to continue the struggle. (The city was not finally liberated until six months later, in a major military operation organized by the National Transitional Council, that ran from August 19 to 28.)[13]

One of those who died during the march on February 25 was a fifty-year-old man named Ali Mohammed Talha. His name does not figure in any of the journalistic accounts of this day that appeared in the international or local media at the time, and I have not been able to find out any more about him.[14] The video I want to discuss here records the moments immediately before and after his martyrdom.

(This video is difficult to "transcribe" or even describe. It contains so little dialogue and so little precise, locatable action. But to attempt—and fail—to describe what happens in it may in itself help shed light on the very specific ways in which it operates. In the following paragraphs I offer one possible version.)

A man is advancing through space. He is among other men, though the space between them is not clearly defined, and the crowd seems too strung out, too fragmented to really count as "a crowd." On the soundtrack, there is a lot of noise, of a kind we may (or may not) recognize as the sound of wind buffeting the camera's microphone. We may get the sense that we are near the sea.[15] There is a large space that seems to open up on the horizon, far ahead of us and to the left, which seems to hold the future toward which we are heading—promise or disaster. Yet while the bodies move that way, the camera almost ignores this space and seems intent for much of the time on pointing off toward the right, and down toward the ground, when it's not tilting off wildly up into the sky, dodging and jerking across the multiple layers of off-white cloud.

The sea is only a suspicion. Yet the men who have gathered here continue to advance and fall back in waves, and these human waves form a larger rhythm, which surrounds and absorbs the faster rhythm of the camera's tilting up and down. It is as if the group is testing some invisible boundary, trying to push it forward, incrementally, or at least to hold the line. At the same time, the way the camera is angled creates a long diagonal that emphasizes the inherently unstable geometry of the space, which is further pulled apart by the asymmetries of the faulty stereo sound.

The crowd surges forward twice, and twice it falls back. During the second, more chaotic retreat, there is a strange hiatus: the camera, as if drugged or stunned, in any case in need of relief, suddenly tilts up and then stops moving for several seconds, and the sky, plus a shard of ochre building, finds itself caught within the frame. Just at that moment the sound of gunshots intensifies, and then suddenly, with a single cry, the crowd rushes forwards

again. And a few seconds later we realize that although we are moving, we are not going anywhere—the barrier that stands between us and the sea, between us and the future, has not been demolished, will not be overrun.[16]

True, we keep surging forward, even stronger than before, but others are already trying to work their way back. We are going to meet someone who is returning to us. Returning to us dead. As a martyr. When the camera almost collides with his blood-ied head, we run alongside him for a while, then let him go on, while the camera instead reverses course one last time to follow the trail of blood that he has left behind him, as if retracing the steps he could no longer take.

We follow this trace as if it could lead us somewhere, as if it might prove something. As if. And as we advance, the shadow of the filmmaker falls across that trail, as if to cross it out. Or to imprint himself upon it. Or it on him.

The Opposite of Power

On one level, this video simply exemplifies and intensifies the aesthetic strategies discussed in chapters 3 and 4. The immersion of the viewer in a reality that is as much tactile–kinesthetic as it is visual reaches a kind of peak in this single shot that unfolds in all its complexity and unpredictability over more than five minutes. Yet at the same time, this video might appear to be the *opposite* of the videos considered thus far. For it deploys the very same formal and sensory strategies that gave them their vitality, only to be brought up sharp against the incontrovertible evidence of death, which is now no longer merely an idea, or a word, or a threat, but an irreversible and intolerable fact.

In the video of Abdennacer Aouini discussed in chapter 1, the dead were an "invisible crowd"—ghostly presences that lay concealed in the night and in the imagination of those present, felt rather than seen. In the videos of the martyrs, such as this video of the death of Ali Talha, the dead step out into the light of day and reveal themselves in all their vulnerability and finitude.

In the place of the vital haptic body that so many of these videos bring to life, we are suddenly confronted with that body's other, its unbearable double: the human corpse, in all its visceral obscenity and abjection, as it collapses out of life into the definitive motionlessness of death.

The appearance of the dead body from among the filmer's comrades enacts the limits of the subject in all their finitude and finality, even as it exceeds them. And in doing so, it forces us to confront all those aspects of our embodied being which the first-person perspective may sometimes lead us to believe we can defer or ignore. As Judith Butler writes:

> there are certain photographs of the injury or destruction of bodies in war, for example, that we are often forbidden to see precisely because there is a fear that this body will feel something about what those other bodies underwent, or that this body, in its sensory comportment outside itself, will not remain enclosed, monadic, and individual.[17]

The vision of the rupture of the body's limits by an act of violence, while it is certainly felt as an attack on our self-image, is also an invitation to abandon the attempt to confine our experience within those limits suggested to us by the images of intact bodies with which we spend most of our time. The corpse is then, in one sense, the *obverse* of the experience that the majority of these videos orchestrate. Yet at the same time, death, and the acceptance of death, are also obscurely perceived to be the condition of that sense that the revolution brings of finally being fully alive. As Dork Zabunyan writes: "If these [images, as acts of witness] are perceived as legitimate, they owe their legitimacy to the very act of rising up, in which the final frontier that separates death from life is dissolved ..."[18] And he cites the Syrian filmmaker Oussama Mohamed who stated, in an interview he gave in April 2011:

> something in our minds has changed once and for all. Myself, even, I have the feeling that death no longer has the same meaning.

I find myself thinking of my own death with equanimity: maybe it's just an impression, but I think that today we are in a situation in which death can become synonymous with life. The people who are slain today are a part of me.[19]

If this is so, then it is in part because, as Mohammed Bamyeh has argued, death is not the opposite of life but of power. For death is "the guarantor of equality par excellence." There is no hierarchical prerogative that can provide exemption from its sway. Death is "the most universal common." As such, it marks the exit from the realm of governance and thus the recovery not only of equality, but also of true freedom.[20] As Canetti observed, the equality generated by crowds may be illusory; but the equality generated by death is quite real.[21]

The equality that is at stake here is not a material equality, but an equality of power, and in particular the power to put to death. By *accepting* in advance her own death, the martyr abolishes the differential of power between herself and the sovereign. More than that, her own death prefigures the *reversal* of that power, by offering its interchangeability as extensible without limitation to all human beings whatever their condition.

There is nothing mystical, then, about this acceptance of death, in all its bloody, messy detail, that we encounter again and again in the anarchive. We do not need to suppose a parallel reimagining of some afterlife, corpses that smell of musk and roses, or some sacrificial pact with an abstraction such as the "nation," in order to bear these images. Nor do we need to suppose that without such dressing up, they can never be anything but traumatic, an education in brutality. Like war, the revolution spares us what we most fear—not to die, but to die *alone*.[22] And the attention of the camera to the dead and the dying is, then, neither mere voyeurism nor simply witness to the worst. It is also witness to the fact that even in death, we are *together*. Ali Talha's death may strike those of us who were not there, who did not live through these events, as a form of horror, or (if we are more disposed to be gentle) as a tragedy. But it is above all proof that even at that moment, there were

people there to bring him back from where he had fallen, to name him, and to recognize his name as the mark of the general interchangeability that governs them all.[23] And to be governed by this is *already* to have emerged from under the cover of all other forms of governance.

The convergence of this exit with the discovery of *courage* is not, then, a coincidence. Once one's own personal death no longer seems so important, one has entered, in the simplest of senses, into a realm where *heroism* now seems part of the ordinary repertoire of everyday life. As Bamyeh puts it, describing the "new patriotism" that emerged during the Arab revolutions:

> Each martyr, typically a friend and a neighbor rather than a professional activist, not only opens up an account that requires being settled, but also proves empirically that heroic qualities, earlier thought to be distant or mythical, now reside naturally in ordinary individuals.[24]

It is because "we are already dead"—not as the singularities we are, but as the isolated individual subjects that the regime (of power and of knowledge) has produced in our place—that each one of us is now able to live without reserve, so completely and so intensely. For that which is really alive in us is "impersonal and uncountable."[25] And this life we are living is, above all, the certainty that we are now not only together with one another, but together as equals.

The Shadow of the People

Hamid Dabashi has described how he was unable to complete the book on suicidal violence that had occupied him for more than a decade until the Arab revolutions reframed the concept for him:

> It was the suicide of Mohamed Bouazizi (1984–2011), the young Tunisian street vendor who set himself on fire on December 17,

2010, in protest to police harassments, that dramatically concluded the whole notion of "suicidal violence" I was developing in this book and thus effectively completed my thoughts on the matter. Before that tragic event setting a massive transnational revolution in motion, it was the "suicidal violence" that targeted both the *self* and the *other* of the suicidal person that had triggered my study. After Mohamed Bouazizi's suicide, it was the solitary site of that violence, the body of the person, and the sparing of others from the site of his suicide that gave the whole topography of my thinking about the matter its closure.[26]

Mohammed Bamyeh, on the other hand, identifies a related but rather different turning point, when he writes of the ethical transformations he witnessed in Cairo in the days leading up to the revolution:

in place of earlier incidents of individuals setting themselves publicly on fire in desperate protest of personal problems, there emerged an ethic of preparedness for sacrifice in the name of a collective cause. Revolutionary ethics emerged with this transformation from self-immolation to preparedness for martyrdom. In other words, a transformation from suicidal personal desperation, in which one is prepared to kill oneself, to a new patriotic sense, in which one kills neither himself nor others. Rather, the martyr of the new patriotism confronts only the regime, neither his compatriots nor other strangers, and only with his bare chest, with no illusions and full knowledge of stakes involved.[27]

The privileging of this second attitude over the first does not, however, mean that the original gesture of desperation was unnecessary or irrelevant to the spirit of self-sacrifice that succeeded it. Rather than an opposition between these two moments of the revolution, the Invisible Committee proposes a more dialectical relationship:

A man dies, and a country rises up. One event does not cause the other, it is just the trigger. Alexandros Grigoropoulos, Mark

Duggan, Mohammed Bouazizi, Massinissa Guermah—the name of the dead man becomes, for these few days, or weeks, *the proper name of the general anonymity, of the common dispossession.*[28]

This convergence of anonymity and the proper name is figured in the video of Ali Talha's death in the two opposing moments between which it hangs suspended. On the one hand, there is the epiphanic moment at around 3:30 when the camera fixes the sky above this street in Souq al-Juma'a for several seconds. Time is arrested, just as it was for Tolstoy's Prince Andrei after he was shot at the Battle of Austerlitz, in the moments before he loses consciousness:

Above him there was now only the sky—the lofty sky, not clear yet still immeasurably lofty, with grey clouds creeping softly across it. "How quiet, peaceful, and solemn! Quite different from when I was running," thought Prince Andrei. "Quite different from us running and shouting and fighting. Not at all like the gunner and the Frenchman dragging the mop from one another with frightened, frantic faces. How differently do these clouds float across that lofty, limitless sky! How was it I did not see that sky before?[29]

And on the other hand, there is the extraordinary gesture beginning at 4:37 where the filmer abandons Ali Talha's corpse to follow instead the line of blood it has left behind as it was transported, leading to the comrades who are searching for his ID card in his crumpled, useless jacket.[30]

By filming his shadow as it falls across the trail of blood he follows, the filmmaker projects himself inside the frame. But he projects himself not as a character in some nineteenth-century novel—a person with a unique physiognomy, a particular temperament, a distinctive wardrobe, and a mailing address—but as an anonymous silhouette, the space where a person *could* be. This shadow doubles the ecstatic openness to life suggested by the shot of the clouds against the blue sky, embodying an act of acknowledgment, even consent, to the fact of death as

unavoidable. The shadow *signs* the video, but it signs it not on behalf of the individual qua individual, but on behalf of the community. To belong to that community, to gather with it physically in the street, to proclaim its existence, is to accept the possibility of one's own death and to assert the value of that possibility. In this moment, the unique and the common reveal their interdependence. It is in order to protect the possibility of a unique life for all, even the weakest, that "the people" are called to exist.[31]

This passage effectively positions Ali Talha as the double of the cameraman, his dark misshapen jacket rhyming with the other's shadow. One is alive and anonymous, the other dead, identified, and named. But in that act of naming, and in the hovering over him of the filmer's shadow, there is a double displacement taking place. Like Mohammed Bouazizi in Sidi Bouzid, Ali Talha becomes—briefly, for the space of that one afternoon in Souq al-Juma'a and for the duration of this one video—the name of what is common to all, the name of what is most vulnerable and fragile in each of them, the name of their common dispossession, not as that which is to be refused, but as that which is to be assumed and embraced so that it can be deposed, laid down. And this mirroring between the filmer and the corpse of Ali Talha is reflected in the symmetry of their empty silhouetted forms—the shadow of the one, where it falls across the shapeless, blood-drenched jacked of the other.

As the filmer leaves Ali Talha's body behind to follow the trail of his blood, we watch his shadow advancing before him. And as he films his shadow passing over the bloodstains on the ground, we feel a *transfer of responsibility* taking place. As Bamyeh puts it, each death opens an account. The image of the filmer's shadow against the martyr's blood is not simply a striking image, an unusual formal proposition, or a wordless abstract lament. In the *physical contact* which it mimes between the empty, anonymous form of the one, and the vital substance of the other's recently extinguished life, between energy (light) and matter (blood), this video shows us one of the ways in which the dead hand down not only obligations to the living, but also

convictions, capacities, energies. And in doing so, it does not simply function as a symbol for the circulation of revolutionary desire and responsibility—it *enacts* another link in the chain of that circulation, in which video archetypically plays the role of a *converter*. For it is through video (among other media) that the solid matter of reality is transformed into the oscillatory energy of the image, and vice versa, as it passes from that street in Tripoli, to a computer screen in Benghazi, or Beni Suef, or Brussels, and back out from there, reentering the world away-from-keyboard through its afterlife in the viewer's own body, where it mingles with our desires and memories, to give them form and direction and to lend them force.

Still frames from video posted to YouTube by 17thFebRevolution on February 27, 2011. To view, and for more information, go to vimeo.com/channels/thepeoplearenot, video 5.

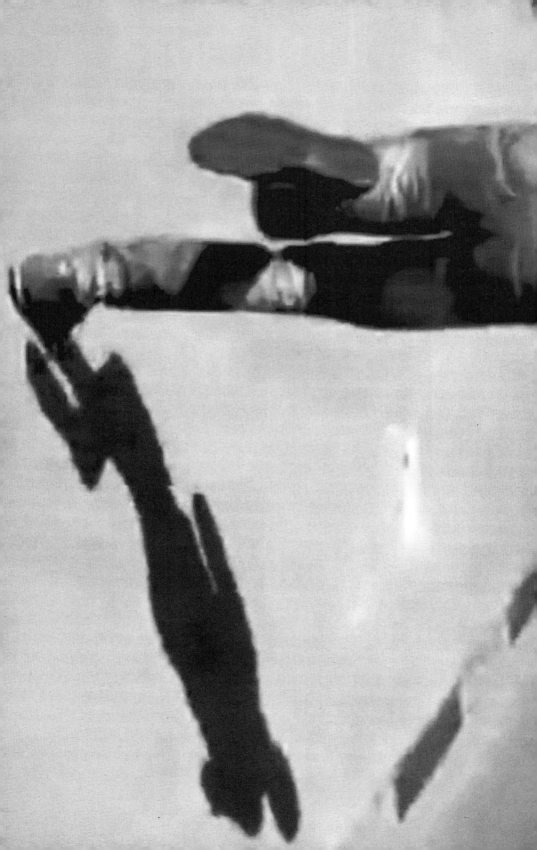

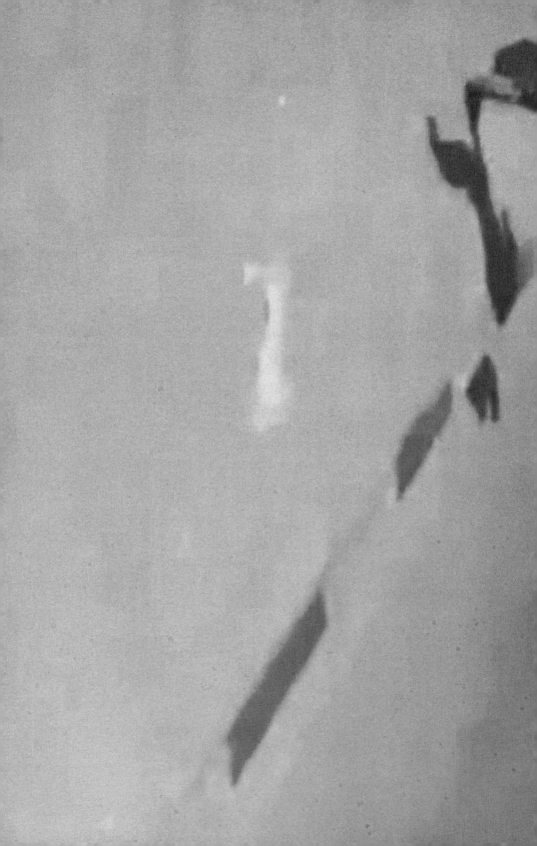

II

Video as a Critical Utopia

6

The Filmmaker as Amanuensis

—*I want to meet the president! I want to meet the president! I have a lot to tell him! I want to speak to him! I want him to hear my voice! Instead of him sitting there, knowing nothing. Maybe he's not guilty. Maybe nobody tells him the truth ...*
—*No, he's guilty alright!*

<div align="right">Dokki, Cairo, Egypt, January 25, 2011</div>

Still frame from video posted to YouTube by FreedomRevolution25, January 24, 2012. To view, and for more information, go to vimeo.com/channels/thepeoplearenot, video 6.

We Have Found Our Voice

On the afternoon of February 3, 2011, the Egyptian novelist Ahdaf Soueif finds herself walking around central Cairo. Her appointment to give an interview to a satellite TV channel has just been canceled after pro-regime *baltagiyya* (thugs) invaded the station's office and forced them to close down. So instead, with no particular agenda, Soueif walks into Midan Tahrir, the epicenter of the revolution, and starts to survey the scene around her:

> I go to look at the front line of yesterday's battle. The pavements are broken up and the corrugated-metal sheets are stacked in case they are needed again. "Don't assume treachery, but be on your guard": men lie on the treads of the army tanks to prevent them moving. The regime's *baltagis* have been beaten back but they're regrouping on the flyover. Lines of young men with linked arms protect the entrance to the Midan. The clinic that was set up when the *baltagis* were beaten back hums with activity. Doctors in white coats change dressings on wounds, take details. Two lawyers—in their legal court gowns—take statements. A woman sees me writing and comes up: "Write," she says, "write that my son is in there with the *shabab*.[1] That we're fed up with what's been done to our country. Write that this regime divides Muslim from Christian and rich from poor. That it's become a country for the corrupt. That it's brought hunger to our door. Our young men are humiliated abroad while our country's bountiful. Be our voice abroad. Tell them this is a national epic that will be taught in schools for generations to come. We've been in Tahrir since Friday and the whole Midan was sparkling. Look what they've done to it! Look at that microbus: twelve people on it at all times and the banners never came down and the flag never stopped waving. The army stopped the ambulance from coming in but these young doctors—they sewed up the *shabab* on the pavement. My son, it took an hour to dig out the pellets from his legs. And then he went back in … "

And Soueif comments: "Everybody, everybody here has become an orator. We have found our voice."[2]

The most obvious way, it seems to me, to approach this passage from *Cairo: My City, Our Revolution*, Soueif's memoir of the first year of the Egyptian revolution, is as, in the best possible sense of the word, a literary trope.[3]

The author, whose dress and demeanor are apparently so different from those of the Egyptians around her that she is instantly identified not simply as a journalist, but as a *foreign* journalist ("Be our voice abroad"), encounters an otherwise anonymous female figure who emerges from the crowd in order to tell her what to write, only to instantly disappear back into the collective once her instructions have been delivered. And Soueif, at least as far as we can tell from her own account, complies with those instructions. She submits to this exercise in dictation, recording both the universal and the anecdotal, the picturesque and the banal, the coherent and the confusing, the story and the moral of the story, in what she presents as her interlocutor's own words.

Of course, this kind of self-abnegation is the very stuff of the journalist's trade. But Soueif is not just a journalist. She is a novelist, a writer. Moreover, when we meet her at the beginning of the book, she is a writer suffering from a very specific kind of writer's block. Despite repeated entreaties from her London publishers, she has completely failed to produce the book about Cairo that she had sworn she was going to write. And it is only with the outbreak of the revolution that actually writing a book about Cairo, *her* book, begins to seem possible again.

Still, that possibility is not presented in this scene as due to her having tapped into some inner well of inspiration. Instead, Soueif agrees implicitly to act as amanuensis not only for this one woman, but for the whole unfolding national epic. And in doing so, she is able to reconnect not only with herself and her native city, but, as a middle-class intellectual, with her people too. The authorial "I" disappears, and in its place comes the "we" of the Egyptians with whom she is now reunited.

Of course, behind this allegory of Soueif's creative renaissance lies the figure of the intellectual as the conscience of the Egyptian

(or wider Arab) nation as it has been handed down since independence, if not before. Perhaps her most obvious precursor is Naguib Mahfouz, who positioned the narrator of his seminal 1959 novel *Children of the Alley* as the one literate man who is able to transcribe the stories of his community. Mahfouz's narrator is clearly intended as both the novelist's alter ego and a prototype of the intellectual who "speaks truth to power." His decision to locate the writer precisely as the scribe of the community speaks not only to Mahfouz's own ambitions, but also to the ambivalence with which he viewed the function of his profession. The postcolonial intellectual is at once the guardian of the collective memory of the people and a privileged intermediary who speaks the language of the State, and is thus often called upon to provide the regime with a genealogy that will legitimize its power.[4]

Soueif's role in this passage, however, is distinctly less ambiguous than that of the narrator of *Children of the Alley*. Unlike him, she has not been coopted by an ally of the ruling caste, who offers her privileged information and relies on her to collate numerous sources under his guidance so as to put the events of the past in their "right" order; her only mandate comes directly from the people, through their one anonymous representative. And this episode, rather than framing her work and providing a grid through which to read its structure (which, in Mahfouz's novel, is also the structure of a universal history), occurs somewhere in the middle of her text, where it figures as just one more event among others. In doing so, it reinforces the sense of *fragmentation* that suffuses Soueif's memoir and which makes it such a good example of what Ayman El-Desouky has identified as those "discontinuous modes of narratives that emerged in the wake of January 2011 and that rely on the larger national imaginary for their cementing temporality."[5] Rather than confirming her privileged status as author, it is just one episode in the process that began on the first page of the book by which she embraces her role as simply one more Egyptian among so many millions. In her vision of Egyptian society as a resonant and self-organizing structure, Soueif's task is not to stand outside it and

totalize it; it is simply to take her place. And that place is not a special, privileged place. It is simply a "space into which you"— that is, anyone—"could fit."[6]

This passage thus enacts a moment of transmission and reconciliation between two very different worlds: one turned inward and speaking in colloquial Arabic, the other looking outward and writing in English; one oral, the other literate; one collective, the other singular. By agreeing to put herself at the service of the first voice that comes along, Soueif inherits from her interlocutor a kind of benediction that extends well beyond this particular paragraph, suggesting that we read her book, in all its polyphonic, nonlinear complexity and openness to revision and incompletion, not as the work of an individual virtuoso, but as something at the same time far more modest and far more ambitious: a first, provisional attempt at transcribing the great anonymous poem of the revolution.

Soueif's memoir is one of the most striking pieces of writing to have appeared to date in English from the Arab revolutions. My purpose in this chapter, however, is not to analyze this text for its own sake. Rather, I am interested in how the passage I have just discussed might in its turn serve to orient a reading of the countless online videos that these revolutions have generated. Might we not also see them as, in some sense, the scattered fragments of some great collective film that has yet to be edited—as so many individual acts of audiovisual *dictation*, transcribing the epic poem of the people as it is enacted, just as Soueif purports to do in the episode discussed above?

TRANSCRIPT

(English translation based on original Arabic dialogue.)

TITLES (in English): January 25, 2011 Day One of the Freedom Revolution Dokki, Giza1

The filmer advances with the crowd as they chant.

CALLER
Down with Hosni Mubarak.

CROWD
Down with Hosni Mubarak.

CALLER
Hosni Mubarak is going, he is going.

CROWD
Hosni Mubarak is going, he is going.

The camera swings round to the right, and discovers a woman standing there, waiting to speak to the filmer, while the crowd continues to flow past, and the chanting continues.

LEILA
Let me tell you something. My name is Leila Mohamed Mohamed Abdel-Galil. Tell the president we are tired. There is no bread in the shops. We stand in line for two or three hours. People queue at the bakeries from six in the morning till one in the afternoon. The second thing is the schools and private lessons. There is no education.

MAN
There's no meat, either!

LEILA
Every morning we make sandwiches for the kids to take to school. Our kids learn nothing at school, when they get home they have to take private lessons.

MAN

Keep moving, the police are just behind.[7]

LEILA pauses, as if about to follow his lead.

CUT TO:

Further down the same (?) street: the crowd is still advancing and still chanting.

CROWD

Hosni Mubarak is going!

After a moment, the camera again swings to the right, and lands on LEILA, who is now walking as she speaks.

LEILA

Let me tell you something. The least would be to live like humans, not like this. We are tired. Women are the most tired people in Egypt. Make the president feel for us. All we ask is that he come down and see the people for himself, not wait for reports in his office or listen to his ministers. They are the ones who have taken everything! Even if they live a hundred years, they won't be able to spend all the money they have stolen!

CROWD

Down with Mubarak!

LEILA

Ok? We want to take back our rights! We want to live like human beings. For once, we don't want to be humiliated before other countries, while we watch our children lose their way. That's all.

The crowd has arrived at a junction. The sun is low in the sky.

CUT TO:

A different street. The crowd continues to advance, chanting. Now there are more women around us, not just men as before.

The camera turns slowly to the right again, as the women exclaim and smile, then back to the left, but LEILA has already seen the movement, and begins to address the filmer at the top

of her voice. She seems more agitated, and her monologue is visibly beginning to irritate the women around her.

LEILA

I want to meet the president! I want to meet the president! I have a lot to tell him! I want to speak to him! I want him to hear my voice! Instead of him sitting there, knowing nothing. Maybe he's not guilty. Maybe nobody tells him the truth …

MAN

No, he's guilty alright!

LEILA forces her way past the other marchers to keep up with the camera, ignoring their interjections and comments.

LEILA

Maybe his aides hide the truth from him. That's all we want.

Despite her efforts, LEILA falls behind and the camera continues to advance. The marchers, now mainly men again, turn to look at the camera as the filmer draws alongside them.

ANOTHER MAN

This country does not belong to us.

CROWD

Bread! Freedom! Human dignity!

ANOTHER

This government is unjust. A kilo of meat costs 10 pounds, which means that when one, for example … [8]

LEILA appears out of nowhere and interrupts him.

LEILA

I want to say just one word to the president! Mr. President, give me a piece of land anywhere, and build me two rooms, and plant me a palm tree, and give me a goat to milk, and I will eat dates and not go to work …

CROWD

Leave, leave, Mubarak!

LEILA

Because when we work, all the money we earn is spent on electricity and water bills and transportation. Listen to me, so that my voice will be heard!

ANOTHER MAN

A kilo of sugar costs 10 pounds!

ANOTHER (*reprimanding LEILA*)

We are not here just for one person's problems, we are here for all the people.

LEILA

I know! I am telling him because I want him to feel for all of us.

CUT TO:

Same road, same crowd.

ANOTHER WOMAN

What I want is …

Then the crowd carries her away.

MAN

We are here against tyranny and corruption. That's the only reason we are here. We want the country to be put right, because it has been wrecked and destroyed. All we want to do is uproot tyranny and corruption.

As the camera moves forward a few paces, the woman marching just in front of him starts to talk, as if on cue.

WOMAN

We want a free country, a country where Muslims and Christians can both worship freely, where mosques and churches can be opened, so we can pray and practice our faith. We Muslims are oppressed, we are oppressed in our own country. There is corruption. Six percent of the people own 80 percent of everything …

Again the camera moves forward a few paces, leaving the woman behind, and the person in front of her picks up the role of speaker:

ANOTHER MAN
Look here, boss! We are here to tell all the ministers and officials that the people's minds have opened up! They have become aware. Look at the price of meat! Look at the price of tomatoes!

The camera moves forward again, and the individuals' speech merges back into the chanting of the crowd, as they pass before a stretch of sidewalk where many people are standing watching, without joining in.

CROWD
Join us, O our people!

ANOTHER WOMAN (*screaming*)
Ten pounds for a kilo of tomatoes!

A Mutual Choreography

On January 25, 2011, the first day of the Egyptian revolution, a march set out through the west bank Cairo neighborhood of Dokki moving toward the Nile Corniche, in the hope (ultimately frustrated) of being able to cross over toward Tahrir Square. Among the marchers was one young man with a camera. And as he took out his camera to film, something rather interesting happened to him. Something not entirely unlike what would happen to Ahdaf Soueif some nine days later.

The original video posted by FreedomRevolution25 lasts seven minutes and twenty-four seconds, but in my discussion here, I will focus on the first four and a half minutes (transcribed above), both for their internal consistency—they form almost a miniature film in themselves—and for their relevance to the argument I wish to make.

In the videos discussed in the first part of this book, the people were invoked or felt more than they were seen. They were less an object of vision than a point of view. And I would suggest that in this respect those videos are typical of one major strand within the vernacular anarchive. In this body of work, what matters as a rule are less the bodies in front of the camera than the body that is carrying it and all those that can be sensed and felt around it and behind it, but which cannot be seen, at least not clearly and distinctly.

In this video from Cairo, however, the people are presented to the camera with a clarity and fluency that are quite remarkable. My interest here, then, is to look in more detail at what happens on those occasions when the people *do* appear before us distinctly, in the clear light of day. How do they present themselves to the camera? And how does the camera respond, not merely to their presence, but to their newfound *visibility*?

This short film can be approached in a number of ways. On the most basic level, it seems designed to illustrate one of the most prominent chants of January 25: "We are tired of being quiet!"[9] A people who have long been excluded from any meaningful role in the political life of their country—who, as one of

them says here, do not feel as though they belong to their land or as though their land belongs to them—are suddenly freed of the initial layer of fear that had sealed them over, and find a certain tentative sense of exultation in simply going out into the street and giving vent to their thoughts and feelings at the top of their voices, however anxious they may remain about the potential consequences.

On another level, this video clearly also anticipates something like the figure we met in Soueif's text. Of course, there are differences. Instead of Soueif's anonymous woman, we meet someone who begins by telling us her name: Leila Mohamed Mohamed Abdel-Galil. And instead of the writer condensing her interlocutor's wisdom into fourteen sentences, the videomaker allows Leila to hold forth here for almost three minutes, including a nonnegligible amount of repetition.

Moreover, the videomaker is perceived by Leila as a conduit, not to the outside world, as Soueif was, but rather to the president of the country himself. The message is, in that sense, less external, less impersonal. And the claims and demands it seeks to negotiate are, at least rhetorically, much more modest. Instead of asserting a power, they entreat attention and indulgence. Whether it is the character of Leila Abdel-Galil or that of the anonymous cameraman (who remains throughout unseen and unheard), or the fact that this is only the first day of the revolution and the people are still unsure of their power, or even of their existence qua "people," the mood is very different from what it will be only nine days later on Tahrir Square.[10] The themes are the same—hunger, corruption, division, humiliation, a country that has been destroyed. But nothing has yet been built in its place, and the mood is even somewhat *ancien régime*, with Leila's insistence that Mubarak, like Louis XVI before him, is an innocent man misled and manipulated by his advisors.

However, there is something else happening in this clip, which seems to me even more interesting than the features I have mentioned so far. And this is the relationship between the cameraperson, or perhaps one should say the camera, and the people who take turns to speak through it.

The most obvious thing to say is that we seem to have here, at first sight, a kind of spontaneous mutual choreography, which reaches its peak in the moment starting around 2:50 when the camera glides from first one, to another, and then to a third speaker, almost without missing a beat. And this same felicity is already present in the opening movement of the video, when as the camera swings round to the right it comes to a halt on Leila, who is already standing there, ready to deliver her speech, as if she was simply waiting for her cue.

I want to stress the word *spontaneous*. Although at times this video seems to aspire to an almost art-house elegance in its serial representation of the individuals who make up the people, it also gives a very strong sense of *not* being directed by the filmer.[11] If there is a cue that Leila is waiting for, then, it is not a cue from the cameraperson as director, it is a cue from the camera as one of the antennae of the world. And indeed, as the video proceeds, it becomes more and more transparent that within this apparently simple and gracious act of standing up to speak, there is a struggle for power going on among the people themselves, and one which only they, and not the cameraperson, can decide.

True, whether by subsequent editing or decisions made in camera, the moment that might seem the crucial moment is elided (through a cut at around 2:47). But the main outline of this drama is clear. Four times Leila Abdel-Galil emerges from the crowd and effectively takes control of the camera, demanding and commanding its attention. And if the first two times this happens very smoothly, through some combination of charm and the convergence of mutual curiosities, the second two times it is not at all smooth: she has to grab the camera back, if not physically, then by sheer force of character.[12]

So we don't see the moment when the camera is finally freed from Leila's attempt to monopolize it. But we do see what comes afterward. We move from a struggle between the individual (Leila) and the group around her to a fluid movement that encompasses three different individuals, three different points of view. In so doing, the camera reconstructs the crowd as a series of concrete subjective positions rather than simply an aggregate

of bodies and voices that form the ground against which the individual figure can emerge. And we also hear the argument that immediately precedes this decisive ellipsis. To the man who tells her that they are there not to listen for one person but for everyone's problems, Leila responds: "I know. I am trying to make *all* our problems felt."

There is a great deal more riding on this passage, I believe, than might at first be apparent. For what is at stake here is not just the outcome of one particular argument between a group of strangers brought together by the happenstance of a political demonstration. What is at stake here are two radically different ideas about *representation*.[13]

In one of these conceptions, the individual functions as the representative of the collective, condensing all its possibilities and problems and allowing the individual spectator to iden-tify with them on condition that they pass through her. The individual here is necessary to make the collective manageable, identifiable.[14] But there is also another approach to the collec-tive, which aims not to isolate one figure who can represent the "mass" but rather to decompose and articulate that mass itself into a series of distinct, but related, subject positions, without the need for a figure to mediate and unify these different posi-tionalities. In this latter case, each person who briefly emerges for the camera as an individual does so in her own right and with all the limits and limitations that that right supposes (and which Leila, toward the end of her "solo" intervention, seems all too happy to ignore). This person then does not appear to us *in the place of* other individuals, as do, for instance, the "individuals" we typically meet in "character-driven documentaries" (whose explicit, even deliberate specificity and uniqueness is always balanced against their capacity to stand in for, or offset, some identifiable segment of the larger world around them).[15] Instead, she serves principally to open (or re-open) a space within which other people (who may, like her, be *anyone at all*) can emerge into appearance in their turn, just as she has done.

Leila, of course, is not a "good subject," even for a disrup-tive politics. Through her desire to monopolize the camera's

attention, she opens up a space to which she might not otherwise have had access, while at the same time tending to close it down for others. But her contradictions do not simply evoke the spectator's empathy and amusement; they also serve to set in motion a dynamic that embodies for the camera the larger tension between the two modes of representation I have described above. This tension is important because this video, I believe, does *not* propose that we choose one of these modes of relating the individual to the collective over the other. Rather, it proposes that we understand the revolution as a process that can move fluidly between these two positions, but only for so long as it recognizes the priority of the second over the first.

This tension, this movement, then leads to a third moment (immediately after the end of the four and a half minute segment transcribed above), which functions almost as a synthesis of the previous two. Now the crowd regroups, the people link arms in the face of the enemy and, letting their individualities be momentarily subsumed into a larger, almost anonymous, collectivity, they march forward chanting, finally, not for cheaper vegetables or to save the king from his rapacious courtiers, but for whatever it is that they name "Revolution."

Here, then, in this video, we meet the people not as it was once held to be, reified and objectified into some sort of naturally unified entity, but rather as it is in the process of its becoming and emergence, of its progressive, nonlinear occupation of the space where, up until this moment, it was not. And this becoming takes the form, on the one hand, of the serial iteration of subjective positions as the attention of the camera passes from one person to another, and on the other, of the temporary and provisional resubmersion of those singularities back into the collective. It is this movement back and forward between the singular-serial and the collective-univocal that makes possible a genuinely collective form of enunciation, just as it is the filmer's readiness to submit to the speech of the people, to their direction, that underwrites their mutual transformation, the reciprocal exchange of roles and qualities between them.[16]

In this anonymous and apparently "artless" video, we can see unfold the same process that Gilles Deleuze, in his discussion of the direct cinema of Pierre Perrault and Jean Rouch, described as the "becoming-other" of author and subject.[17] And this reciprocal exchange is nowhere more evident than in the transfer of "authorship," of the "directorial" role, from the person with the camera to the person who appears to and for the camera and who, simply by the fact of so appearing, subordinates the camera to their will far more surely than they could have done if they were holding it.[18]

Tokens of Obedience

The fragility of the filmmaker's authority over the filmmaking process is a constant trope of documentary practice. Michael Renov theorizes one form of this reversibility of power when he identifies domestic ethnography as a site of "shared textual authority."[19] What specifically interests Renov are those films in which the camera itself, the physical object as instrument, is seen to change hands, wrested away from the filmer by the filmed. But there are also less direct if no less powerful ways in which filmic authority can be transferred, explicitly or implicitly, from one side of the lens to the other.

In his 1991 essay "Whose Story Is It?" David MacDougall considers a number of cases in which documentary films in general, and ethnographic films in particular, may be said to "belong" to their subjects as much as (if not more than) to their professional "authors." His analysis ranges widely, extending from the casual assumption of control he reads into Bob Dylan's looks and gestures in D. A. Pennebaker's *Don't Look Back* (1967), to the larger questions of collective cultural appropriation he has encountered in his own work with Aboriginal communities—those moments when the filmmaker gradually realizes that the film he is making "is no longer outside the situation it describes" but is now, somehow, "inside someone else's story."[20] Such forms of subaltern reappropriation are no less real

or powerful for being essentially semiotic rather than material. The transfer of power to the "subject" of the film is thus in many cases quite independent of the obvious but insufficient question of who may or may not have their hands on the camera (or, for that matter, the editing table).

Like MacDougall on Cape Keerweer, the videomakers of the Arab revolutions often seem to have awakened to find themselves in the midst of a story that they do not, and cannot, control. But there is one major difference: it is not "someone else's story" they suddenly discover themselves to be inside, but *their own*. Their alacrity to put themselves at the service of the words and actions of others is less the result of some ethic of professional or artistic modesty than of the direct, visceral experience of their own actions (both as filmers *and* as revolutionaries) as embodying an immanent and plural subjectivity that exceeds their individual experience without thereby denying or suppressing it. Just as Soueif's text invites us to think about dictation as the ideal (and on some level idealized) relationship between the intellectual and the people, so the many videos in which a person beside or in front of the camera turns to the filmer and tells her or him, "Film!" suggest that what we may commonly think of as "direction" is experienced here less as a proprietary expert function than as a constantly circulating, and constantly revocable, mandate.[21]

In such a situation, the filmer is less someone who knows how to represent the people (that is, someone who knows how to turn the individuals she selectively films into *representatives* of the collective) than someone who knows how to accept her own role as the people's *delegate*, their messenger. To see the lack of authorial pretension in these videos as merely a function of their "amateur" or "domestic" status is, then, to completely miss the point. Contemporary media practices are governed by preexisting distributions of authority and competence that divide them into elite, industrial, and "participatory" or "citizen" forms (for instance), the better to police them. The vernacular videos from the Arab revolutions disrupt these distinctions and deny them their authority. In their place, they seek to establish a

radical democracy of images—one that supposes the authority of *anyone* to speak to and for the collective.[22]

In doing so, these videos show us the revolution as something slightly different from the straightforwardly "horizontal" and "leaderless" process that has been idealized by many observers of recent uprisings and social movements, whether they are observing them from within or from without. While from certain distances, the revolution may certainly appear this way, when seen from up close—not so close that it disappears into a blur of haptic proximity, but close enough for individual faces to emerge, however briefly—it reveals itself as both more complex and more interesting. The collective that traverses the video discussed above is best characterized not by the absolute absence of any form of leadership or representation, but by its constant engagement with a process of dynamic negotiation that may allow such functions to appear, but only for so long as they remain controllable and limited in scope and acknowledge their own transience.

This video chimes, then, with the analysis of contemporary social movements put forward by Rodrigo Nunes:

> Regardless of what individuals' ideas about decision making, leadership and representation might be, and the practices that they derive from these, their general and most constant framework of interaction is best described, from the point of view of the system, as *distributed leadership*. It is not that there are no "leaders"; there are several, of different kinds, at different scales and on different layers, at any given time; and in principle anyone can occupy this position. That is, they are not leader*less* but, if the poor wordplay can be forgiven, *leaderful*.[23]

These revolutions are "leaderful" because they do not seek to abolish authority, but rather to keep it answerable to the collective and to keep it circulating; that is, to ensure that it remains a form of *practical authority* that cannot be translated into a claim on status or power outside of the context in which it has been granted.[24] The result is a mode of leadership that has more to do

with service, or the coordination of independent initiatives, than with "command and control."[25] The same can be said, mutatis mutandis, of the people's attitude to representation. In the revolutionary moment, the people may appear to actively seek out representation—by individuals, by writers, by cameras, and by camera people. But they do so only on condition that this representation remains, as Subcomandante Marcos might put it, obedient to them.[26]

Both Soueif's text and this video by FreedomRevolution25 seem designed to foreground just such a relationship, in which the act of filming or of writing serves to express not the person who is behind the camera (or the pen and notepad), but the person who is in front of it. The accuracy of that claim is always open to question, of course. But if both Leila Abdel-Galil and Soueif's anonymous woman invoke for their interlocutor the role of the public writer, they do so less in the sense of demanding the literal reproduction of their words than in the sense borne out by Madiha Doss's ethnographic work with the public writers of the Ataba neighborhood in Cairo—that is, as a metaphor for the kind of fidelity to their intentions, and the kind of effective impact on the ultimate recipient, that they would expect of any competent amanuensis.[27]

In other words, what matters here is less the accuracy of the *content* of the resulting video or text than the fidelity and form of the *gesture* itself—the nature of the action it embodies. By presenting itself as the direct result of the filmer's decision to submit to Leila Abdel-Galil's choice of what she would and would not say (and subsequently, to the crowd's decision to take the floor away from her and distribute it to others), FreedomRevolution25's video becomes more than just a document of her words, her demands, her vision of the world. It is, above all, a *token* of obedience and thus a ground of *trust*.

This token is offered by the filmer twice over: once, in the form of its making, to Leila and the other people around him on the street that afternoon; and a second time, in the form of its uploading, to all those people who will later come to see it on the Internet. By temporarily but repeatedly ceding textual

authority to his interlocutors, the filmer creates one of those signs or narratives "that originate in a deeply shared social condition, signaling shared destiny, and speaking *to* that condition, not representing it, with both speaker and addressee fully present" which Ayman El-Desouky identifies as the "specifically Egyptian cultural practice" of *amāra*.[28] And it is precisely through such practices that the people come to recognize themselves, not simply as self-enacted on the tabula rasa of some existential present but as always already bound together *as* the people.[29]

It is this gesture of obedience, rather than any explicit demonstration of "art" or "expertise" on the part of the "filmmaker," that legitimizes this video, just as it is her obedience to the anonymous figure who tells her to "Write!" that legitimizes Soueif's memoir for her readers.[30] Starting from these two texts, we might trace this same gesture, this same positioning of the filmer in relation to the people, through many of the vernacular videos that have emerged from these revolutions. The dialectic of obedience and trust is no less present elsewhere for not being explicitly thematized. By assuming the equal power, competence, and entitlement to act and to speak of whoever may choose to appear before them and their camera, the videomakers of the Arab revolutions do not simply record their testimonies and their actions. They redistribute authority, both over the videos they make and over the world they collectively inhabit. As a result, these videos are not simply documents of a moment of possibility that now, alas, would seem to be receding ever more rapidly into the past; they are also messages that continue to circulate, their power to effect change intact and undiminished, and that may still one day reach their true and most effective destination.

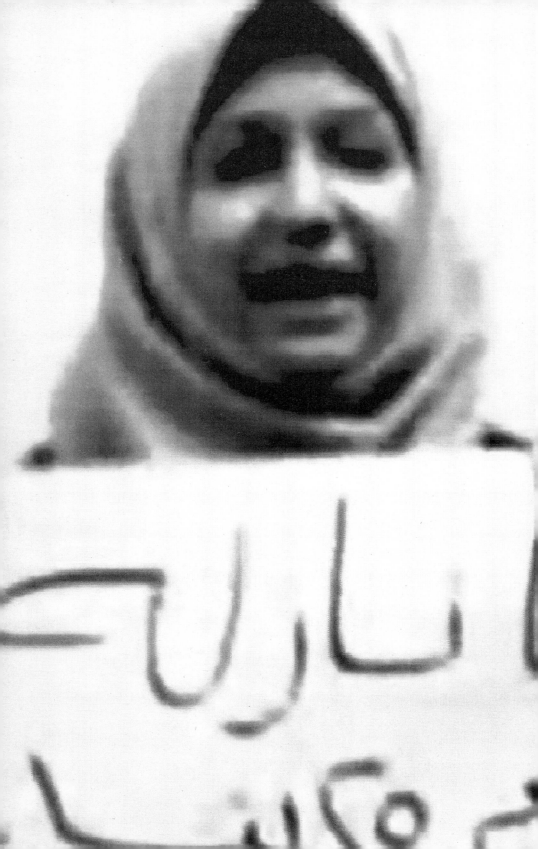

7

The Party of the Couch

If you just sit at home and follow us on Facebook, then you are the cause of our humiliation.

You will be humiliating ME!

So if you have honor and dignity as a man, come!

Cairo, Egypt, January 18, 2011

Still frame from video posted to YouTube by Iyad El-Baghdadi, February 1, 2011. To view, and for more information, go to vimeo.com/channels/ thepeoplearenot, video 7.

Inside

Both online and offline, the Arab revolutions were dominated by the images and actions of bodies in the streets. Writing about the videos of the Tunisian and Egyptian revolutions, Ulrike Lune Riboni has remarked on the systematic lack of videos made indoors:

> "Interior speech," what people say to one another in their homes, in cafés, or other collective spaces, remains invisible. The process through which these revolutions became self-reflexive would seem not to have been filmed. Indeed, more generally, there are few videos that were made indoors. In this way, these videos run counter to the trend to abolish the boundary between the public and the private, which characterizes most contemporary image-making. Here, intimacy is seen as necessary, to be protected, and, in part, taboo.[1]

Over the countless hours I have spent watching online videos from the vernacular anarchive, I too have been struck by the near-total absence of images made in indoor spaces that could properly be described as domestic. There are certainly videos made off the street, but the spaces in which they were made tend to be quasi-public spaces—the covered areas of mosques, for example, or the corridors of hospitals. What is lacking are videos that were shot inside people's *homes*. Of course, there are many videos made from the windows or balconies of apartments, or the roofs of buildings. But these, like the video from Tunisia discussed in chapter 1, were all made looking *out*. They treat the home, that is, not as an object of vision but simply as a point of view from which to access and observe a wider world.

This absence marks a significant departure from the stereotypical image of amateur online video practices as dominated by the public exposure of the makers' private lives. It also marks a major difference between the way in which professional Arab filmmakers represented these revolutions and the ways in which their own frontline actors chose to document and upload them.

Thus, in all the YouTube videos I have seen, there is no equivalent of, or even close cousin to, the interior scenes that run throughout Omar Shargawi and Karim El-Hakim's *Half a Revolution* (2011), shot during the eighteen days in Egypt. Here, the filmmakers extensively document the often emotional conversations that would take place each night as their friends, who had spent their days out on the streets, regrouped in one or another flat to exchange stories, discuss strategies, and catch up on news from other parts of Cairo. They also interweave with their main narrative another strand dramatizing co-director El-Hakim's growing doubts as to whether he can remain in Egypt with his wife and young child as the conflict with the regime grows increasingly violent. In the end, he decides that he cannot, and he leaves the country before the end of the eighteen days that would eventually lead to President Hosni Mubarak's ouster. The acknowledgment of incompletion embodied in the film's title suggests this ironic convergence of public and private history—underscoring the unstated assumption that the latter will tend to model for us the former.

There is nothing in the vernacular anarchive to compare with the scenes in Hamza Ouni's film of the long Tunisian revolution, *El Gort* (2013), in which the two main characters, Khairi and Wachwacha, invite the director into their homes and unburden themselves to him of their most intimate troubles. Nor is there anything like the intense intergenerational drama within the filmmaker's own family that is played out in parallel with the occupation of Yemen's Change Square in Sara Ishaq's *The Mulberry House* (2013). And there is certainly nothing at all like the intimate conversations that can be found throughout Jehane Noujaim's Oscar-nominated *The Square* (2013), in which the Egyptian actor and video activist Khalid Abdalla can be seen arguing about the revolution with family friend Mona Anis while she peels the zucchini for dinner or chatting late at night over Skype with his father who is in London.

Producing and sharing scenes such as these would seem to pose no problem for these Arab filmmakers who speak the

international lingua franca of the authored documentary. Nor do they seem to pose a particular problem for their subjects (many, but not all, of whom are from the same social milieu as the filmmaker). But they apparently constituted a no-go area for the rank-and-file revolutionaries with cameraphones who collectively created the vernacular anarchive.

There are a number of ways in which we could interpret this refusal to film people gathering indoors. Clearly, part of the motive may have been tactical, relating to the need to secure spaces for political discussion and organization that would not be directly and immediately accessible to monitoring and surveillance by the regime. And we could also see it simply as reflecting a stereotypical concern with the policing and enforcement of privacy that is one of the constant tropes of conventional wisdom about the Arab region. But it is also possible that more strategic considerations may have come into play. If the goal of the revolution was to get people out into the streets, filming them in their own homes would not be much use (on the supposition that like attracts like). In this sense, the refusal to film in "private" spaces has little to do with the pregiven cultural value and meaning of those spaces and everything to do with these videos' pragmatic role in advancing the goals of a movement whose main tool for placing pressure on the regime was physically assembling the people in the street, not listening to them sit around at home and talk.

Whatever the reasons for this choice, one of its consequences is to establish online video as a more socially egalitarian terrain than it would have been if filming indoors had played any significant role in the creation of the vernacular anarchive. For to show individuals and families in their domestic spaces would be to specify and particularize them in ways that would inevitably have disrupted the lived experience of revolutionary unity against the regime. By showing people in the spaces that they can afford to rent or buy (or which they have inherited), and by showing how they have chosen (and can afford) to inhabit them and decorate them, videos made in and of domestic space would inevitably have revealed a range of social and cultural

differences, even conflicts, that their simple presence in the street would not so easily give away.

The fact that in the street these distinctions are still visible—in the ways in which people dress, speak, move, and gesture—is beside the point (though often the tactile–kinesthetic aesthetic described in the chapters in part 1 leads to an inevitable blurring of such signs for the viewer, except when a higher quality image—itself a leading marker of social class, or at least disposable income, on the part of the camera owner—tends to restore their legibility). The street, where bodies gather and voices are raised together in common chants, permits the *willing suspension* of all this coded knowledge about people's origins and class status. Indeed, one could argue that it is because just enough of this knowledge *does* persist outdoors, that people can take pride in their collective decision to ignore it, to set it aside, in order to construct their unity as "the people." Place the same persons in the context of their home life, however, where the conversations are more personal, and the furniture and size of the rooms, their state of repair, the books, bottles, and/or ornaments on the shelves (if, indeed, there is any shelving), speak for them, and these class distinctions, along with the various ways in which people may attempt to buy their way into and out of them, become impossible to ignore. By adopting the mainstream Western documentary trope of using intimate conversations in indoor settings to develop depth of character and dramatize political debate, the authored documentaries from the Arab revolutions reintroduce—in some cases reflexively and skillfully, in others clumsily and unwittingly—the semiotics of class cleavage in a way that the vernacular anarchive itself steadfastly refuses.[2]

This choice on the part of the vernacular filmers stands out even more plainly when we consider a series of remarkable videos produced by the Mosireen collective in Egypt, which deliberately use the domestic interiors of their subjects as a central element in their *mise-en-scène*. Mosireen's work is highly various, and the videos that make up the series devoted to the testimony of the families and close friends of the martyrs are hardly "vernacular" video in any straightforward way. Most of

them are highly edited and structured, and they are generally shot on digital single-lens reflex or other large-chip cameras, giving them a shallow focus look that makes them more akin visually to the authored films cited previously than to most of the other videos discussed in this book. These videos are largely structured around direct-to-camera testimony shot within the homes of the martyr's family, or in the immediate neighborhoods around their houses. As a result, they make no bones about the fact that many (though not all) of these martyrs were drawn from the ranks of the urban underclass. This fact is everywhere apparent in the everyday spaces and lives to which the videos quietly but deliberately direct our attention. In this way, these videos contribute to a larger political claim which several members of the collective have elsewhere made explicit in their writings: that whatever else it was or might appear to have been, the Egyptian revolution was essentially a manifestation of class struggle.[3]

As the sister of the martyr Toussi says in the video dedicated to his memory, referring to the infamous treatment of his corpse by the security forces:

He was a great person. But the poor get trampled on. They trample on them, and kill them, and drag them in the streets. Our ending is getting thrown in the garbage. That's where we end up. And why? Because we're poor. Because they know we won't say anything. They know we are weak.[4]

In these videos, the social semiotics produced by filming in domestic interiors is not simply accepted; it is deliberately adopted and used to articulate a distinctive vision of the revolution as a *social* revolution and not simply a struggle for political or human rights. In this context, the broader "unity" of the people is self-consciously put at risk in order to contribute to the potential for a different unity—that of the millions of Egyptians who live in working-class neighborhoods just like these.

A similar choice to show something of how people live in their homes, though made for different reasons and producing

somewhat different effects, can be found in an important subset of the videos produced by the Syrian collective Abounaddara. Again, their work is highly varied and resistant to any simple summary. And again it includes, among other features that distinguish it from more vernacular forms of video production, a large number of videos of first-person testimony recorded in domestic (and other) interiors.[5]

Thus, the short video *Blowing in the Wind* (2012) uses its indoor setting to conjure a set of social connotations that could hardly be more different from those of Mosireen's video homage to Toussi.[6] Here, a young woman sits in an informal pose, cross-legged on a large double bed which, while not luxurious, nevertheless bespeaks a relatively comfortable middle-class lifestyle—something in keeping with what we glean of her work as a school teacher in Damascus. She tells two stories to the filmer —one about the first day after she removed her hijab, when she remembers feeling a lock of her hair blowing in the wind against her face; and one about the day before she first put on the hijab, when she remembers feeling the rain falling on her hair, wetting it "for the last time." The video ends with an extended silence, as she giggles and continues to play nervously with the pen in her hands, as if uncertain what to add or even what she may have meant by confiding these two anecdotes before the camera.

The effect of this video is complex. Its elliptical presentation, largely free of any significant context, underlines the way in which meanings, and the memories associated with them, are plastic, perhaps even undecidable—in particular for those of us who come to this video as "outsiders." (Abounaddara are always acutely aware of the dangers of assuming the positionality of the audience as somehow neutral or otherwise "unmarked.") And this ambiguity is further underscored by the silence at the end, which suggests not only an uncertainty in the speaker's attitude toward what she has just said, but an analogous suspension of judgment on the part of the filmmaker. The camera's physical intrusion into a space that might be seen as the very archetype of the private (a woman's bedroom) to purloin these personal anecdotes (and expose the person who tells them) is

thus in some way compensated by the secrecy and silence that flood into these final seconds, concealing both the speaker's own intentions and those of the person who films her. The result is a first-person confession that seeks to disarm any easy judgment of this mode of address as simply a retreat into—or an invasion of —the personal and the private.

In a sense, then, *Blowing in the Wind* executes a move that is opposite and equal to that made by the *The Martyrs: Toussi*. The Mosireen video clearly claims both online video and the home space of its protagonists as places from which the people can speak, even if we may and should continue to disagree about who exactly constitutes "the people." Abounaddara's video, on the other hand, offers a moment of intimacy, whose content is two brief sensory memories, not in order to conflate private space and public politics, but rather to unsettle our very sense of where one ends and the other begins. That both videos were made in contexts where access to the public spaces of their respective societies was subject to increasingly violent repression by the State only adds to their wider political resonance.[7]

Toward a Definition of Vernacular Space

The exclusion of indoor domestic space from the vernacular anarchive might appear then as the audiovisual "shadow" of these revolutions' central performative tactic: the mass reappropriation of public space through the occupations and sit-ins staged in squares and streets. But as the work of both Mosireen and Abounaddara reminds us, the boundary that divides the "public" from the "private" is not given once and for all; it exists to be questioned and displaced. Indeed, as Jacques Rancière has pointed out, the distribution of exactly what is "public" and what "private" is never the given from which politics starts; it is, rather, the essential object of political struggle.[8]

In the case of the Arab revolutions, it is even more important not to assume that the distribution of "space" that these videos enact can be reduced to these categories that we tend

to take for granted. As Shahd Wari points out in her study of how Palestinian refugees inhabit the public spaces of Berlin, the public/private dichotomy itself developed in the context of Euro-American modernity and cannot be straightforwardly transposed outside the biopolitical project which subtends it. Thus in Arabic, not only are there no literal equivalents for the English terms "public" and "private" (or for their classical antecedents), but there is no neutral substantive corresponding to "space" which these terms could then be used to qualify. It is not surprising then that, in the course of her fieldwork on public space, Wari was obliged to abandon the use of the term "public space" altogether, as it was simply too confusing and too subject to misunderstanding by her Arabic-speaking interlocutors.[9]

Behind this difference in taxonomies (which ultimately may fail to do justice either to German or to Palestinian experiences of urban space) lies the conflict between the plurality of *vernacular* practices and experiences of space on the one hand, and the single reifying and rationalizing spatial logic that James Scott has identified as a central part of the project of the High Modern State on the other. From the point of view of the State, space ceases to be inseparable from and determined by the particular actions that traverse it and accumulate within it; it becomes instead identified with a highly abstract model that is held to represent the spatial existence of the world both objectively and exhaustively. Space thus becomes neutral, universal, and—above all—measurable: a container that exists independently of its contents. This High Modern conception of space, which is also the space of colonialism (and of many if not all postcolonial successor regimes, which inherited not only the bureaucratic mindset of their former colonizers, but also many of their intellectual assumptions and material interests), is driven by a logic of ownership, not use. In seeking to produce a one-to-one correspondence between spaces and the persons responsible for those spaces (driven initially by the desire to maximize extraction in the form of tax revenue), it effectively overwrites all those other, fuzzier logics, in which a single "place" could participate in many different "spaces" and enter into many different kinds of

relationship with different people, in ways too complex for any central administration ever to map, let alone control.[10]

Such a vernacular practice of spatiality can be seen in Farha Ghannam's ethnography of the peripheral Cairo neighborhood of al-Zawiya al-Hamra, where she did fieldwork in the 1990s and where the residents' experience of space has less to do with urban planners' designation of "public" versus "private" space than with their own actions and practices. It is their collective appropriation of space through their everyday activities, and through the levels and layers of mutual visibility that accompany them, that determines which spaces are *alifa* (familiar, from the noun *ulfa*) and which *lammin* (threatening, from the noun *lamma*), to adopt the vernacular Egyptian terms that Ghannam reports. Unlike the public–private dichotomy, *ulfa* and *lamma* are relational terms: they are not only context- and occasion-dependent, but they are applied differently by different people. As a result, they lie at an entirely oblique angle to the public–private distinction.[11]

Seen through this lens, these revolutions might then be understood as concerned not so much with the reclaiming of public space for "the public" (whoever they are), nor with the grassroots "privatization" of state-controlled space (as Lawrence Rosen has proposed), as with the making *alifa* of the spaces that the revolutionaries invested—that is, of returning them to the de facto control of the community, through the simple act of living in them.[12]

These contemporary vernacular spatial practices analyzed by Ghannam are largely consistent with the premodern vernacular organizations of space in the Arab (or more broadly Mediterranean) world that Timothy Mitchell has tried to reconstruct, albeit in necessarily fragmentary form.[13] Again, we are confronted with a world in which space is not hypostasized or abstracted from the ways in which it is inhabited and traversed, but is experienced rather as an open-ended series of occurrences or events, whose essential character is always *relationally* determined:

Rather than a fixed boundary dividing the city into two parts, public and private, outside and inside, there are degrees of accessibility and exclusion determined variously by the relations between the persons involved, and by the time and the circumstance.[14]

In his account of the premodern city of Cairo, Mitchell figures this space as an accumulation of different levels and moments of *enclosure*:

> ... building usually involved opening up an enclosure, such as a courtyard enclosed by rooms or columns The house, or the shared housing in the case of poorer dwellings, then expanded around this enclosure, in whatever shape and size the presence of neighbouring buildings allowed. Its generally blank and irregular exterior seldom corresponded to the shape, or represented the purpose, of its carefully oriented interior. In this sense, there were no exteriors, and the city was never a framework of streets on which structures were placed. As we will see, streets too were enclosures. The city was the spacing of intervals or enclosures forming a continuous materiality.[15]

In the vernacular city, interior and exterior are essentially reversible, and every space is *already* a collective space, whose conditions of access and exclusion are collectively managed and whose internal boundaries are constantly experienced as plastic and negotiable. But this experience of the city is only accessible to those who inhabit it and are at home there—those for whom this territory is *alifa*. To outsiders, the vernacular city appears as a pure exterior, a single impenetrable surface, which seems designed to repel invaders, and in particular, to exclude that ultimate outsider, the State.

And it is this practice of vernacular space as space *outside of* and *illegible to* the spaces of the State that reemerges so forcefully in the occupations of space throughout the Arab revolutions.[16]

Inside Out

The inclusive logic of vernacular space is directly dramatized in another series of videos from the vernacular anarchive, which speak directly to the reversibility of the interior and exterior. We have already seen in the video *The Martyrs: Toussi* by the Mosireen collective, how the home might itself become a space where political speech is staged. This same inversion of interior and exterior is taken a step further in a number of videos of a more properly vernacular nature which emerged from the Syrian revolution, and which form an integral part of those actions that were termed "home sit-ins" (*i'tissâm manzalî*).

This practice seems to have begun when it was felt that it had become too dangerous for Syrian women to attend the regular outdoor demonstrations that the revolutionaries were holding. As a consequence, groups of ten to twenty women would gather in the apartment of one of their number, dressed in such a way that their identities were more or less successfully concealed. The subsequent "sit-ins" as documented on video effectively reproduce the multiple rhetorics (spatial, visual, aural) of the outdoor demonstrations of which they are clearly intended as both the repetition and the extension. The reception room in which they are held is reorganized and decorated to recreate the spatial and political dynamics of the square. Walls and tables are strewn with pictures of the martyrs, while the women take up position, chanting toward their "virtual" audience from behind their banners just as they might have done to a real audience had they felt able to go outside.[17]

These videos do not record the ongoing everyday life of these interiors, but instead use them to stage unusual and highly ritualized performances specifically addressed to the camera. These performances may include poems, songs, and even the reading of "revolutionary communiqués." Even the camera movements themselves take on a self-evidently political significance, as they deliberately scan the images and texts that have been displayed across the space in advance.[18]

The home sit-in thus becomes the occasion for a radical

repurposing of these spaces and the subversion of the usual codes governing people's conduct within their own homes. Through and for the presence of the camera, a space that usually serves to shelter actions and words from more general inspection is transformed into a space that is open onto multiple wider worlds and from which explicitly political statements and gestures can be broadcast, while also limiting the violence to which the participants are likely to be exposed, at least in the short run. Here, the interior continues to function as a protective membrane, while at the same time it is explicitly figured as a surrogate exterior. This exterior is concealed from the regime for the duration of the staging of the event, only then to be exposed to a much wider (and more anonymous) audience than are many street demonstrations, through the posting of the video online.

The interior can thus come to include the exterior, while still continuing to function in some ways as an interior. (If this is so, it is because, as Mitchell argues, both the interior—the room— and the exterior—the square—are equally *enclosures*.) And the reverse is also true: by being occupied, the exterior squares and streets of these revolutions begin to function in some ways as surrogate interiors: that is, they are equally protective and protected spaces—protected above all, if only temporarily, from the gaze of the State. In this way, just as indoor space can be used to recreate an outdoor experience that has become inaccessible, so outdoor spaces can be repurposed as provisional, extended interiors. And this may help explain why the exclusion from the vernacular anarchive of "interior speech" observed by Riboni also extends to those moments of "interior speech" that happened to take place out of doors, in the open air.

The omnipresence of conversation and argument between both friends and strangers everywhere that streets and squares were occupied during the Arab revolutions is not in doubt. As Mohammed Bamyeh remarks:

Life in Tahrir Square during the first weeks of the revolution, for example, was characterized by debating circles everywhere, and it was virtually impossible to be left alone, to not be talking

to someone else, usually a complete stranger, for a significant amount of time. Talk was in fact the most frequent social activity ...[19]

The near-total absence from the vernacular anarchive of such talk in open spaces is therefore all the more remarkable.

Thus, there is no equivalent in the vernacular anarchive of the intense political discussions among small groups of activists encamped on the square that regularly punctuate Stefano Savona's documentary *Tahrir* (2011). Nor is there anything remotely like the spontaneous (and tragically prescient) argument over how the Egyptian revolution would end that Samir Abdallah recorded one night in early 2011, which was included in his work-in-progress *Au Caire de la révolution* (2011–).[20] While several people who followed closely or took part in these revolutions have told me that many videos of such debates and arguments can indeed be found on YouTube, I have never come across any of them in many years of searching, and neither has Ulrike Lune Riboni in her narrower (but doubtless also deeper) exploration of the vernacular anarchive of the Tunisian revolution.[21]

The fact that observational scenes of small groups of people talking politics among themselves could be, and were, filmed outdoors in revolutionary spaces by many professional filmmakers, just as they were indoors, again suggests that it was not the people themselves who were reticent about being filmed during such discussions—whether by their fellow citizens, such as Abdallah, or by outsiders, such as Savona. It would appear instead to be the filmers who took it on themselves to determine that such scenes were not relevant to the vernacular record, even if they were one way in which bodies gathered on the street. *Eavesdropping*—so central to the way in which speech is represented in the dominant cinematic traditions, both fictional and documentary—was discounted, if not positively disvalued. As with the analogous embargo on filming indoors, part of the motivation was presumably tactical—a concern for what should and should not be placed at risk of state surveillance by being

recorded and shared online. But this reticence seems to have gone far beyond such considerations, and to speak to *a larger requalification of their experience of outdoor space itself*, and thus of what it meant to engage in conversation there.

Commenting on the omnipresent conversations to be found in Tahrir and in other occupied spaces, Mohammed Bamyeh captures something of the highly charged intimacy that seems to have characterized them when he says that the participants in such encounters were not only engaged in inventing new meanings, but were also "performing an erotics of agreement."[22] Just as the revolutionary moment suspends the opposition between the individual and the collective, through an experience of being singular–plural, so it also suspends the opposition between private and public space, through the experience of an intimate exteriority, reinventing the most empty and lifeless of planned urban spaces as complex sequences of porous yet protective enclosures, produced performatively wherever the people come together in the open air.

Rather than the life of the home being the last (and largely mythical) reserve to which the sovereignty of the individual over herself is fatally reduced, it was now the streets and squares of the city that became the stage for the reinvention of larger, more expansive forms of relationship, sufficiently rooted in custom and improvisation to dispense with any need for the mediation of the State. It was here that a different kind of spatiality now began to emerge, one whose intrinsic relationality was more *ethical* than geometrical.[23] And the dominant metaphor for this extension of the values of the interior out into the exterior was, perhaps inevitably, the family—not as a representational microcosm for the larger society, but as the hyperbolic emblem of the strength and depth of the bonds of solidarity that were suddenly being recognized as everywhere possible again, even—or especially —between strangers.

As Asmaa Mahfouz put it on the eve of the Egyptian revolution, reporting the responses she had received to her initial video message of January 18, 2011:

Everyone who talks to me, talks as if I'm his sister or his daughter or his mother. I felt like I am truly the daughter of Egypt. I felt that I am your daughter and you are concerned about me. This is the most beautiful thing I have ever felt in my life.[24]

Thus, the street and the square cease to be impersonal exteriors and become instead a larger version of the home, whose internal divisions and rules are negotiable and fluid, but whose external boundaries are all the more fiercely regulated and guarded, since they serve to define the *only* absolute exteriority—that of the people themselves in relation to the State.

Swimming with Aisha

While the homes of the people are largely absent from the vernacular anarchive, there is one kind of domestic interior that is very well represented there, at least in the cases of Tunisia, Libya, and Egypt—countries that saw their former rulers and their clans removed from power. These are the videos in which the filmer takes us on a tour of the palaces and other properties belonging to the former dictators.

The transgressive force of this footage is, of course, amplified by the fact that the intrusion is *asymmetrical*. As already noted, no corresponding footage exists in which the people invade and expose their own living conditions. After having suffered regimes whose security apparatuses reserved the right to penetrate their homes at any moment, there was doubtless something profoundly liberating in the ability to turn the tables on them in this way. Nowhere is this clearer, perhaps, than in the multiple videos of Libyans not only inspecting the house of Aisha Gaddafi (the daughter of their deposed ruler), and the damage which previous visitors have done to its luxurious appointments, but also simply taking the time to splash around in her swimming pool.[25] In the case of Egypt, the actual residences of the Mubarak clan seem to have been well-protected, but there were a number of instances in which revolutionaries documented their invasion of the offices of various security corps, "liberating" computers,

shredding people's files, and generally lampooning the system under which they had suffered so long.[26]

These "home invasion" videos bear a close kinship to those that preceded the fall of the regime and in which the portraits of the dictators were subjected to various forms of humiliation and destruction that amount to a form of symbolic putting to death. (I discuss this phenomenon further in chapter 8.) These are moments of extraordinarily powerful semiotic reversal, in which the people take control not so much of the material levers of power (which often remained well-sequestered and beyond their reach) as of the *language* that had been instrumental to their oppression.[27] These videos of home invasion after the flight of the dictator have a similar symbolic value in their transgression of spatial boundaries (albeit a transgression made possible by a prior shift in material power). It is because the ruling family has fled, or the police have been withdrawn, that these explorations of a previously forbidden domain have now become possible.

The transgressive tours through the spaces that had belonged to those "other" families include some of the happiest moments in the vernacular anarchive. At the same time, these videos convey a strange sense of unreality. Is there really nothing behind the curtain that had previously concealed the regime and its agents but some well-watered lawns and a few flat-screen TVs? The real levers of the power that had so long been exercised against the people seem insistently absent. Even the hard drives and paper files that the Egyptian revolutionaries are so elated to get their hands on when they visit State Security will later turn out to be "props" in a mutual *mise-en-scène*, rather than the real functioning nervous system of the regime.[28] With the "triumph" of the revolution, we pass from the self-evidence of the people's appearance, and the reclaiming of State-controlled space as vernacular space, to the illusions and subterfuges of power, sustained by multiple layers of lies, evasions, and manipulations. These excursions into the provisionally abandoned corridors of power mark perhaps the end of the beginning of the revolution—the conclusion of its honeymoon period. It is

not surprising, then, if some of these acts of celebratory revenge leave a bitter taste in their participants' mouths.[29]

TRANSCRIPT

(From the English subtitles provided in the original YouTube clip.)

ASMAA MAHFOUZ *(addressing the camera)*
Four Egyptians have set themselves on fire to protest humiliation and hunger and poverty and degradation they had to live with for thirty years. Four Egyptians have set themselves on fire thinking maybe we can have a revolution like Tunisia, maybe we can have freedom, justice, honor, and human dignity. Today, one of these four has died, and I saw people commenting and saying, "May God forgive him. He committed a sin and killed himself for nothing."

People! Have some shame!

I posted that I, a girl, am going down to Tahrir Square, and I will stand alone. And I'll hold up a banner. Perhaps people will show some honor. I even wrote my number so maybe people will come down with me. No one came except three guys! Three guys, and three armored cars of riot police! And tens of hired thugs and officers came to terrorize us. They shoved us roughly away from the people. But as soon as we were alone with them, they started to talk to us. They said, "Enough! These guys who burned themselves were psychopaths." Of course, on all national media, whoever dies in protest is a psychopath. If they were psychopaths, why did they burn themselves at the Parliament building?

I'm making this video to give you one simple message: we want to go down to Tahrir Square on January 25. If we still have honor and want to live in dignity on this land, we have to go down on January 25.

We'll go down and demand our rights, our fundamental

human rights. I won't even talk about any political rights ... We just want our human rights and nothing else. This entire government is corrupt—a corrupt president and a corrupt security force. These self-immolators were not afraid of death but were afraid of security forces! Can you imagine that? Are you also like that? Are you going to kill yourselves, too? Or are you completely clueless? I'm going down on January 25, and from now till then I'm going to distribute fliers in the street every day. I will not set myself on fire! If the security forces want to set me on fire, let them come and do it!

If you think yourself a man, come with me on January 25. Whoever says women shouldn't go to protests because they will get beaten, let him have some honor and manhood and come with me on January 25. Whoever says it is not worth it because there will only be a handful of people, I want to tell him, "You are the reason behind this, and you are a traitor, just like the president or any security cop who beats us in the streets." Your presence with us will make a difference, a big difference! Talk to your neighbors, your colleagues, friends and family, and tell them to come. They don't have to come to Tahrir Square. Just go down anywhere and say it, that we are free human beings. Sitting at home and just following us on news or Facebook leads to our humiliation—leads to my own humiliation! If you have honor and dignity as a man, come! Come and protect me and other girls in the protest. If you stay at home, then you deserve all that's being done to you, and you will be guilty before your nation and your people. And you'll be responsible for what happens to us on the streets while you sit at home.

Go down to the street, send SMSes, post it on the net. Make people aware. You know your own social circle, your building, your family, your friends. Tell them to come with us. Bring five people or ten people. If each of us manages to bring five or ten to Tahrir Square and talk to people and tell them, "This is enough! Instead of setting ourselves on fire, let us do something positive." It will make a difference, a big difference.

Never say there's no hope! Hope disappears only when you say there's no hope. So long as you come down with us, there will be hope. Don't be afraid of the government, fear none but God! God says He "will not change the condition of a people until they change what is in themselves."[30] Don't think you can be safe anymore! None of us are! Come down with us and demand your rights, my rights, your family's rights.

She holds up a handwritten poster to the camera.

I am going down on January 25, and I will say "No" to corruption, "No" to this regime.

The Cause of Our Humiliation

The absence of indoor scenes during these revolutions is nowhere more remarkable than in the almost total absence of video blogs from the vernacular anarchive. This absence is itself obscured by a small number of extremely high-profile examples of the genre, which emerged from the region at key moments and thus became the trees concealing the lack of any corresponding forest. (The examples from Tunisia of videos deploying direct speech to camera cited by Ulrike Lune Riboni serve mainly to underline how they *refuse* the conventions of the vlog, rather than embrace it.[31]) This lack is all the more remarkable if you consider that the vlog, or video blog, was at that time still the archetypal online video form of the Euro-American Internet. Indeed, one survey suggested that vlogs were, at least during the years immediately preceding the Arab revolutions, the single most widely watched genre of user-generated online video content, accounting for some 40 percent of the "most popular" online videos as measured by multiple criteria.[32] This genre, in which a single person speaks directly to the camera in a domestic setting, such as a bedroom or home office, and where the sense of intimacy is generally enhanced by the implication that they are alone as they record their message, would seem to be almost a logical impossibility for the vernacular anarchive. Of the small number of vlogs I have come across, many turned out to have been recorded by Arabs living abroad. And those which were made in their home countries differ substantially from the Western model.

This point can be illustrated by turning to the vlog, which for many outsiders almost came to define the Egyptian revolution: that recorded and distributed by the April 6 movement activist Asmaa Mahfouz on January 18, 2011. Popularized in the English-speaking world as "the vlog that helped spark the revolution," this video is perhaps most remarkable for the ways in which it is *not* a vlog, as much as for the ways in which it is.[33]

What is perhaps most remarkable about this video is how it avoids drawing any attention not only to Mahfouz's personality,

but to anything which might make us feel we were in a person's home. As if to play down the sense of involuntary intrusion that the viewer might feel on finding themselves having entered someone else's personal space, even if invited, the camera is placed so as to more or less entirely eliminate any sense of the environment in which the video is made. Mahfouz's gray and white dress not only flattens her body out, it flattens her back into the off-white wall just behind her. The only details that persist—a fragment of a gray door with its nondescript handle to the right, the top of a standard-issue office chair to the left— complete the feeling of impersonality. We are not in someone's home, indeed, we are hardly in someone's office. Mahfouz hangs suspended in this anonymous space. But where better than anonymity, from which to speak to all of us?

This sense of being "nowhere" is reinforced by the repeated references to "home" that dominate the central section of the video. Mahfouz repeatedly calls her viewers out for "staying at home," for "sitting at home," for not "going down" into the street as she does. The fact that she speaks to them as she herself is sitting indoors is undercut by the fact that this indoors could not look less like a home. And this tension effectively prepares the way for her final rhetorical gambit, as she dismantles the last reason one might have to stay indoors and keep oneself to oneself: "Don't think you can be safe anymore! None of us are!"

There is no reason to stay home, because there is no place worth calling "home" anymore. The home has been so violated by the regime that the only place that the sense of protection and intimacy associated with those words can be recreated is not inside a house or apartment, but out in the streets. And it is the people in the streets who are thus the true successor of the family, because only they can maybe offer what the family holed up in its apartment can no longer offer: security.

If this vlog, then, is in some sense an anti-vlog, which eschews all the personal trappings, all the theater of intimacy that characterizes the Euro-American genre, it is in part because an Egyptian's home is no longer her fortress. Far from being one of the places where politics might be nurtured and renewed,

the home is here positioned as totally unable to provide the kind of solidarity and security that the people need, whether they have already chosen to side with the revolution or not. The home, in this sense, stands for the lack of any possible home, for a generalized insecurity, a world in which even the most intimate interior spaces are experienced as *lamma*, not *alifa*. In this world, the only way to recreate the values of the home is to exit from the literal, physical space of the home. The literal home is no longer a resource for the revolution, as the authored documentaries discussed above would still have us believe; it is its principal antagonist.

Indeed in Egypt, those who did stay home, undecided whether to join in the uprising or not, came to be known somewhat derisively as *hizb al-kanaba*, the party of the couch.[34] In doing so, the home became identified not with the kind of close relationships which can empower people to act in concert and even to risk their lives for one another, but rather as the domain of inaction—the place where people lounge around drinking tea, gossiping, and watching television, while others take the real risks on their behalf. Where the traditional vlog tends to reinforce the sense of domestic space as self-sufficient, because it is designed to provoke and enable the kind of "response" from other "users" that they can make without their having to leave their own bedrooms, Mahfouz's anti-vlog makes explicit the hidden and deeply paradoxical message running not only through those vlogs that do exist, but, implicitly, through all the videos in the vernacular anarchive of these revolutions. For what each one of them says to us, if we watch it closely enough, is: "Stop watching videos!"[35]

The injunction "Don't watch videos!" is obviously paradoxical: it is only by watching a video (*this* video) that we can hear it. And it is (at least in appearance) only in order to deliver this message that such videos exist. Perhaps it would be more accurate to say that each video aspires to be the *last* video we watch or need to watch. Each video aspires to be the one that finally tilts the balance, that finally gets all its viewers out on to the street, that finally empties the living rooms of the country.

The aim of Mahfouz's video, then, is to eliminate not video so much as its home-bound audience—to evacuate the entire population from their comfort zone on the sofa out into the streets. Once we are outside, we can still go on watching each other, filming each other, and watching each other's films. But there will be no one left sitting at home, *just* watching. Instead, watching will be fully integrated with making the revolution happen. The revolution will not eliminate the need to watch; it will simply return the act of watching moving images from the domestic spaces to which they have become confined to the streets and squares in which they had their origin, and where they can once more function as they should—as one more link in a chain of active solidarity.[36]

The vernacular anarchive of the Arab revolutions thus seeks to eliminate or subvert the tradition of the Euro-American vlog inasmuch as it represents an unwarranted privatization of collective energies. Asmaa Mahfouz's message is not just aimed at the lazy, the timid, and the cowardly. It is also aimed at all those who would confine the role of video to the surveillance of domestic spaces and the performance and transcription of individual psychological states—that is, to those formal maneuvers that directly or indirectly contribute to the dissolution of the people's living solidarity as the essential site of their resistance to the regime. Her direct address to the camera explodes the desire for eavesdropping and other forms of voyeurism. In speaking out, she expresses her frustration, not with images as such, but with those images that serve only to confirm us in our own passivity. And the proof that *video itself* can become a form of action must be supplied by *my* decision to abandon my role as a (provisional, tactical) spectator and act now in my turn.

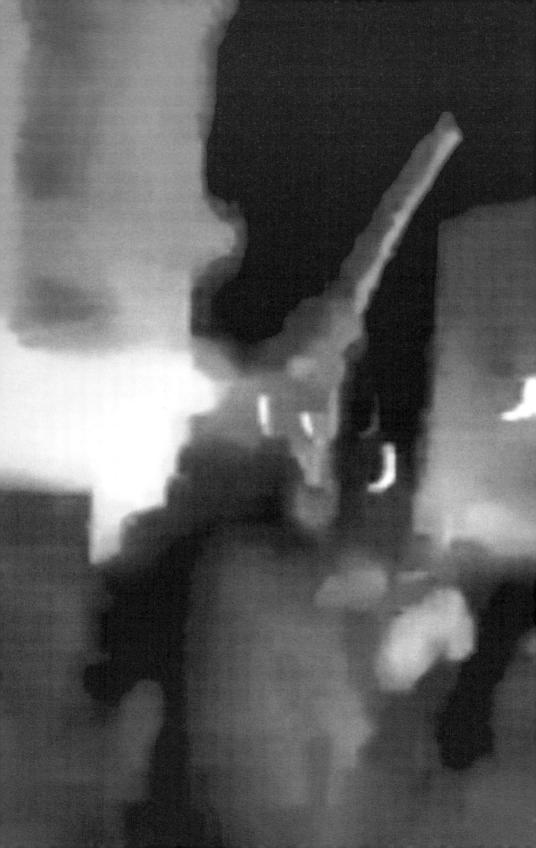

8

O Great Crowds, Join Us

Young people of al-Dahira! Join us on al-Gezaer Square!
O great crowds of al-Dahira! God is greater!

Tripoli, Libya, February 2011

Still frame from video circulated on Facebook on April 15, 2011, and subsequently deleted. To view, and for more information, go to vimeo.com /channels/thepeoplearenot, video 8.

The Address of Video

In 2006, I traveled to Algeria to attend the funeral of a friend, N., who had died tragically in his late twenties from a rare form of cancer. While in his village, two of his cousins were delegated by the family to look after me and another mutual friend with whom I had made the journey. It was a beautiful spring. In between the often lengthy rituals of mourning, they would take us on extended walks and drives through the surrounding countryside, in which sharing our memories of N. was interwoven with a sense of mutual discovery and the exercise of a hospitality that made equal room for politics and for botany, for humor and for sadness.

One of the main threads in our conversations was their memories of the 2001 insurrection which, starting from the Kabyle region where we were, had brought large swathes of the country to the verge of a situation of *dual power*.[1] They would take great pleasure in telling us stories of how events had played out in their village. One day, while passing a nearby village, a few throwaway remarks testified to the spirit of rivalry that existed between them and their neighbors. To draw them out, I asked our guides how they, the inhabitants of village X, had been able to work with the inhabitants of village Y during the insurrection —if indeed they had—given how they seemed to view them. The answer came back immediately:

> Suppose one evening they're watching the news on the satellite channels, and they see that down in X, we've torched the police station? Then all the guys in Y will go out and meet on the square, and they'll say to each other: "Did you see what they did down in X? What can we do? How can we go one better?"

I was reminded of this story in early 2011 when I started watching revolutionary videos from across the Arab region. As the revolutionary energy spread from one place to another, I had the distinct impression that what I was seeing on YouTube (and learning about through other social media) was a large-scale

version of the way that the Algerian insurrection had propagated in 2001. If filming was a means of participation for the filmer, then the videos that were produced and uploaded were not just documents of that participation, but rather (in the most direct sense) *invitations to others to act in their turn*. Like Asmaa Mahfouz's vlog, their discourse was not impersonal or objective, but directly addressed to a "you" who was no less concrete for being pluralized in unpredictable ways by their diffusion throughout the Internet. More specifically, they were inviting the viewer not only to emulate but also to compete with what they had seen, to try to exceed the model in revolutionary fervor. Indeed, perhaps the reason there were so few vlogs from these revolutions was that *all* the videos produced by revolutionaries were felt to contain this element of direct address, this imperative that was no less powerful for being left implicit.

One of the clearest examples of this sense of video as a vector for mutual emulation can be found in the countless videos in which protesters from across the Arab world are seen to deface, dismantle, and otherwise destroy the portraits of their much-hated leaders that had too long occupied their public (and thus mental) spaces. Elias Canetti has described the equalizing intent of this kind of symbolic violence well:

> The destruction of representational images is the destruction of a hierarchy which is no longer recognized. It is the violation of generally established and valid distances. The solidity of the images was the expression of their permanence. They seem to have existed forever, upright and immovable; never before had it been possible to approach them with hostile intent. Now they are hauled down and broken to pieces.[2]

In the vernacular anarchive of the Arab revolutions, the way in which these acts of destruction are wreaked varies from place to place and depends in part on the type of portrait that is available to be destroyed. In Egypt, much of the revolutionaries' on-camera rage was vented on the billboards that littered the cities' skylines with images of Hosni Mubarak and his son

Gamal.[3] In Tunisia, such operations could be even more spectac-ular. Once posters were brought to the ground, they would often be set alight and even run over by cars. In one extraordinary sequence, a group of young men from Sousse risk life and limb to scale the facade of a building in order to bring back a giant portrait of Zineddine Ben Ali for ritual desecration (attempts to burn it *in situ* having failed) before the encouragement and awe-struck gasps of a large crowd of onlookers.[4]

Syria, on the other hand, is (or rather used to be) particu-larly well-endowed with gilded metal statues of Hafez al-Assad. Harder to destroy satisfactorily with artisanal methods, they nevertheless provided a magnetic focus for the rage of demon-strators in the early months of the revolution, who would seize every opportunity to have at them, hammering on them with whatever suitable implement came to hand, including some-times their own shoes.[5]

Of course, not all such operations were as public as these, performed by the light of day before large crowds of onlooker–participants. Other such acts inevitably took on the character of clandestine commando raids, due to the risks involved, especially in places such as Syria where the regime continued throughout 2011 and 2012 to control large swathes of the country and bru-tally repress the least sign of agitation. Thus, one video shot at night shows two men, their identities well concealed, as they set fire to a giant roadside portrait of Bashar al-Assad, before making their getaway. Here, the video makes public the energy and courage inherent in an act of defiance that might other-wise have survived only through the charred trace of its material consequences.[6]

Both these images, and the actions they represent, would appear to be infectious. They seem to be offered and received in the same spirit of playful rivalry and deadly serious purpose as the prov-ocations that circulated among the villages of the Kabyle region some ten years earlier.[7] Each of these videos should, I believe, be understood not only as a documentary affirmation ("We did this! It really happened!") but also as an invitation to do likewise, or to go one better ("*See* what we did? What can *you* do?").

In this way, these videos are not merely produced from *within* these revolutions, because their point of view is that of people who are among the revolutions' actors. They are also part of the internal structure of enunciation through which the people come to constitute themselves as "the people." As Judith Butler has insisted, this "people" is a people that includes not only those present at the event where the video was made, but also—and above all—those who were absent at that time but are now present before their computer and/or phone screens to watch these images and to pass them on to others.[8] For these acts of (re)circulation are also among the actions by which the people perform themselves as present and through which the actions of a numerical minority achieve a resonance that extends their energy not simply to a majority, but to that which, in each of us, is "all of us."[9]

These images, in other words, are not principally *about* a "them." But nor are they simply *from* a "we." They are also very clearly, and very pointedly, addressed *to* a "you."

TRANSCRIPT

(English translation based on original Arabic dialogue.)

Tripoli, Libya. The filmer is advancing through the night, holding his phone vertically as he films the scene around him. At first the only people in the frame are faint figures in the distance, but we can hear the sounds of an assembling crowd, who will grow stronger and come closer to the camera as the video progresses.

FILMER
Young people of al-Dahira, join us on al-Gezaer Square!
O great crowds of al-Dahira neighborhood!
God is greater! God is greater!
Where are you coming from?

PROTESTER
From Amani.

Confused shouting.
The video image momentarily freezes, as we hear people beating on improvised drums.

FILMER
Where are you coming from?

ANOTHER PROTESTER
From Amani.

FILMER
Young people from Amani and Dahira, come and join us!
Join us o you great crowds!!!
Where are you coming from?

ANOTHER
From Souq al-Juma'a.

FILMER *(ecstatic)*
Souq al-Juma'a!!!
Where are you coming from?

ANOTHER
Souq al-Juma'a.

FILMER
People of Souq al-Juma'a, join us!

More and more people are arriving; the confusion of sounds, images, and bodies becomes greater and greater.

FILMER *(voice deepening)*
O great crowds, come and join us!
Where are you coming from?
From Alfiyun? From Souq al-Juma'a?
Where are you coming from?
From Souq al-Juma'a?

Then the video ends as abruptly as it had begun.

I Know Exactly How He Feels

A man advances through the night. He holds his cameraphone out in front of him, in the most natural, vertical position, so that the frame is upright, like himself. It is less a window onto the world than a door through which he might pass toward whatever is coming next—a door so narrow, it seems there may only be room for one person to go through it at a time.

At first, the other people around him are more a presence than an image. A few stragglers in the distance, a pair of blurred headlights coming toward us, but above all their *sounds*—the sound of voices, car horns, the beating of improvised drums. Then, as the bodies begin to approach and coalesce, their chanting becomes intelligible. Suddenly, we are not looking for the crowd: we are among them.

Even before he meets them, the filmer addresses them: "Young people of al-Dahira! Join us on al-Gezaer Square!" And as he comes close enough to feel their presence, their sheer numbers, his entreaty turns to exultation: "O great crowds of al-Dahira! God is greater!" Yet despite the joy that grips him, he does not lose sight of his initial project. He does not seem to want to join the crowd that sweeps toward him like an inexorable river: he wants *these* people to join *him*. He wants them to follow him to al-Gezaer Square.

For a long time, I found the spatial dynamics of this video very difficult to understand. It seemed to me that the man holding the camera was trying to turn the crowd around, to lead it back toward *another* meeting point, in the opposite direction to the one in which it was flowing. And this attempt, expressed so joyfully and with such excitement, seemed to me all the more entrancing for the entirely quixotic and utterly hopeless nature of the project the filmer had set himself.

Of course, that is almost certainly not what is going on. To judge by the available visual clues, the filmer has come *from* al-Gezaer Square, which lies behind him, and he is heading out into the crowd to encourage them to keep moving toward the place that he has just left.[10] He is an emissary of the square that

is their natural destination, not the lone contraflow prophet of some better option. Even as he advances against their momentum, he remains in this way part of the crowd that he is greeting and directing. There is, despite appearances, no real opposition between his "I" and their "we." Which explains why his joy at being reunited with his people is so complete and so unambiguous.

This video was shot in Tripoli in February 2011, during the heady week preceding the beginning of the Libyan revolution when it seemed as if Mu'ammar Gaddafi might leave as rapidly as Zineddine Ben Ali and Hosni Mubarak had before him, and the eastern working-class suburbs of the capital rose up in electric sympathy with Benghazi and the other rebel cities of the Cyrenaica. But I first came across it not while deliberately watching videos from Libya, but on the Facebook timeline of A., an Egyptian musician and activist. In the comments underneath (which have since been deleted, along with the original video), A. remarked to a friend how he completely recognized the emotion that this filmer was experiencing: "I know exactly how he feels!" And this remark then triggered an exchange with several other Egyptian friends who all reaffirmed A.'s initial response of recognition. In the discursive space opened below the video by the Facebook comment function, I watched this video resonate among them, as they exchanged exclamations and confirmations back and forth. Through watching this video and responding to it, they were able to relive something which (they all agreed) they had in common not only with the filmer, but with one another. These images from Libya provided—or prompted—a language in which they could talk again about what had just happened in Egypt.

As these reactions testified, there is a powerful sense in this short video of the kind of energy that can be released by the sudden realization that one is no longer alone. This recognition of a shared desire, a shared determination, that is felt by the filmer in the street as he meets the crowd advancing toward him extended into the memories summoned up by A. and his friends. And in watching this video and talking about it, they

experienced again that sense of the common bond that had united them on and off the streets of Cairo, even though this was, in a very literal sense, not *their* revolution they were watching —for indeed, they were more than a thousand miles away.

Video as *Amāra*

The Italian filmmaker Stefano Savona has speculated that maybe 90 percent of the cameraphone videos made during the eighteen days of the Egyptian revolution were never uploaded to YouTube, but remained instead on people's flash cards or hard drives. The figure is an anecdotal estimate, but probably points us in the right direction. Savona explains that, having returned to Cairo a year after filming his documentary *Tahrir* (2011), he was surprised to find that many of his friends were storing countless videos on their memory cards which they had never thought to upload to the Internet or otherwise share in public but which they kept with them at all times. They would produce these videos whenever they met a stranger who claimed to have been present at the same time in the same place as they had. By showing each other the images they had made, veterans of the same event could thus establish a deeper bond than words alone might have allowed. Such fragments of video function, then, less as keepsakes than as a warranty of the truth of the tales that they would go on to tell one another—and perhaps, also, as a token that the person to whom they would tell them was worthy to receive them.[11]

What Savona's friends do when they meet in cafés or on street corners is a smaller scale, differently networked version of the way in which many similar videos circulate through YouTube and thus on out into the wider social networks.[12] As I have suggested above, these videos are not just inert documents: they are acts of direct address. They not only challenge the viewer to respond to them in kind, by emulating or surpassing the actions they record; they also address the viewer retrospectively, as A.'s conversation with his friends about the Tripoli video shows.

They provide an occasion on which one's past feelings and reactions and actions can be compared with those of others and can be seen to fit with them (or not). In this way, past, present, and future enter into a mutually validating and sustaining network.

These videos thus add to existing cultures of shared vernacular practice and take part in the generation of new ones. They establish networks in which the nodes are linked together not just by their ability to access one another, but by the fact that they share certain common practices and common values.[13] In this sense, these videos function as *tokens* that may be valuable in themselves, but which are above all valued as the medium through which trust can be established and which can open the way to dialogues and conversations that are not only more complex, but also more intimate, and thus, for the participants, more risky. Crucially, these bonds of trust are not simply a contract between two individuals; they depend on the invocation of the collective of which they both form a part—most obviously, through "the people" as it was formed and affirmed in such and such a place, on such and such a day, and who are therefore present in the videos taken there—even where the videos in question have not been put into broader public circulation but remain within the "private" space of one's personal flash memory card.

These videos, then—both those which remain in the camera-phone's memory and those that circulate on the Internet—function as what Ayman El-Desouky calls *amāra*: tokens of trust formed out of "socially cementing speech and embodied gesture" that signify shared destiny to those that recognize them and that are used to build those relations of practical solidarity on which the revolution depends. El-Desouky traces this specifically Egyptian practice (but which may well have parallels and equivalents in other Arab societies, or even in completely different parts of the world) to a short story by Yusuf Idris (1927–91) that dramatizes the structural misunderstanding between the people and the intellectual, which results from the failure of *amāra*.[14]

In "The Chair Carrier" (written and first published in 1968), Idris's narrator believes he sees a throne moving down a street in

central Cairo on five legs.[15] One of these legs turns out to be an emaciated man who looks for all the world as though he has just stepped out of a Pharaonic mural. Seeing him exhausted, the narrator implores him to stop and take a rest, but the carrier insists that, although he has already been carrying the chair for several millennia, he is doing so on instructions from the Pharaoh-God Ptah-Ra, and he cannot just stop and put it down without the god's permission. At each attempt by the narrator to persuade him into the rational course of action rather than continuing with his senseless and outdated task, the protagonist responds by asking for the *amāra* of Ptah-Ra. The narrator is unable to provide this (or even to understand what it is he is being asked for), and so the chair carrier goes on his way, forever carrying, abandoning the narrator to worry over his own inability to alleviate the people of their burden, even though no obvious material or political obstacles stand in his way.

While *amāra* is translated as "token of authorization" in the standard English version of Idris's story, El-Desouky proposes that it has in fact a much wider and more profound meaning than that phrase suggests. For him, the practice of *amāra* is that of "producing signs and tokens of a shared destiny." More specifically, in the context of both Idris's story and the history of Egyptian progressive intellectuals' love–hate relationship with "the people," *amāra* means finding a mode of speech which would allow the intellectual to speak to the people on their own terms and in their own language:

> But it seems that when the intellectual turns to the people to speak their own truth to them, the speech that seeks to articulate shared knowledge and modes of production of the people seems to falter and communication seems to fail.[16]

It is this failure that the Arab revolutions in effect redeemed, not through the efforts of any intellectuals but through the people's emergence as those who are competent to speak their own truth:

When the people speak their own truth, collectively, what they produce is the linguistic, gestured and performed articulations, embodied memories, of their shared knowledge. For these forms are the culturally effective modes of producing common identity and of explaining the world through this common identity. In the face of the powers of resonance inhering in these articulations, the speech of the intellectual seems somehow removed and lacking such force of social signification. The collective social has effectively revealed itself as a new and radical possibility of the political. The aesthetic practices of *amāra* ... project a socially transformed public sphere: expressions of *amāra* index a collectively shared knowledge of the group, while the binding character of this knowledge works through cultural memory as the ability to establish connections and to constitute identity.

The question of the *amāra* is a question of the production of signs, verbal and visual, and of narratives that originate in a deeply shared social condition, signaling shared destiny, and speaking to that condition, not representing it, with both speaker and addressee fully present. It is not simply a question of the people being made aware or brought to knowledge, but first and foremost a recognition that the people already know and that they do indeed speak their knowing, beyond a specified content or demand. They do not always and only speak in demands, they articulate their knowledge of social realities in socially cementing forms, and that is how they exercise their power.[17]

The practice of *amāra* is thus in itself the essential message that these tokens carry, beyond any more specific content or form. The two strangers comparing video footage of their presence at the same barricade, on the same day, are not simply checking the veracity of each other's stories. They are sharing signs of a common destiny at the most literal possible level. And the sense of mutual recognition which this act creates is the intimate version of the more public act of recognition set into circulation by A. and his friends' discussion of the Libyan video on Facebook, and how they could recognize in it their own emotions of joy in finding they were no longer alone.

Amāra as Form-of-life

In chapter 2, I argued that the people of the Arab revolutions, as they are revealed to us through the videos in the vernacular anarchive, are essentially a performance. For Judith Butler, this performance and the claims it carries are implicit in the simple fact of bodies gathering together, in one place or in many places, offline and/or online, before any words are spoken. Still, Butler's analysis, as I read it, fails to pose one essential question: how is it that people are able to establish sufficient *trust* in one another that they are able to gather together in the first place? What prepares them to risk their bodies together to the point where they can begin to experience themselves as a *people*? On what *ground* are they able to assemble in order to share not only their power, but also—and perhaps above all—their *vulnerability*?[18]

Ayman El-Desouky's theorization of *amāra* suggests one answer to this question. The mutual trust of the people is not a groundless leap into the void; it is rooted in a whole world of shared knowledge that is also a world of embodied practices— of habitual gestures and customary actions which define certain ways of being together that have been elaborated, not rationally and prescriptively, but intuitively and iteratively, over spans of time much longer than those of any individual's personal epi- sodic memory.[19] These practices are thus embodied forms of collective memory that carry with them a certain minimal sense of knowing who the other people are with whom I will gather, and of knowing in particular that we share certain basic values— what Caroline Rooney, commenting on El-Desouky's work, has called "an ethics of solidarity"—an ethics that is *inherent in the forms of the vernacular itself.*[20]

This sense of a common moral horizon based on shared everyday practices of speech and gesture enables the kinds of risk without which these revolutions would never have gotten started. And these quotidian, even banal practices, in turn, need to be reimmersed in such heightened periods of concerted col- lective action—Butler's "anarchist intervals"—if they are not to fall into fossilization and decay but are instead to be renewed,

repoliticized, and reinvented. *Amāra* forms, as El-Desouky explores them, are above all those forms that guarantee the possibility of such acts of radical *translation* between an old form that may no longer be directly applicable in the present, and the new forms that are needed and that can only be elaborated through spontaneous collective action. They are, in other words, *forms-of-life*, in the sense that Giorgio Agamben has given to the term: forms which render existing dualities inoperative and that, rather than abolishing them, open them instead to new uses.[21]

These forms provide a basis for entering into relationship in moments when nothing substantial is yet given in advance, and without predetermining outcomes in a rigid and stultifying manner. They are perhaps necessarily *nondiscursive*, for it is their ambiguities and opacities that open them to the invention of new and unexpected practices and meanings. Paradigmatically, then, they are *vernacular* forms that are primarily embedded in and supported by our bodily experience, not our rational thinking.[22]

The story by Yusuf Idris which provides El-Desouky with his starting point offers a perfect example of the embodied, antidiscursive nature of the forms-of-life that are in play here. For the failure of the narrator of Idris's story is, above all, his failure to move outside of, or beyond, the level of rational discourse.

Having failed to convince the chair carrier to put the chair down through his own arguments, the narrator then discovers a written note from Ptah-Ra pinned to the chair itself, instructing the carrier to take the chair to his own home, put it down, and sit in it. Of course, he assumes that the problem is now solved, and he joyfully announces the good news to the carrier. But the written note turns out to be no use, either: the chair carrier cannot read, and the message from Ptah-Ra as relayed by the narrator is of no value without the *amāra* that should apparently accompany it but does not.

El-Desouky proposes that the error of the narrator is to assume the *amāra* is some sort of inert physical token, when in fact what is needed is a living gesture. The intellectual's failure is that he does not (or cannot) "communicate with the people in resonant modes of speech, originating in the expression and

recognition of a common fate and a shared destiny." By remaining within the discourse of instrumental reason, he fails to engage with "the people's languages of urgency," including their gestural language and physical movements, which are inseparable from their words.[23]

This gestural language is incipiently present in the narrator, as Idris goes out of his way to make clear:

All this I told him with great joy, a joy that exploded as from someone who had been almost stifled. Ever since I had seen the chair and known the story I had felt as though it were I who were carrying it and had done so for a thousand years; it was as though it were my back that was being broken, and as though the joy that now came to me were my own joy at being released at long last.[24]

The narrator here is in a state of intense kinesthetic empathy with the chair carrier: but it never occurs to him to translate that empathy into action. The idea that it might be a gesture from his body that is needed—one that would identify his destiny with that of the man before him—does not even cross his mind.[25] He remains, instead, the uncomprehending spectator of his own estrangement. And through his failure to cross the barrier that separates the spectator from the performer, he is condemning that performer to continue to live in the past. As in any genre of performance that depends upon the active collaboration of the audience, it is only through the spectator's response to the chair carrier's call that they can share not only the present moment, but something like a form-of-life. The chair carrier, in this sense, is not a figure of the long-suffering people of Egypt: rather, he is an allegorical figure of the intellectual's own blindness. For it is his sense of his role as the potential liberator of his people that has become instead the burden that *he* carries without knowing it and that has completely stifled and repressed his own capacity for spontaneity, creativity, and joy.

The allegory elaborated here corresponds to a remarkable degree to Fanon's account of the final—and still unsatisfactory—

stage in the evolution of a colonial literature, in which the alienated intellectual seeks to be reunited with the people, only to confuse their living culture with its "outer garments," which are nothing but "mummified fragments."[26] This is precisely what Idris's narrator does in his hallucination of the chair carrier, reducing the Egyptian people to a figure that has stepped out of an ancient mural, not a living human being. This reification tells us nothing about the people and everything about the intellectual's vision of them. As Mohammed Bamyeh puts it in his commentary on Fanon, the result is a literature that speaks to the people, but only to tell them "that their oppression is all there is to them."[27]

From this negative example, then, we can deduce several things about the nature of *amāra*. The power of *amāra* stems from the fact that it enables trust to circulate beyond the level of any act of conscious intellectual assent, or any rational mode of choice, in the form of a shared knowledge that is thoroughly embodied. "When the people speak their own truth, collectively, what they produce is the linguistic, *gestured and performed* articulations, *embodied* memories, of their shared knowledge."[28] And for this knowledge to travel, it must invoke a coordination of bodies that is neither formless nor entirely predetermined—bodies that are capable of entering into a relationship that is based on, and leaves room for, *play*.

The idea of political commitment as a pure act of will operating in an existential void is revealed here as the real obstacle to any effective collective action. As Giorgio Agamben puts it:

> When one wants to recover life, anarchy, anomie and ademy in their truth, it is necessary therefore first to release oneself from the form that they have received in the exception. This is not however only a theoretical task: it can occur only though a form-of-life... . The destitution of power and of its works is an arduous task, because it is first of all and only in a form-of-life that it can be carried out. Only a form-of-life is constitutively destituent.[29]

If in these revolutions the people found the courage to act, and thus to enact themselves *as* the people, it was not simply through the countless political debates and discussions that their gathering together made possible, but also through the rhythmic interplay between their bodies—a practice of coordination and attunement rooted not in some authoritarian orchestration, but in their own egalitarian and distributed forms of shared knowledge. Such a coordination leaves room for both the familiar and the unheard of, the known and the unknown, because it is essentially *dialogical*—not a hierarchical communication, but an exploratory, questioning contact between equals, experienced not as political discourse or rational argument, but as something closer to the give-and-take implicit in the rhythms of vernacular song, dance, or poetry.

These rhythms embody the collective memory of the community, not in an intellectual currency of inert signs that can only speak to the head, but as living physical gestures that emanate from and engage our full embodied being, that make full use of our capacities for sensation, movement, and emotion as well as for reflection. The ability of the videos in the vernacular anarchive not only to document what trust made possible but to elicit new forms of trust themselves, is rooted in the circuits of embodied empathy that circulate through them. These circuits do *not* remain locked in the virtual, as Idris's narrator does, but constantly reengage the actual—including through the gestures of making, and watching, video. They enact and communicate tactile, gestural, and emotional intensities. And they do so not in order to impose *amāra* as a frozen language or a fossilized tradition—some sort of absurd throwback to a mythical (here, Pharaonic) past—but to open up the *other* bodies around them to the possibility of new potentialities and new uses—including to the possibility of a revolution.

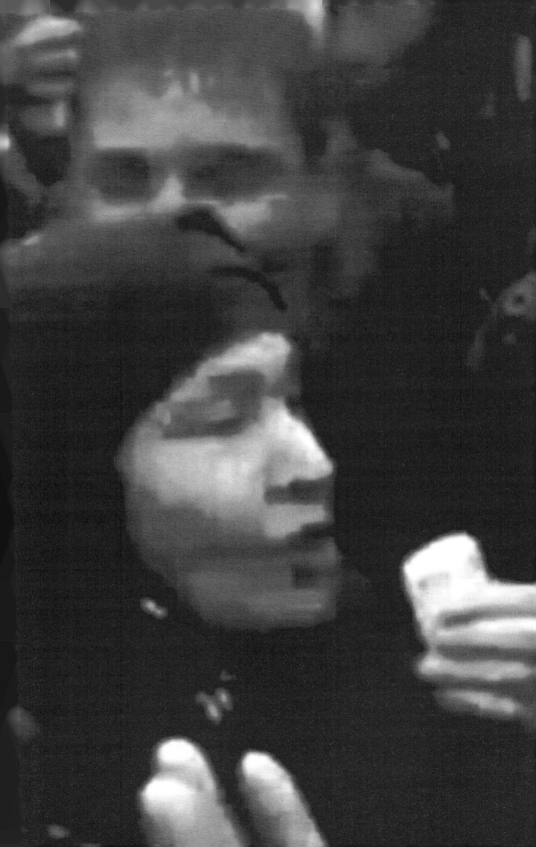

9

The Mulid and the Network

PETER: *So what did you make of the revolution, then?*
L. (laughing): Well, you know how much I like a good mulid.
And the revolution, that was one hell of a mulid!

Conversation with L., Cairo, April 2012

Still frame from video posted to YouTube by webamri amri, January 29, 2011. To view, and for more information, go to vimeo.com/channels/thepeoplearenot, video 9.

The Culture of the People

Many participants and commentators have remarked that the Arab revolutions of 2010 onwards were not simply social and political movements; they were triggered, and were in turn nourished by, an outpouring of vernacular creativity that, far from being merely decorative, functioned as an integral part of the revolutionary *energy* itself. And we have seen in the video of Abdennacer Aouini's celebration of the Tunisian revolution (chapter 1) how, in moments of intense political epiphany, the distinction between rhetoric and poetry, between words as political actions and words as words enjoyed for their own sake, may tend to break down.

In one of the best accounts of the "Independent Republic of Tahrir," Sahar Keraitim and Samia Mehrez write:

> Public performances, sketches, street art, graffiti, poetry and chanting all sprang up in and around the *midan* in a manner that redefined the very role and place of cultural production ... This was the culture of the people for the people, all inspired by Tahrir.[1]

And the same dynamic has been documented across the region, from Manama to Tripoli, and from Aden to Aleppo. Nor has it been limited to capital cities, as liberated spaces proliferated throughout the countries to which the revolutionary wave spread.[2]

Thus, in the vernacular anarchive, we may come across a Libyan man reading a poem he has composed to a small group of bystanders in a Benghazi street late one night.[3] Or a Yemeni man, clearly wounded in the recent struggles, waylaying the filmer's passing camera in order to recite some of his own verse.[4]

In Egypt, two young men, one of them injured in the fighting to occupy Tahrir Square, perform a song against Mubarak to a small group of onlookers.[5] Elsewhere, a rare interior video from Syria (filmed in a mechanics' workshop) shows a young man singing a violently anti-Assad song while his friend interjects encouragements.[6]

Women are also strongly represented as performers, often taking central roles.[7] Thus we may see an older woman in Tunisia borrowing a megaphone to improvise an incantatory curse on Zineddine Ben Ali and all his family, while the entirely male chorus around her responds to each line with an enthusiastic, indeed almost incredulous, "Amen!"[8] In Bahrain, meanwhile, twenty-year-old student Ayat Al-Qormezi galvanized crowds at Pearl Roundabout with her incendiary poems–performances for which she would later be imprisoned and tortured.[9]

These videos clearly reaffirm the vernacular texture of these revolutions. Not only are the forms of language that are mobilized generally the local forms of dialectal Arabic, but this dialect, even when poetically heightened (as, for instance, in Al-Qormezi's work), is often replete with locutions and phrasing that are redolent of proverbial sayings and oral idioms which locate it within, or at the overlap between, highly specific linguistic and social contexts.[10]

As Ayman El-Desouky puts it, commenting on the chants and slogans of the first days of the Egyptian revolution:

> The verbal artistry of the demands and their semantic force are most striking in how they performatively reproduce and mirror the lexical and syntactic structures of common forms of speech and proverbial linguistic forms that are associated with the spheres of cultural production constitutive of "Egyptianness," or experienced culturally as such.[11]

In doing so, they break with any sense of a single master narrative of the revolution that could be handed down from on high, as had always been the case in previous periods of Egyptian history that were experienced as progressive:

> ... in stark contrast to the elevated forms of revolutionary speech, still alive in people's memories from the 1950s and 1960s, slogans were shouted such as: "dabit shurta ya gari wa akhuya, leh tidrabni wi tihbis abuya?" ("Police Officer, you neighbour and brother, why hit my brother and arrest my father?"). And of course the most

famous slogan of the day, "al-gaish wi-sh-sha'b eid wahdah!" ("The Army and the People are one hand!"). Expressions such as "eid wahdah" (connoting solidarity, but literally the regular army personnel encountered first were from among the ranks of the people) and "gari wa akhuya" (connoting familiarity and long-lived acquaintance, but also again reminding security forces that they are indeed from among the people) come straight from common everyday forms of speech and idiomatic expressions associated with certain social conditions and communal relations.[12]

To the extent that historical memories are invoked, they tend to derive from moments when the people came out in open opposition to the postindependence state, rather than consenting to be represented by it. In Cairo, on January 25 a march that started in Shubra can be heard repurposing chants that were previously heard during the 1977 bread riots, when the people rose up against then-president Anwar Sadat's decision to implement IMF-inspired cuts in subsidies on basic foodstuffs. Thus, chants such as "They all dress in the latest fashions / While we are sleeping ten to a room," and "They eat pigeons and chickens / We eat beans till we fall down dizzy" are directly taken from the repertoire of 1977.[13]

These creative and above all *rhythmic* dimensions of the revolution are thus amply recorded in the vernacular video anarchive. Compared with the near total lack of footage of more prosaic and rational forms of communication and conversation, even in outdoor spaces (see chapter 7), the profusion of such clips as these testifies not only to the delight which they gave to the assembled revolutionaries and their desire to share those moments with those who could not be there, but also to the function of video in revolutionary times as not merely a "transparent" medium for the relaying of discursive or factual "content," but as *itself a form of rhythmic–musical performance on a level with these poems and songs.* Through the intrinsically participatory dimension of sound (what Jean-Luc Nancy in his work on listening refers to as "methexis"), these videos thus inherit the particular vocation of music and poetry to transgress and overflow the boundaries

that might all too easily come to separate performer from audience and to draw the audience members, whether offline or online, into participating in the performance itself—that is, in the revolution.[14]

Call and Response

In their 2005 essay, "A Medium of Others: Rhythmic Soundscapes as Critical Utopias," Phil Weinrobe and Naeem Inayatullah consider seven features through which African music can be seen to constitute "a deep politics through its form."[15] Six of these features they take from the work of the musicologist Olly Wilson: call and response structures; a heterogeneous sound ideal; rhythmic tension; a percussive mode of playing all instruments, including the voice; a high density of musical events; and integration of listener response, including physically through dancing. The seventh feature that they consider, restraint, is taken from the work of John Miller Chernoff, and they find it most notably figured as the demonstration of virtuosity through doing *less* rather than more.

Taken collectively, these seven features can be interpreted as the nondiscursive formulation of "deep everyday criticisms of modernity," which Weinrobe and Inayatullah sketch out in these terms:

> Thus, call and response structures suggest dialogical and conversational orientations as opposed to monological methods of communication; a heterogeneous sound ideal can be thought of as a bow to the "plurality of timbres" or a "democracy of differences" that oppose homogeneity; rhythmic tension suggests an expectation of, and a comfort with, social tension that opposes the norm of a unified harmony; a percussive mode of playing calls for dance thereby emphasizing that physical activity serve as the basis for forming a type of community that goes beyond cultivating a sedentary audience; and a high density of musical events may be seen as the result of a desire to include others and otherness.[16]

Restraint, meanwhile, serves to create

a sonic structure that, relative to other sensibilities, is more generous and mutually supporting, one that is relatively free of a monocular vision, and that is constituted by a collective sensibility in which each individual thread is both necessary and evident.[17]

The result is not a single prescriptive model for an ideal politics, but a wide range of creative and unforeseeable soundscapes that serve as living illustrations, quasi-experiments, and critical utopias on how to relate to others in the wider drama of life.[18]

Weinrobe and Inayatullah base their discussion of the politics of form specifically on the work of three Nigerian musicians (Stephen Osadebe, Fela Kuti, and Sunny Adé), and they propose a general contrast with "Western music" (both classical and pop), while insisting that their "African music" is a "changing same," in the spirit of Paul Gilroy's "anti-anti-essentialism." They also acknowledge that all seven of these features can be found, singly at least, in Western music, and they provide a list of examples to underscore this point, ranging from Billy Bragg to John Zorn. Their case rests, then, on the meaningful convergence of several different but related formal features in specific situated practices, rather than on some universal meaning that might inhere in a particular form considered in and of itself.

Each of these formal features can of course exist in a wide range of different implementations, which may carry different inflections of meaning. Take for example call and response structures, of which Weinrobe and Inayatullah write:

Call and response expressions rest on a continuum that ranges from an "echo" at one end and a more dynamic conversational answer to the calling phrase at the other end. The echo is a repetitive response, so that if I say "good morning" I can expect my listener to respond with "good morning." The "conversational response" expression of the call and response continuum, at the other end, goes beyond echo by providing a more deliberate and articulate reaction. Such an answer might provoke a different

call with a still more elaborate response in the next repetition, and so on.[19]

Call and response structures, then, vary from direct repetition of a simple phrase, to engagement in complex conversational elaborations of a single initial "argument," whether composed in advance or improvised on the basis of a broadly shared repertoire. The purely *musical* structures thus created interact with, and are reflected in, the larger *dramatic* structures that determine the integration or exclusion of the audience in the performance, by soliciting or discouraging various forms of listener response. All these responses, if permitted, will in one way or another turn the "passive" listener into an active and embodied participant in the music itself, whether on the same terms as the designated performers (that is, as a dancer or singer in her own right) or in a more specific and more discreet register (as in the more-or-less vocalized expressions of *tarab* or *saltana* that characterize the audience's ecstatic response to skilled performance in certain forms of Arabic music).[20] Indeed, it might make more sense to distinguish musical forms (and their politics) not according to the presence or absence of call and response structures, but rather by the degree to which those structures are deliberately used to engage the explicit (and explicitly physical) participation of the audience in the making of musical meaning.

Such a scale might start, at one extreme, with the purely internal (musical) figure to which the audience's response is expected to be equally internalized—as in, for example, the question-and-answer phrasing of themes in a Haydn symphony, to which the audience's affective and kinesthetic responses, while real, are largely invisible (though none the less keenly felt by performers and other listeners alike). At the other end of this scale would lie a variety of overtly dramatic practices which deliberately puncture and dissolve the boundary between performer and audience in order to elicit a demonstratively performative physical response from the *listeners*, without which the musical performance itself would simply cease to be meaningful. The Sufi *dhikr* ritual discussed in the Introduction to this book is

one obvious example of such a practice in which the music exists not to be listened to in stillness and in silence, but only in order to solicit an embodied and vocal reaction from the audience, who are thus *incorporated*, physically and rhythmically, as active and indispensable participants in the performance itself. Another relevant example would be "the traditional practice of [the audience] inviting the reciter to repeat and elaborate the tone of the line" during Qur'anic recitation.[21]

My choice of call and response as an example is no accident. On the one hand, such structures are omnipresent in the songs and poetry of the Arab revolutions and thus in the vernacular anarchive.[22] In this they draw on countless local traditions of antiphonal music-making, which survive today not only in sublimated forms, such as the conventions of ecstatic listening that surround the *tarab* genre, but also in more directly dramatic incarnations, such as the traditions of poetic dueling that remain a staple of vernacular celebrations across the region, from the Palestinian wedding poetry studied by Nadia Yaqub to the popular "flyting" rituals that figure so largely in the wonderful first installment of Emmanuelle Demoris's five-part documentary *Mafrouza* (2007–10) set in an informal neighborhood of Alexandria.[23]

On the other hand, antiphonal structures have in recent years formed the subject of one very well-known political analysis of cultural forms from within postcolonial studies—that advanced by Paul Gilroy in his writings on the music of the Black Atlantic. For Gilroy, antiphony is in fact definitive of the cultural and political forms created by the Black Atlantic, and he describes its import in these terms:

> there is a democratic, communitarian moment enshrined in the practice of antiphony which symbolises and anticipates (but does not guarantee) new, non-dominating social relationships. Lines between self and other are blurred and special forms of pleasure are created as a result of the meetings and conversations that are established between one fractured, incomplete, and unfinished racial self and

others. Antiphony is the structure that hosts these essential encounters.[24]

Gilroy's allusion to an "ethic of antiphony" is tantalizingly abrupt, the more so since call and response structures are both highly various and widely distributed not only throughout, but also *beyond* the Black Atlantic.[25]

Thus, for example, Ali Jihad Racy has argued that in the Egyptian *takht* ensemble,

> musical texture articulates different social positions: antiphony between performers signifies social compatibility, heterophony among performers signifies social reciprocity, and monophony by performers signifies social hierarchy. [Thus] different musical textures enable distinctive social strategies, allowing for individual agency (through improvisation) within a highly structured performance tradition.[26]

While Racy's discussion of antiphony in *takht* performances is broadly compatible with Gilroy's interpretation of similar structures in hip-hop or Gospel, my point here is not to argue that *because* Arab musical structures share the same predilection for call and response structures as the African diaspora musics considered by Gilroy, they *must* therefore prefigure the same kind of political utopias that Gilroy finds in them (which would also raise the vexed, and doubtless insoluble, question of the influence of Arabic and Islamic musical practices on those of sub-Saharan Africa and the Black Atlantic—and vice versa). Rather, I invoke these examples and precursors in order to provide a sense of the range of both the musical and the political possibilities encompassed by the term "call and response," the better to locate within that range some of the specific practices we may encounter in the vernacular video anarchive, and to begin to think through those examples *not only as musical structures but also as structures of online video itself.*

At Maspero

On the evening of October 9, 2012, I joined a march that was descending Cairo's Al-Galaa Street toward the Nile Corniche, to commemorate the first anniversary of the Maspero massacre. Our purpose was to honor the memory of the twenty-eight people who had been murdered exactly one year earlier by the Egyptian army and police as they demonstrated peacefully outside the State TV and Radio building against the demolition of a Coptic church in Upper Egypt.[27]

As we passed the Nile Hilton, I was greeted by an old friend from my days as a journalist at *Al-Ahram Weekly* in the late 1990s. "It's good you're here today," L. told me. "This is the first time in a long while that I feel like we have the old Tahrir atmosphere back."

Half an hour later, the procession drew to a halt outside the Maspero building. Instead of stasis, a type of Brownian motion immediately kicked in, the crowd forming and reforming into ever less linear patterns, like the fragmentary concatenations thrown up by a kaleidoscope. The flowing energy of the march was reconfigured as multiple proximate pockets of activity—circles gathered around one or another person, who would cup his hand to his mouth as he led the others in a chant. (And though it was mostly, but not always, a man who led the chanting, women were also everywhere—including riding high on the shoulders of compliant young men so as to get a better view of the proceedings as they filmed them.)

Some of the callers mounted on others' shoulders, others simply stood at the center of the circle. All began to work their words off the people immediately around them. By chance, the circle nearest to me was at that moment being led by K., an activist whom I'd met for the first time at a mutual friend's house a few days earlier. Spotting me again in the crowd at Maspero, K. grinned and walked over to hug me and exchange greetings. Then he plunged back into the circle and launched into a rising crescendo of insults and provocations against both the Supreme Council of the Armed Forces and the Muslim Brotherhood, as

the people gathered around him followed both lines of attack with enormous relish.

In the hour I spent that night floating around in the crowd outside the TV building, I began to realize a number of things of which I had only had the vaguest intimations from watching such events as they are filmed on YouTube. Above all, I saw some of what is "edited out" by the usually limited duration of the clips people upload: the way in which each circle of chants self-organizes, so that one person will lead the chant for several minutes and then give way to another, who takes over, only to be replaced in turn by a third, and then a fourth, the whole process mediated by a repertoire of glances and hand signals to ensure smooth transitions and fairness in taking turns.[28] And how each circle is only one among many that may be unfolding simultaneously within a relatively limited space, and yet all those different circles coexist quite happily, each with its own style, its own emphasis, its own internal dynamics, its own peculiar audience, and largely untouched by the other circles around it, which nevertheless work with it to support and structure the crowd.

No sooner had I realized this (and the importance of realizing this) than the battery of my camera, which had been with me (and chargerless) since the morning, ran out. When I went to look at YouTube the next day, there were many videos that had been posted from the demonstration, but few that illustrated the way in which the circles formed and engaged in the kind of "leaderful" distributed self-organization I have just described. And there were none that showed how, if you walked through the crowd, you would pass by first one circle, then another, then another, whose mutual copresence seemed judged to create just the right amount of cross-rhythm between the different chants, the right degree of "sonic heterogeneity" (to borrow Olly Wilson's term) so that this interference would be audible as dissonance—so that the presence of the other circles would be felt—yet without creating a level of conflict and distraction that might prove overwhelming for their neighbors.

Integrating this kind of polyrhythmic, polycentric soundscape must be much easier for Egyptians who are used to attending

the *mulid*, for that is exactly how such festivals are described by Anna Madoeuf:

> The noise and intensity of the festival varies by the day (increasing towards the last day of the festival period), hour (peaking around 11 P.M. or midnight), and by location within the sprawling space. The mulid is an auditory as well as luminary roller coaster: The crack of toy-rifle fire aiming for prizes, the squeak of swing-sets being carted in, the clash of cymbals and drums accompanying merry-go-rounds, the calls of merchants competing for customers, the sounds of whistles from bands of children, the cry of battling marionettes in shows, the steady chant of Quran recitations, and the bouncing lyrics of popular secular music, all mingle together with the rhythmic chanting of the Sufi dhikrs that flow from the tents and loudspeakers. One also hears the sound of swarms of mini pick-up trucks invading the quarter, loaded with material for setting up the tents, with carpets and chairs, generators, electric installations, sound equipment, as well as those necessary effects of daily life (food, table and bed coverings, kitchen utensils, etc.). The raising of tents, placement of equipment, and set-up of the fairgrounds lasts several days. The quarters hosting the mulids seem to almost disassociate themselves from the city and become a busy world unto themselves while settling into the rhythm of the festival.[29]

The result is a constant competition for the participant's attention, which requires in return special capacities both for distraction and absorption in order to be enjoyed to the full:

> People walk, but others sit or lie down; some talk, sleep, eat, and drink; others laugh, watch, or do nothing; but all are there together, tied to the mulid world-making process of the city. How can one be connected to one scene or to one action, and then disconnect from it in order to involve oneself in another story that is unfolding in parallel? Simply by turning from one place, either by looking elsewhere or by leaving it physically. In this way, many levels of integration are combined in one or many scenes,

simultaneously or not, from exclusive to disparate, from subjugation to indifference, from intense to the dilettante experience.[30]

The Maspero anniversary demonstration thus reproduced, on a smaller scale and with a reduction in the possible sources of heterogeneity, the *mulid* spatiality, "full of possibilities, interpretations, and multiple microterritorializations."[31] And the constant forming and reforming of the chanting circles seems, in retrospect, as if designed to enact the kind of distributed network that Rodrigo Nunes has described as "diffuse vanguardism":

> Leadership occurs as an event in those situations in which some initiatives manage to momentarily focus and structure collective action around a goal, a place or a kind of action. They may take several forms, at different scales and in different layers, from more to less "spontaneous." This could be a crowd at a protest suddenly following a handful of people in a change of direction, a small group's decision to camp attracting thousands of others, a newly created website attracting a lot of traffic and corporate media attention, and so forth. The most important characteristic of distributed leadership is precisely that these can, in principle, come from anywhere: not just anyone (a boost, no doubt, to activists' egalitarian sensibilities) but literally anywhere.[32]

At the micro-level, the forms of organization that I saw that night (but was myself unable to film) are well-illustrated by one specific online video from the Maspero 2012 demonstration.[33] Here we see how as soon as the more "formal" speeches end at around 7:00 p.m., a circle immediately forms in the crowd, and over the next four minutes, a succession of men—from youths in tee-shirts to a middle-aged man in suit and tie—take turns to lead the chanting. Not only do they pick up the rhythms of their predecessors, but they also ring changes on them, and in this way steer the whole process by varying its rhythmic and emotional intensity, until finally they move off from in front of the cameraperson, taking with them the knot of crowd that has formed around them.

The *mulid*, then, as it is reenacted by the post–January 25 demonstrations in Egypt, is not just a religious or vernacular *topos*. It is essentially a set of related and overlapping yet fundamentally heterophonous practices that generates its own complex network of rhythms and counterrhythms, its own particular spatial and temporal palimpsest of calls and responses.

There Is Only "Us"

Following my participation in the Maspero memorial demonstration, I spent part of the next day searching online to see what others had recorded and uploaded of the event. It soon became apparent that what for me had been the most striking feature of the chanting I had witnessed—the way that it was distributed within the different circles *as well as* between them—was *not* what had caught the attention of the vast majority of those who had filmed and uploaded their videos of these chants. Nor, for that matter, was it the first thing I had chosen to film myself, before my battery ran out.[34]

I take this to mean, not that the filmers are not aware of this dimension of the chanting, but that they take it for granted—that they do not feel the need to document it so as to demonstrate it explicitly. They film, not to map *from the outside* how these chants as a whole are distributed through some preexisting space, but to focus in on one particular moment in them, and to experience it from within, as though they were closely absorbed by that particular chant to the temporary exclusion of all others. This positioning and focus speak to a sense of filming as a form of immediate, bodily participation. To borrow a phrase from the Invisible Committee, these filmers are involved in and with these practices as something held in common, where "the communist gesture is to approach things and beings *from within*, to apprehend them *from the middle*."[35]

The result is that the chants are never filmed at the molar level of their distribution through space and time across the whole of the space occupied by the crowd at that particular moment, but

always at the molecular level. Each individual chant is filmed as if it were a whole unto itself, rather than only one tiny fragment within a much vaster soundscape. When these videos are then uploaded to YouTube or elsewhere, the complex and hetero-phonous nature of the demonstration as a whole *is* translated into the new online medium. But it is present there, not *within* one specific video, but rather as *the texture and density of the complex video assemblages that are thus generated across the YouTube platform.* As a result, the provisional online assem-blages of videos around an event, such as that which briefly emerged in the wake of October 9, 2012, may be seen to function in a way *analogous to the demonstration itself.* It is the YouTube interface itself which, for as long as it is actively occupied by the revolutionaries, produces concatenations and proximities of rhythms which exist only as the provisional disposition within online "space" of the videos posted, with all their individual contingencies and intensities. After the demonstrators have dis-persed from the street, YouTube thus becomes a space in which the *mulid* can continue. But its continuance there is also highly ephemeral, even if it can be called back repeatedly by a suffi-ciently persistent viewer. The *mulid* of the revolution, even when it moves online, remains a *performance*, and one in which not every aspect is simply and freely *chosen.*[36]

The result is a pattern of *call and response* that traverses both individual videos *and the vernacular anarchive as a whole.* And it is the collective resonance that forms not only in these videos, but also (and above all) *between* them, that gives the anarchive itself a structure which is both more complex and more concrete than would be implied by simpler translations of online circula-tion through the metaphor of the "network."[37] To watch these videos—two, three, twenty, or any number of them—is to hear chants call to chants, gestures call to gestures, and bodies call to bodies, both *within* individual videos and *across* the spaces that separate them one from another. The provisional rhythmic topology created by such intense waves of activity would thus seem able temporarily, but decisively, to overcome the funda-mentally "aimless structure" of the online database that critics

such as Alexandra Juhasz have decried, creating instead a set of connections that are profoundly ethical *and* political.[38]

Of course, online "space" is neither "space" in the High Modern sense (a neutral featureless container) nor the kind of vernacular spatiality considered in chapter 7; rather, it is a representational effect produced by the "calling" of the databases that lie behind it. That is, it exists only as a performance of the database.[39] As Molly Sauter has pointed out, within the multiple metaphorical spatializations through which we apprehend the network, there is nothing today that really corresponds to "public space" as it is generally understood: as she succinctly puts it, "there is no 'street' on the Internet."[40] After all, the Internet began life as a "pseudopublic academic intra-net," and its evolution since is more properly construed as the "privatization of a perceived commons" rather than of an actual one. The result is that (as Ethan Zuckerman puts it) "there is no public space on our contemporary internet, only complex, nested chains of private spaces."[41]

Nevertheless, computing technology, and with it the Internet, is inconceivable in anything like its current form without the metaphors of spatialization that enable us—not only users like you and me, but also the people who design and engineer all the layers of both hardware and software on which it runs—to apprehend it, imagine it, manipulate it, and produce it. Computer culture "spatialize[s] all representations and experiences," including our experiences of the computer itself.[42] Likewise, Sauter has repeatedly pointed out how online activism depends upon the repertoire of physical actions built up by offline activism in order to understand just exactly what it is doing. Since the electro-hippies and the Electronic Disturbance Theater, it is analogies with physical, spatial actions (sit-ins, occupations, blockades, pirate raids, picket lines, even cattle-rustling) that allow activists to formulate what it is they intend to do online and how they can go about achieving it. Spatiality is written so deeply into our repertoires of electronic agency that it may be impossible to disembed it without in the process rendering ourselves powerless. And while the dominant language

of the commercial Internet may tend toward the High Modern vision of a single controllable, policeable space, where the only imbalances of access and power are those that favor the owners, actual practices include some that are sufficiently immediate, relational, and opaque to suggest a more complex topology that can also generate more vernacular configurations.[43]

The question then is how the mass uploading of vernacular videos by revolutionaries—both those that record and transmit the rhythms of their songs and chants, and those that convey less explicitly rhythmical events—reinvents, albeit only temporarily, the *structure* of online space. I would suggest that it does so not by offering an overarching geography that might render that space legible and controllable from some Archimedean point, but rather by producing a vernacular micropolitics that starts from the bottom up and spreads not through design or conscious intention, but through resonance. The result is what Mohammed Bamyeh has called a "space of anarchy," Hakim Bey a "temporary autonomous zone," and James Scott "non-State space"—the unfolding of a spatiality that presents itself not as rational, objective, abstract, and Cartesian, but on the contrary, as intrinsically embodied, performative, affective, polycentric, and experiential.[44] Like the *mulid*, it is a "rhythmic reordering ... superimposed on a preexisting space, while absorbing it and partially blurring it." Through an act of "active imaginary reterritorialization," it creates a topology that is "ephemeral and explicitly counter-realistic" and that teems with "potential inversions, solidarities, and subversions."[45]

In creating this resonant structure, the call and response forms that I have documented in this chapter can be seen to play a crucial role, by instilling an embodied ethic of solidarity based on dialogical engagement with multiple others and by insisting on an egalitarian, voluntary, reflexive, and always revocable, distribution of voice. When we try to view this structure synoptically, it appears then as a discontinuous and fragmented manifold that relies on the invocation of a larger collective imaginary to provide a sense of cohesion (a spatial analog of the disrupted and disruptive temporal structure of the revolutionary

memoir discussed by El-Desouky).[46] By their refusal to explicitly represent the space (and time) of the revolution as a coherent and intelligibly navigable whole, the concatenations of video that emerge on YouTube (and elsewhere on the Internet) invoke even more intensely a background of shared memories and shared experiences as the necessary condition of their own fragmentary aesthetic. In this way, the viewer is led to invest even more intensely, at all levels—affective, embodied, ethical, and political—in the field of resonant subjectivity that is thus staked out. The fact that not every video answers every other video directly does *not* undermine the collective orientation to dialogical provocation—the invitation to us to view each new video *as if* it were both a *response* to an earlier video and a *call* to the viewer to go out and make her own video (that is, to enact and film her own revolutionary action) in order to answer it.

This provocation is directly visible in certain videos, such as Asmaa Mahfouz's first vlog (discussed in chapter 7). And it is present too in those responses to them that leave traces in other media, including writing (see the Facebook comment thread on the Libyan video discussed in chapter 8). But it is above all everywhere implicit in the intensity with which these videos collectively inhabit the embodied and haptic dimensions of the audiovisual, as I have argued throughout chapters 1 to 5.[47] The dynamic that the filmer's body imprints upon these images is thus above all an invitation to the viewer to *respond* to others—both the others in the film and the others who are, like her, its audience—so that in this way all those involved will find themselves caught up in the circulation of revolutionary energy and thus inspired to act beyond what they commonly believe themselves to be capable of. This mimetic relationship of call and response, which song and poetry formalize but which is present to varying degrees and in various forms throughout the continuum of human action and expression, is rooted in those "preparatory bodily attitudes" and "incipient movement responses" that underwrite the kinesthetic and affective empathy exemplified by the narrator of Idris's story "The Chair Carrier" (discussed in chapter 8).[48] But it also embodies

the broadly distributed capacity to go beyond mere empathy and open oneself to this energy that, in circulating, defines the people as not just a "they" but *also* a "we."

For we cannot watch these videos as an isolated, individuated "I." We enter into them by consenting to a form of perception that exists *only* in the first-person plural. The fact that the people are more felt than seen throughout the vernacular anarchive, that they register more as an intimate presence whose vibrations are recorded by the cameraphone "directly," without being brought to optical representation, mean that for the viewer, the experience of watching these videos is the experience that we, too, in watching them and responding to them, *become the people.* And the fact that the people are never simply visible *as* the people but are always "missing" as well as "not missing," have always to be *searched for* as well as being intuited and felt, means that our response to this call is not simply a mechanical reflex, but is always a conscious (if not an entirely rational) choice (see chapter 4).

The result is an experience not of individual videos, but (in Andreas Treske's phrase) of a whole "sphere" of online video.[49] Such spheres exist, not as empirical series of discrete video-elements, but as collective spatial topologies that are irreducible not only to their underlying database mechanics, but also to any straightforwardly Cartesian geometry. In this way, they position us not as rational individuals, driven by personal interests and goals, but as fully embodied and connected human beings, subject to ecstasies and doubts, to intuitions and transformations, and to ineliminable obscurities.

Together, the videos in the vernacular anarchive reveal the existence, somewhere both within and beyond the Internet, of multiple "zones of offensive opacity" (to adopt the term proposed by the French collective Tiqqun). And these zones are perhaps, in the final analysis, nothing other than ourselves:

There is an opacity inherent to the contact of bodies. Which is not compatible with the imperial reign of a light that shines on things only to disintegrate them.

Offensive Opacity Zones are not to be created. They are already there, in all the relations in which a true communication occurs between bodies. All we must do is accept that we are part of this opacity. And provide ourselves with the means to extend it, to defend it.[50]

In these videos, by assuming the primacy of its own formal-sensory possibilities, video becomes one of the means by which such zones can be defended and extended. It is through such assemblages—of videos, but not only of videos—that the distributions of knowledge and of ignorance, of perception and of blindness, of distance and of intimacy, which support the political regimes these revolutions have sought to bring down (and in which we may perhaps recognize the lineaments of a larger political dispensation, whose measureless ambition seeks to imprison and reduce life everywhere) can be temporarily rendered inoperative, so that new relations may emerge among the "people"—that is, between the numberless singularities that compose and traverse an "us." Because it is in such moments that we realize that "There is no social heaven above our heads, there is only us and the whole set of concrete bonds, friendships, enmities, proximities and distances that we experience. There is only us ... "[51]

The Last Broadcast

<div style="text-align: right;">10</div>

No one is gonna believe what they're gonna see right now on this channel.

It's just crazy ...

<div style="text-align: right;">Benghazi, Libya, March 19, 2011</div>

Still frame from video posted to YouTube by LLWProductions, March 20, 2011. To view, and for more information, go to vimeo.com/channels/thepeoplearenot, video 10.

TRANSCRIPT

(The transcript is based on original English dialogue.)

SPEAKER

... on top of us, yeah I know ... I know, I heard this.

Hello hello? Check check check.

Check check check hello?

If you can hear me, hello.

He is bombing Benghazi, no doubt. I have seen it myself, with my own eyes. Right now I was in an area called Hayet Doular. Doular area. And he has bombed it. He has bombed it, although that area, has no, nothing ... not even a camp, nothing.

Exhales loudly.
I can't talk much, I'm waiting for the battery to charge, and then I'm going to go live with you.

I mean, this is just not good any more. He has to be, he has to be stopped. I mean, I, I, I just ... I just don't know ...

Sighs. Speaks in Arabic:
Hagibli maya.

Leans over.
Give me some water.

He takes the bottle and drinks. We hear him swallow.
Okay, I have the video here, I'm preparing everything.

I'm just gonna connect it. Once the battery charges a little, I'm going to download it from the camera, and stream it to you live on the channel. I mean I don't believe that this is happening. Seriously, I don't believe this is happening.

I'm preparing it right now. Just give me some seconds for the camera, for the battery, to charge in, because the video was too long, I don't want to switch on—to switch off at all.

Pants as he leans forward.
Oh my God!

The planes, they said it's with us, I don't know, I'm not sure about anything any more. I just can't be sure about anything.

Silence.
Give me some water please.

Pause.
Where is Al Jazeera? Why they are not talking any … ? Where is the media? They should be there right now, taking videos of what's happening …

Pause.
The bombing hasn't stopped. The bombing is still happening.

Silence. Woman's voice faint, off. He looks up to his right, then back down to the screen.

More silence.

Sniffs. Tapping (?) noises.

Sniffs again, and swallows.
I'm sorry I, I, I can't talk, I really, you will see it all in the video. I mean, it was crazy. And it was just, you know, out of order. And people there were just all over the place, you know. They were looking, but they were in shock. They couldn't, they couldn't believe what was happening, I mean, it was just, you know, out …

Breaks off, sighs.
Okay. Okay, I'm going to try to get the battery in there. Try to get it, yeah, just try to do it as fast … Just try to download it as fast as I can, with the camera. I hope it's gonna work, because it can't, it can't—charge that much.

Pause: tapping/camera manipulation noises?

Taps on keys, hum is interrupted by this.

Windows jingle.

Okay, it's started. Let me just download it as fast as I can, okay?

Sniffs.

Hardware mounted noise.
Okay, come on, come on, come on.

Taps.
Yeah.

Silence—taps, sniffs.
Okay.

Silence.
Okay, it's downloading.

I hope to get it before it dies.

Big sniff, presses fingers to forehead.

Taps.
No one is gonna believe what they're gonna see right now on this channel. It's just crazy, I don't know what has bombed that place.

Crosses hands in front of camera.
But the missiles I have seen ... and, and and ...

I'm sorry, I can't talk, I can't talk, I can't I can't talk, I can't I don't know what to say. I can show you the missiles first. We have the images. Yes, I have the images here.

Pause.
Okay, I will play the images for you of the missiles.

Pause.
And—I'm gonna have to hang up, I'm gonna put the ... the the the ...

Tape cuts abruptly.

I'm Gonna Have to Hang Up

A man breaks off a conversation to turn toward the camera. As he leans closer, his eyes come into view. Yet these are not eyes in which we might recognize ourselves: they are empty orbits, two rough smudges of blackness. And even when I say "a man," some latitude of approximation is implied.

From the very beginning, the surface of the image is recalcitrant to our reading. No sooner does a figure emerge than the pixels that make it up regroup, block, and bleed. The face, that we know should be the center of our attention, oscillates between expressionism and abstraction. The skin tones stretch into ever more garish shades, while the body underneath recedes into the darkness of its sweater—as if the man who is speaking to us, moved by a paroxysm of patriotism, were trying to merge with the flag that hangs behind him on the wall.[1]

While his figure seems poised on the verge of some definitive withdrawal, his voice reaches us clearly, not only across distance and time, but also across all the generations of sampling and compression that separate us, wherever and whenever we may be, from him. Not that the soundtrack is without its own imperfections, of which the most obvious is the near-constant low-frequency hum that serves as a sort of drone, musically binding the whole sequence together. And his voice, too, is insistently incarnate. Its silences are not silences, for they are repeatedly interrupted by a body that is panting for breath, sniffing as if to hold back a head cold, calling for water, sighing or swallowing. Here, the oral largely exceeds the vocal—to such an extent that, by the end of the shot, I find myself hearing the machine hum not so much as a mechanical intrusion on some desired transparency, as just another symptom of the too-great proximity of *this* body.[2]

So then I try to reconstruct what has happened. This man has run in from somewhere. He is obviously still in some kind of shock, both physical and emotional. In a camera (which I do not see) he claims to have some images, both video and still images, that he wants to show me.

Everything that unfolds before (and with) his webcam is about wanting to show me those images, about wanting me to see them. And at the end, it is the person who wanted to show them to me, who wanted me to want them, and who has succeeded in transmitting this desire to me who will definitively frustrate me of its object.

So I am promised images that I am told I will not believe even if I *do* see them and which I never get to see. I am promised them by a man who is out of breath, who has no words, and sometimes, for long stretches, no voice even, with which to describe them. I am promised something that cannot be described, that cannot be believed, and that will *not*, in the end, be made visible. And instead, I am made party for more than five minutes to the long, arduous, complicated, ultimately unsuccessful and only intermittently intelligible process of trying to extract those images from the camera and put them into the computer.

This video, then, proposes a kind of paradox. If the images are inside the camera—the one that has been brought back from outside—then they must be *real*. Indeed, we have the testimony of the cameraman to reinforce that of the camera. As he tells us: "He is bombing Benghazi, no doubt. I have seen it myself, with my own eyes."

And the camera was, in turn, with him, in order to bear witness to his witnessing.

If the images, on the other hand, were to get into the computer —if the battery could be charged in time, if the camera would "last" long enough, if they could finally be "downloaded"— then we could see them. But there would also be the risk that they would not, then, be quite so real to us. They would lose something of their reality in being made visible. They would be, as we are repeatedly told they are, unbelievable. And the bond of trust between viewer and filmer, that everything in this video both assumes and leads toward, would be broken at the very moment it is consummated.

The testimony of the camera, then, its power to vindicate the truth, lies less in the images that it can show us than in these images that remain enclosed inside it. Just as the conviction

that the cameraman's words carry is reinforced by his inability to find the "words" for what he has seen. Just as the images he himself has seen with his own eyes remain forever trapped inside him. The force of veridiction that resides in the camera, then, lies less in the images it makes than in its refusal to share them with us. And the more adamant that refusal is, the greater the truth. So that the ultimate proof that the atrocities that the whole of this video desperately points toward *did* in fact take place is that we will never see them. The ultimate proof is that there is no proof that can be shared. Their resistance to representation becomes, for us, the guarantor that these were, in fact, singular events, events in which one or more than one particular lives hung in the balance, in which people died, or risked death, not as images, but as real bodies made of flesh and blood. For the death that can be represented is only a generic death, an idea of mortality, an element in a scenario, and not the absolute and irreversible interruption of the present that will one day really happen to me as it will to you.[3]

This video, then, promises us images of devastation, destruction, horror. And instead, all we get to see is a man sitting in a room in front of his laptop, trying to get it to do something for him and failing. We see him struggle with the physical signs of exhaustion, thirst, confusion, shock, and recalcitrant technology. We hear his body fighting with lack of breath, with mucus and congestion, and with uncooperative equipment. And we also see his own image struggling, in vain, to cohere in and through the webcam and its associated software.

Of course, as Laura Marks has argued in another context, there is a sense in which the less we can see in these images, the more physical, sensual reality we are inclined to lend them.[4] The less they speak to our eyes, and through them to our rational minds that seek to comprehend and control the world, the more they speak directly, viscerally, through their excess of proximity and their flagrant failures of control, to our bodies. Even as our interlocutor denies us the images he cannot describe to us, his own image and the sounds that orchestrate it take on an ever greater and more incontrovertible presence, until they come to

stand in for those other absent images. Not for the horror that they can never hope to emulate, nor for the transparency and referential clarity which we imagine we are denied, but for their immediate, preconceptual givenness, the specter of whose arbitrary cancellation is the ground of that horror's possibility.

The result is a kind of visual litotes, in which the more the cameraman insists that we have not yet seen the images he wants to show us, the more we get the feeling that the *real* horror, the real image that announces both his and our ineluctable mortality, is to be found not among the images that are trapped in his camera, but rather in those that lie there before us, pinned and struggling on our computer screens as we watch him go and come among the lacework of the indifferent pixels, until that final, fatal interruption: "I'm gonna have to hang up ..."

These Poor Images

> I have to go now. Please keep the channel moving, and keep the videos posting. And just—I will try if I have any news, I'll try to come and give you the news we have. Even tho that Mo—there isn't much to do ... I will try my best to keep this going.

On the morning of March 21, 2011, Eastern Standard Time, an anonymous American blogger who goes by the handle "LLWProductions" uploaded a portmanteau video to her YouTube channel under the title *Last broadcast from Mohammed Nabbous and Message from His Widow*. The montage is composed of two extended clips, each consisting of a single shot, grabbed from the live stream of Libya Alhurra TV over the previous forty-eight hours, preceded by a brief verbal explanation of the context and separated by a single second of black and silence.

The first clip is the one I have just described: a broadcast made on the morning of March 19 by Mohammed Nabbous, also known as Mo, the sole creator and driving force of this online TV and radio station. In this fragment, he is seeking to

provide video evidence that Mu'ammar Gaddafi's armed forces had just broken a ceasefire recently put in place in response to UN Security Council Resolution 1973.

The second clip consists of an awkwardly framed still image of an Arabesque-style living room, against which plays a radio broadcast made by Nabbous's widow Samra Naas (also known as Perditta) on March 20, shortly after his death. In the few words she is able to speak through her grief, hemmed in by extended sighs and difficult silences, Perditta announces Mo's death, recounts his wish to find death as a martyr, and implores viewers to "keep the channel going" by posting videos and doing whatever else they can to halt the bombing of Benghazi. Her message lasts almost four and a half minutes (only forty-five seconds less than Mo's), and her silences makes up by far the larger part of it, as her insistence on the vital need to sustain and continue Mo's work is constantly interrupted and undermined by the extremity of her own distress. This second clip is extremely difficult to "watch" in its raw exposure of an unbearable intimacy, and I will not offer any further comment on it here.

On the morning of March 20, Mohammed Nabbous was shot in the head by a sniper while reporting a firefight between rebels and the Libyan army. He died around 3 p.m. that afternoon in the hospital. (The audio report he was making as he was shot was also broadcast and can still be found on YouTube.)[5]

By reposting these videos, in this specific montage, so rapidly after Nabbous's death, LLWProductions responds, albeit obliquely, to Perditta's appeal to "keep posting videos." And in doing so, she transforms the meaning of the livestream that was broadcast two days before. By reframing it, not as a breaking report on a war raging just off camera, but as a retrospective homage to the journalist who made it, she shifts this video from the register of forensic reporting to that of funerary memorial. In the place of the evidence of a crime, we are presented with a memento mori.

As a result of this reframing, much of what might have seemed in the original livestream accidental or incompetent, failures of manipulation or judgment, or simply "noise" is endowed with a

greater resonance and a different meaning. Rather than unrelated elements in a banal catalog of arbitrary errors, each misstep is recast as a self-reflexive gesture, exhibiting and commenting on the aporia of media activism in particular and representation in general. Released from the overbearing present of the breaking news agenda, the technical intermittences and disconnections with which the amateur journalist struggled ineffectually are reconfigured as an extended proleptic allegory of the one brutal and definitive interruption that was about to be visited, against his will, upon his own life.

What makes the video of Nabbous's last broadcast so moving, then, is not so much what it was intended to say—the real struggle to communicate and to bear witness that it embodies—but rather the way that message has been extended and redirected through its afterlife in the YouTube ecosystem, thanks to which it now exists principally as part of a montage made by an anonymous woman blogger from the United States.[6] It is as if in repurposing this video fragment, LLWProductions had completed an act of interrupted semiosis, which Nabbous himself had only been able to begin.

It is therefore entirely apt that this reframing is achieved not simply by montage and by verbal context, but also by the (doubtless unintentional) introduction into this video fragment of another layer of opacity and obscurity. For it seems clear that the degraded quality of these images is not simply a further index of the technical difficulties with which Nabbous was confronted on that fateful day in March 2011. Rather, the truncation and pixelation that contribute so strongly to the video's emotional effect would appear to be largely, if not entirely, the result of the additional layers of lossy compression introduced when the original was grabbed, mashed up, and reuploaded. What moves us so strongly, then, as we watch Nabbous's face oscillate on the verge of disfiguration is not something about the images that were broadcast in real time from Benghazi, but rather something about the way in which they have been reflected and refracted back to us from the United States.[7]

So, for me at least, the meaning of this video as we now have it is inseparable from this act of retrospective collaboration between two amateur journalists who never had the chance to meet. In the course of reframing Nabbous's failed attempt to denounce a crime by the Gaddafi regime as both an homage to his memory and as her own denunciation of the crime that was his death, LLWProductions accidentally conferred on it an opacity that radically reroutes the questions we might ask of it.

In the place of the *document* that Nabbous was finally unable to show us, this video now functions as an index linking his mortality to ours, through the mortal body of the video itself.[8] In these "poor images" (to borrow Hito Steyerl's phrase), we see an alternative moral economy emerging, a relationship between indigenous revolutionaries and their international audience that goes beyond the one that Nabbous himself was calling for.[9] Such a relationship would be grounded not on more information, but on less; not on more certainty, but on more humility. It would demand not the impossible proof of war crimes, which always comes too late, but a direct, physical awareness of our shared vulnerability and mortality. And it would be based on the belief that it is by elaborating our own invisible alliances around that shared awareness, rather than through better compliance with the codes of high-resolution visibility promoted by the military-industrial-entertainment complex, that the protection of the most vulnerable can be most effectively addressed.

These last images of Mohammed Nabbous resemble nothing more than ourselves, if only in our fragility and our imperfection. And it is that fragility and that imperfection that call for the invention of new forms of reciprocity, new modes of grassroots internationalism, new modalities of peer-to-peer protection, beyond and without the current modes of power and governance which have so disserved us.

Though we see each other only through a chain of LCDs, and darkly, still let us hope that next time we may see each other before it is too late.

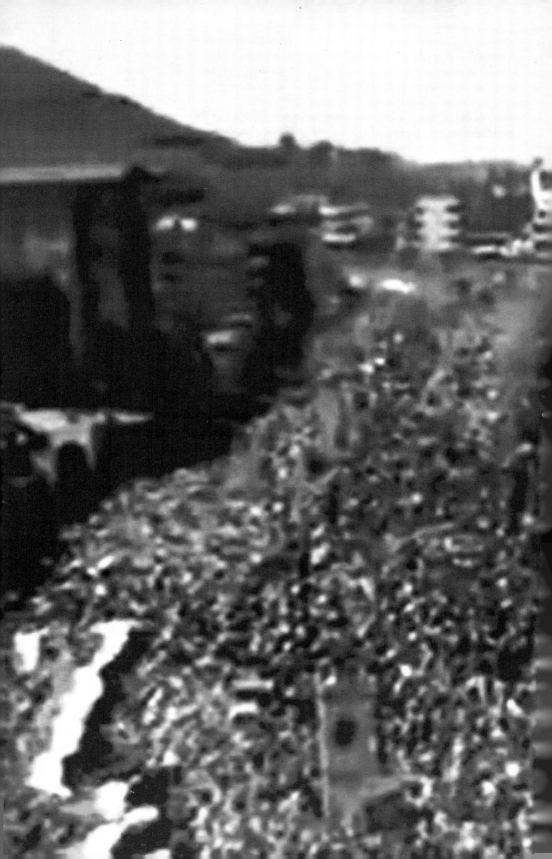

Conclusion

This Is Just the Beginning

In her essay "The Spam of the Earth: Withdrawal from Representation," Hito Steyerl muses on the countless electronic messages that leave our planet every second to wander through interstellar space, where they may eventually be picked up by alien intelligences. Wondering what picture of humanity these signals paint, she suggests that any attempt to reconstruct our species from them would probably end up looking like image spam.

Image spam is one of the many dark matters of the digital world; spam tries to avoid detection by filters by presenting its message as an image file. An inordinate amount of these images floats around the globe, desperately vying for human attention. They advertise pharmaceuticals, replica items, body enhancements, penny stocks and degrees. According to the pictures dispersed via

Still frame from video posted to YouTube by MrEthzxz, June 10, 2011. To view, and for more information, go to vimeo.com/channels/thepeoplearenot, video 11.

image spam, humanity consists of scantily dressed degree-holders with jolly smiles enhanced by orthodontic braces.[1]

The number of such images now circulating in deep space vastly exceeds the number of people currently alive on this planet.

Image spam is, of course, addressed to people who are and look nothing like those in the images it circulates, probably with the aim of inducing them to act—that is, to consume more, or some, of whatever the spam is selling, in the hope that they may thus come to resemble more closely these models. However, Steyerl is interested in the contrary hypothesis:

> What if actual people—the imperfect and nonhorny ones—were not excluded from spam advertisements because of their assumed deficiencies but had actually chosen to desert this kind of portrayal? What if image spam thus became a record of a widespread refusal, a withdrawal of people from representation?[2]

In a world in which mass media is now largely dedicated to the ridiculing of the lower classes, and social media and cell phone cameras have opened up a new regime of peer-to-peer surveillance, it would be only rational for the people to choose to vanish. Before, representation was seen as a scarcity and privilege. Now, it is felt, quite rightly, as an invasion and a threat.

> Thus image spam becomes an involuntary record of a subtle strike, a walkout of the people from photographic and moving-image representation. It is a document of an almost imperceptible exodus from a field of power relations that are too extreme to be survived without major reduction and downsizing. Rather than a document of domination, image spam is the people's monument of resistance to being represented *like this*. They are leaving the *given* frame of representation.[3]

Steyerl relates this self-absenting to the parallel crisis of political representation:

Visual representation matters, indeed, but not exactly in unison with other forms of representation. There is a serious imbalance between both. On the one hand, there is a huge number of images without referents; on the other, many people without representation. To phrase it more dramatically: A growing number of unmoored and floating images corresponds to a growing number of disenfranchised, invisible, or even disappeared and missing people.[4]

Image spam is not a representation of the people, because

in any case, the people are not a representation. They are an event, which might happen one day, or maybe later, in that sudden blink of an eye that is not covered by anything. And as people are increasingly makers of images—and not their objects or subjects—they are perhaps also increasingly aware that the people might happen by jointly making an image and not by being represented in one.[5]

In this book, I have tried to draw attention to some of the features of the videos in the vernacular anarchive of the Arab revolutions that correspond to, or ring variations on, Steyerl's thesis. In embarking on this project to document not themselves, but their revolutions, the people of the Arab countries concerned have produced a body of work in which they are no longer the object of others' representations, but the subjects wielding the camera. It is they who now determine the point of view and the frame. And in doing so, they have invented a paradoxical form of cinema in which they, as the people, are simultaneously deeply present, to the point that they can no longer be ignored, and yet remain largely *invisible*.

Of course, there are images that purport to show us the people in all their splendor and self-evidence. I am thinking of the top-shot images that give us a synoptic view of an avenue, a boulevard, or a square filled to bursting with a crowd that numbers in the hundreds of thousands, if not the millions. While perhaps the best known of the top-shots of Tahrir Square, which came to

serve as the mass media's shorthand for the Egyptian revolution in particular (and even for revolution in general) were made by professionals, there are also plenty of instances in which ordinary revolutionaries with access to a well-positioned balcony or an appropriate rooftop have made such images themselves and circulated them through YouTube and other online platforms.

However, the function of such images may not be as straightforward as it might appear. Do they really serve to demonstrate the *power* of the people, as might be assumed? Or are they not rather, to adopt a term proposed by Steyerl, *decoys* intended to distract and confuse those in the media or in government who might assume that *this* hackneyed image of the people as a unified and overwhelming mass is the only kind of power that the people want or can imagine? To put it differently: do these images *reveal* the people to us and demonstrate their power? Or do they function as another kind of *mask* behind which the reality of the people—and the true forms of their power—can disappear?

The invisibility of the people as I have tried to describe it in this book is a complex phenomenon, which includes a plurality of practices and is open to multiple interpretations. On the simplest level (chapters 1–5), the people are invisible because they are no longer in front of someone else's camera but behind their own cameras. Their presence, then, is produced largely by exchanging an optical visuality for a range of multisensorial registers extending from the tactile through the kinesthetic to the haptic. In these ways, we *feel* their presence, even when we no longer see it, through the least movement of the camera, and in particular through those movements that are nonintentional and that produce forms and figures that exist only on the far horizon of our perception. It is these videos which, more than all the other figures of the people that the vernacular anarchive offers, testify both to the *performative* character of the people and to the *impersonal force* that traverses both them and their actions. In these videos, the people have not merely left the image. They are *already* an event.

This event is the emergence of a "we"—a way of seeing and speaking that breaks with the manufactured and administered

individualism of modern (and postmodern) life and that returns us to our origins in our processual co-existence with the world and with one another. These videos embody and enact that "irreducible demand" that founds all revolutionary legitimacy: "that we can say 'we,' and that we can say 'we' of ourselves (say it of ourselves, and to each other), once there is no leader and no God to say it for us."[6] And this "we" is not simply enacted in the words that these videos record, but permeates them at the level of the embodied gesture. Already at this formal–sensory level, before and independent of any conscious or explicit discourse, they refuse any "outside" from which "we" could be totalized and administered, and they insist on this plurality as not the opposite, but the *condition* of possibility of *my* singularity.

This urgent, originary sense of plurality is confirmed by those figures that emerge when the people come out from behind their cameras and appear in front of them (chapters 6–10). Rather than letting themselves be summarized in a single image, or represented by a countable number of persons (as the visual rhetoric of the dominant media—including in their elite, "authored" variations—would tend to do), the people instead manifest as an open series of subjective positions that are perfectly visible, but whose very iteration implies the impossibility of ever totalizing them. This turning away from totalization releases practices and forms that defy the logic of representation even as they repurpose it and proliferate it, producing instead generative pluralities that are not so much leaderless as, in Rodrigo Nunes's felicitous term, "leaderful," and so resistant to all strategies of condensation and symbolization. When the people appear before us in their plural singularity, there is no one to say "we" for them, there is only themselves. And this is true not only of their actions away-from-keyboard and the ways in which they film them (chapters 6–7), but equally of the ways in which these videos circulate online (chapters 8–10) and the "zones of offensive opacity" which they reveal, not only within the texture of the offline everyday, but also within the interstices of the Internet itself.

The invisibility of the people is not simply a strategy, a with-drawal that has been effected provisionally and that may one day be rescinded. It is something integral to their nature and to the nature of every kind of embodied practice that is oriented toward the messiness and givenness of life, rather than toward that perfection that is simply the image of death under conditions of empire.[7] But in these videos, another knowledge of death appears or resurfaces (chapter 5): that which not only evidences the equality of all, but which also points to the persistence within all of us of that which is genuinely vernacular, thus irreducible to the death-in-life of governance, and therefore apt, at any moment and without warning, to reopen a space of possibility for other forms-of-life together, outside the parameters of what we rather too generously refer to as "civilization."

These videos are properly *vernacular*, both because they are produced without regard for commercial or institutional values, as "common property," and because they incorporate and enact the people's own ways of knowing, which are recalcitrant to the abstract administrative vision of the State. As such, they constitute one of the modes of reemergence into visibility of those older ways of knowing and doing that testify to the continuity of civil society as an arena of what Mohammed Bamyeh terms an "anarchist gnosis" and that provide the basis for a renewed sense of being-together grounded in an ethics and a politics of solidarity.

These videos are not an attempt to produce an *image*, however complex and subtle, of the people. They are part of the much wider attempt by the people to constitute themselves as the people: to enunciate, situate, and articulate not just the fact of their coming together, but its terms and its conditions, its possibilities and its obligations. And central to those terms is that the ongoing, indeed infinite, process of constitution of the people is also and above all its *destitution* as a unified subject that might aspire to take power, and thus perpetuate the cycle of self-alienation and oppression that lies at the heart of the regime of governmentality that structures the State. That is why the people that these images simultaneously conceal and reveal

to us exist only as the circulation that is established *between* one image and the next and between *these* images and the (equally) anonymous viewer to whom they are addressed.

The people, then, are present in these videos not as a single, unified, and persisting subject, but as a serial, plural, and provisional collectivity, in which each individual is constantly open to transformation, is constantly "becoming other." The result is not some totalitarian state of fusion (whether coerced or voluntary), but a shifting palimpsest of "critical utopias," an online/offline *mulid* in which these different blocs of space–time with their heterogeneous rhythms overlap, collide, and enter, more or less easily, into new forms of dialogue with one another.

The people are not an image. But these images enact a people that is at once beyond them and entirely contained (concealed) within them. These images are *not* the people. But they are one of the places in which the people can come to appearance, and thus come into being, for they are embodied and mortal, just like us. And that is why they are part—and only one part—of the process through which, in late 2010 and some large part of 2011, the Arab peoples discovered, to their own astonishment and ours, that they really did exist, after all.

In doing so, they did not simply leave "the given frame of representation," as Steyerl puts it: they broke that frame, thus allowing a different, less defined, more open type of space to emerge in its place, where new kinds of image and new kinds of political practice (whether representational or nonrepresentational) might take shape. What might such practices look like? As Tahar Chikhaoui has suggested, these videos may be less documents of the past, or actions in the present, than premonitions of what is still to come: they prefigure both another kind of politics and another kind of cinema.[8] But they do not seek to define that future. They simply seek to keep it open.

Today, when many of those revolutionaries and their sympathizers feel all too keenly the old frames of the past closing tightly around them again, these images can help remind us of what was once possible. For however remote such experiences may now seem, what was once possible remains always possible:

"For the people has no identity, and history has no end."[9] Or, as some young Tunisians sang in their joy on January 14, 2011:

> This is just the beginning
> The best is still to come.[10]

Acknowledgments

My first attempt to write about the videos of the vernacular anarchive of the Arab revolutions was a paper delivered at the Anarchist Studies Network Conference 2.0: Making Connections at Loughborough University in September 2012. This paper provided the basis for my article "The Revolution Will Be Uploaded: Vernacular Video and the Arab Spring," that appeared in *Culture Unbound* in 2014. Though I have since modified my thoughts on a number of points, large fragments of that text can still be found embedded at various points in the current book. I am grateful to my editors at the Cairo-based online newspaper *Mada Masr*, which published an adapted extract from this text on February 18, 2014, to mark the third anniversary of the Libyan uprising, and who helped me correct several errors of detail in the process.

Chapter 1 has its distant origins in a seminar I gave in March 2014 to the students in the MA program in Performance, Media and Politics at Aberystwyth University. The argument was first presented in something like its present form to the doctoral research seminar in the Media Study Department at SUNY Buffalo in February 2015, and was first published in Arabic in issue 3 (January 2018) of *Al-Maraya* (Cairo).

Chapter 4 started out as a paper on the afterlife of pan-Arabism in the Arab revolutions given at the Media, Communications and Cultural Studies Association annual conference in Bournemouth in January 2014 and has since been substantially remodeled in order to fit the somewhat different context in which it appears here.

Chapter 6 is based on a paper given at Visible Evidence XX in Stockholm in August 2013, as part of the panel "Thinking with a Camera in Revolutionary Times". In slightly modified form, this paper was also given to the Departmental Research Conference of the Television Film and Theatre Studies Department at Aberystwyth University in May 2014. A text that is largely similar to the chapter as presented here, though organized somewhat differently, appeared in spring 2016 as part of a special edition of *Visual Anthropology* on "Visual Revolutions in the Middle East."

Chapter 10 began life as a paper for the Film and Philosophy conference in Lisbon in May 2014 and was subsequently published in *Found Footage Magazine* in spring 2016.

My thanks to the editors of all these journals for their encouragement and assistance, and to their publishers for permission to reproduce my work here.

An earlier version of this book was presented as part of my submission for a doctorate in artistic research at the University of Hasselt in 2016, where my work was funded by a Limburg Sterk Merk fellowship. My colleagues at PXL Hogeschool (now MAD-PXL School of Arts) provided me with exactly the combination of freedom and structure that I needed at that point in my life. I am grateful not only to my doctoral committee and jury members for seeing me through the process, but also to my

very good friends in the indispensable "PhD Anonymous" peer-support group.

My work would not have developed as it did had I not had the good fortune to participate, at different times and in very different ways, in the Collectif Jeune Cinéma (Paris), the Etats-Généraux du Film Documentaire (Lussas), the Flaherty Film Seminar (Hamilton, NY), the Transregionale Forum EU-Middle East (Berlin/Cairo), and the Video Vortex Network (everywhere). The Department of Film and Television Studies at the University of Aberystwyth provided me with a wonderful home-away-from-home for one crucial semester. As is true for everyone who teaches, my most important teachers have been my students. Thanks to them, and to my colleagues at the University of the West of Scotland and Leiden University, for the conversations and companionship.

My thinking about these videos has been inseparable from my experience of editing many of them together into a film. I am grateful to my producers at Rien à voir (Brussels) and Third Films (Newcastle Upon Tyne) for their persistent creative and moral support in the face of an apparently disastrous absence of funding that threatened to last forever, and not simply till after we had started post-production. I would like to thank again here all my collaborators on *The Uprising*, and in particular the many friends who assisted me with research and translation, and whose English versions form the basis for the dialogue transcriptions included in the present volume.

The absence of names in these Acknowledgements, and at certain other places throughout this essay, deserves some explanation. I would have liked to honour here more directly those who carry the different lineages of thought and practice in which my work is embedded, and through which it has been able to flourish. In particular, I would have liked to name all the friends I have made over the last thirty years while living and working across the Arabic-speaking (and more-than-Arabic-speaking) world, including in those places within the space we call "Europe" that are a vital part of any larger pan-Arab archipelago. Their companionship has enriched my life immeasurably,

while their experience, their expertise, their seemingly insatiable appetite for political wrangling (and gossip), their warmth and their humanity, and their immense patience and tolerance, have helped me not only to understand what is at stake in the politics of the present, but also to better understand and accept myself.

However, many of those to whom I am the most indebted have expressed a desire to remain anonymous - in some cases out of unwarranted modesty, in others due to valid concerns for their own safety. In these circumstances, it seems wrong to lift up only those whose privileges, however contingent and/or provisional, make this page a safe space for them in a way it cannot be for others. So instead, I offer my thanks to you all without distinction, and under the cover of a larger anonymity. I hope that all of you who gave so generously of your time to read what I was writing and to talk with me, who invited me to speak to your communities, colleagues and students about these videos, and my own filmmaking, and who challenged me when you saw that I was running off the tracks, will recognize yourselves in these words, and will know that I know how much I owe you.

All the opinions which are nevertheless expressed in this book are, of course, my sole responsibility, as are any outstanding errors of fact.

There are a few people who were more materially involved in the production of this book whom I can and should name. I am thinking in particular of my editor Colin Beckett, who welcomed the project to Verso, and Duncan Ranslem, who saw it through production. Thanks to them for their unstinting support, and to Ida Audeh for her careful copyediting, which has made it look as though my grasp on English punctuation is much sounder than is actually the case.

Meanwhile, beyond and below all anonymity, Lune Riboni was my sister in research, Craig Baldwin and Jon Jost *I migliori fabbri*, Bruno Tracq my partner in crime, Karolina Majewska my partner *tout court*, and our families my family.

The last word (as it has so often been) is for Hani Shukrallah, who became my boss when I joined the staff of *Al-Ahram Weekly* in 1997, where he was then managing editor. Over the years that

followed, Hani was many things to me—mentor, comrade, and above all friend. More than anyone, he gave me the courage not only to think I could write, but to dare to think and write outside my own backyard. The Egyptian revolution gave him new life and energy; the reactionary regimes that followed provoked his anger and his acerbic wit, but did not help his health. He passed away far too soon, on May 5, 2019, shortly after I had finished the final revisions of this text, and before I could bring him a copy to go with the traditional bottle of malt whisky that served as an *amāra* between us whenever we met. He lives on in all those whose lives he touched, and especially in his wonderful children.

This book is dedicated to his memory.

Still frame from video posted to YouTube by Ikbel Amri, January 14, 2011. To view, and for more information, go to vimeo.com/channels/thepeoplearenot, video 8.2.

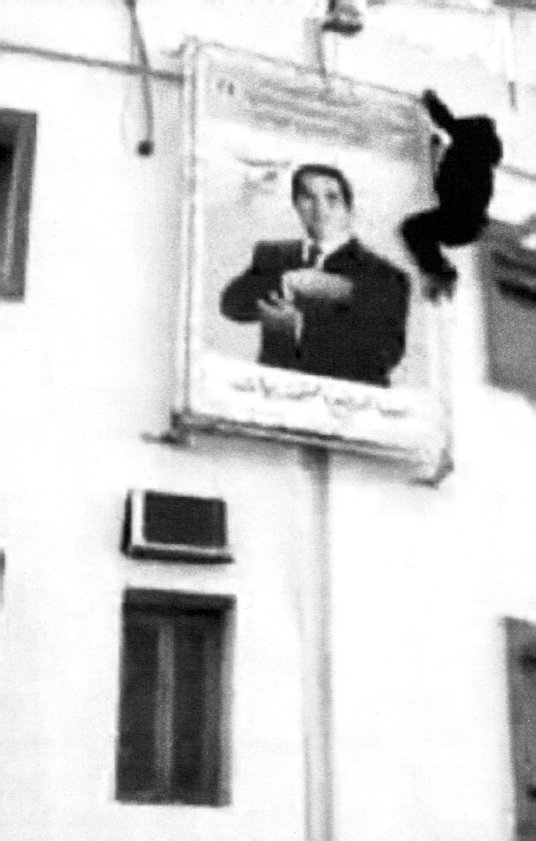

List of Videos Referenced

Numbers refer to copies of the videos archived on the companion channel to this book at vimeo.com/channels/thepeoplearenot.

0.0 Video of revolutionaries evacuating their wounded, Bahrain, originally posted to YouTube on February 18, 2011, and subsequently deleted. Original URL unknown.

0.1 "محمد الربع ساخرا من قصف منزله," originally posted by 5000zukoo on September 21, 2011, at youtube.com/watch?v=NHtEtNIYh6I.

1 "Joie d'un Tunisien—Avenue Habib Bourguiba—soir 14 janvier—Tunisie," originally posted by rideaudur, on January 17, 2011, at youtube.com/watch?v=3eSc5H987QQ.

1.1 "mohamed naser laouini 14_01_2011," originally posted by mehdi achouri, on February 2, 2011, at youtube.com/watch?v=TNzC4O1Qh1c.

1.2 "التونسي الذي أبكى الصحفي و المعارض راشد الغنوشي," originally posted by Abouchahine El Assimi, on January 18, 2011, at youtube.com/watch?v=j1mqHVAN6bQ.

2 "طفل يقود مسيره لباب البحرين," originally posted by IxLovexBahrain, on February 25, 2011, at youtube.com/watch?v=YIKrGP452rg.

3 "فبراير2011 - قمع اعتصام سلمي في قرية الدراز البحرين 14," originally posted by feb tub, on February 14, 2011, at youtube.com/watch?v=R3LazFJowa4.

4 "إطلاق الرصاص على مظاهرة الإنشاءات جمعة بروتوكول الموت" originally posted by jojomom029, on December 23, 2011, at youtube.com/watch?v=pwNr9cKvlQg.

4.1 "من حمص الإنشاءات - مقطع صوتي مضحك," originally posted by one1way2011 on December 23, 2011, at youtube.com/watch?v=sl_i-2uHjw4.

5 "Protest in Souq Al Jumma - Tripoli طرابلس - مظاهرة في سوق الجمعة," originally posted by 17thFebRevolution, on February 27, 2011, at youtube.com/watch?v=RdlBRgioBFc.

5.1 Video of tank entering Talbesa, Homs, on May 28, 2011, originally posted to YouTube, and since deleted. Original URL unknown.

5.2 "In Syria (Daraa): Camera Vs Guns 'The world must see!'" originally posted by thesyrianinterpreter, on May 25, 2011, at youtube.com/watch?v=BTGFSX2WiMc, and subsequently deleted.

6 "Day One of Egypt's Freedom Revolution | January 25, 2011," originally posted by FreedomRevolution25, on January 24, 2012, at youtube.com/watch?v=Co-oJUk_P_A.

6.1 "Egypt's Freedom Revolution, Day 2," originally posted by FreedomRevolution25 on January 26, 2011, at youtube.com/watch?v=ElQV6nCzH30.

7 "Meet Asmaa Mahfouz and the vlog that Helped Spark the Revolution," originally posted by Iyad El-Baghdadi on February 1, 2011, at youtube.com/watch?v=SgjIgMdsEuk.

7.1 "اعتصام منزلي في دمشق 30 أيار," originally posted by tansiqiyatdamascus, on May 31, 2011, at youtube.com/watch?v=iv7CdmLkURs.

7.2 "Asmaa Mahfouz's vlog on the Eve of the Revolution," originally posted by Iyad El-Baghdadi on February 2, 2011, at youtube.com/watch?v=1UUbVr3eB9c.

7.3 "Swimming @ Aisha Gadafi' s house," originally posted by sandowarrior on August 26, 2011, at youtube.com/watch ?v=q2iTltcogDI.

7.4 "Storming Egypt State Security," originally posted by elsaffani, on March 5, 2011, at youtube.com/watch?v=AOpwr XWoQX8.

8 Untitled video shot in Tripoli, Libya, posted to Facebook on April 15, 2011, and subsequently deleted.

8.1 "Mubarak down in Alexandria," originally posted by Mo'men Azkoul on January 25, 2011, at youtube.com/watch ?v=Ak4tATgyoHE.

8.2 "La Révolution du Jasmin: Protesters burning Ben Ali's portrait (SOUSSE, TUNISIA: 01/14/2011)," originally posted by Ikbel Amri, on January 14, 2011, at youtube.com /watch?v=F9a34nCtZGE.

8.3 "SYRIA Cheering Crowd As Protesters Attempt To Destroy Statue Of Assad 04/22/11," originally posted by VexZeez on July 22, 2011, at youtube.com/watch?v=MkLdCHzgsXQ.

8.4 Video of poster of Bashar al-Assad being burned, originally posted to YouTube by xgotfiveonitx on March 27, 2011, and subsequently deleted. Original URL unknown.

9 "L'imprécation de la femme du people," originally posted by webamri amri on January 29, 2011, at youtube.com /watch?v=gh5E2BpkWbA.

9.1 "شعر --- يا طرابلس قولي له.flv," originally posted by MrFreedomlibya on April 11, 2011, at youtube.com/watch ?v=Q4W2qB2_STk.

9.2 "Yemen:one of the revolution's poets/احد شعراء الثورة العربية," originally posted by Basha Ammar on April 20, 2011, at youtube.com/watch?v=z5dk1zWyrSw.

9.3 "أغنية اطردوا حسني مبارك Expell Hosni Mubarak Song," originally posted by forfaith on February 5, 2011, at youtube.com/ watch?v=AdKjMiKqVrc.

9.4 Video from Syria filmed during 2011, originally posted at youtube.com/watch?v=AuXmCKoo4Vc, and subsequently deleted.

9.5 "Ayat Al-Qormezi - A Poem Worth a Year of Brutal Torture and Imprisonment," originally posted by Shayalal3alam on June 15, 2011, at youtube.com/watch?v=mcCEk9s82ac.

9.6 "January 25th, Shubra 2011," originally posted by Gigi Ibrahim on March 24, 2011, at youtube.com/watch?v=59 WBvyrad_0.

9.7 "October 9 MASPERO," originally posted by Farid Credi on October 9, 2012, at youtube.com/watch?v=aM2By5FH6tw.

10 "Last broadcast from Mohammed Nabbous and Message from his widow," originally posted by LLWProductions on March 20, 2011, at youtube.com/watch?v=tiWgDuG6_Is.

11 "Yemen Revolution in sana'a 13 May 2011," originally posted by MrEthzxz on June 10, 2011 at youtube.com /watch?v=CdDPDpej9AY.

11.1 "Tunisie - La joie des tunisiens -Ghannouchi degage," originally posted by partifederaliste TN on January 14, 2011, at youtube.com/watch?v=PwoYt5QxZN4, and subsequently deleted.

12.1 "Friday! A Day of Anger! The Battle for Ramses Square," originally posted by 3arabawy on February 2, 2011, at youtube.com/watch?v=eh7DoZpHcpY.

12.2 Video of revolutionaries riding on bulldozers, Yemen, originally posted to YouTube in 2011 and subsequently deleted.

Notes

Introduction

1. The role of video in Iran was quite different from that which it would later play in the Arab countries. This shift doubtless owes less to "cultural" differences, or to changes in mobile imaging technology, than it does to the specific political ecology in which the movements developed. In Iran, Internet access was already highly obstructed before the protests, and connection speeds were reduced so much within the first week that the Internet became effectively unusable from within the country, especially in Tehran. Nor could cell phones connect to the Net; the required 3G technology had not yet been introduced. It was also widely rumored that abnormally heavy use of mobile or landline bandwidth was being tracked by the security forces and used as a pretext for immediate physical intervention and likely arrest and torture. As a result, Iranians in 2009 were posting videos knowing that they would be viewed mainly by people outside Iran, since viewing them from inside the country was too risky even when it was possible. The Arabs of 2010–11, by contrast, suffered occasional outages and filtering (YouTube in particular was inaccessible in Tunisia throughout December 2010–January 2011, though Facebook remained available), but they do not seem to have been deterred from watching video for fear of

immediate repression. The videos they posted online were widely seen within their own countries and across national borders, and they were clearly intended in the first instance for their fellow citizens and only secondarily for more distant observers. Of course, the risks of surveillance were arguably just as great as in Iran, if not greater—the regimes were simply playing a longer game. I argue in chapter 9 that this difference in audiences and their potential responses can be seen to have influenced the nature and quality of the videos themselves. On the intrication of social media and the Green Movement, see Setrag Manoukian, "Where Is This Place? Crowds, Audio-vision, and Poetry in Postelection Iran," *Public Culture* 22: 2, 2010, 237–63; Bajoghli Narges, "Digital Technology as Surveillance: The Green Movement in Iran," in Linda Herrera and Rehab Sakr, eds., *Wired Citizenship: Youth Learning and Activism in the Middle East,* London and New York: Routledge, 2014, 180–94; and Negar Mottahedeh, *#iranelection. Hashtag Solidarity and the Transformation of Online Life,* Stanford, CA: Stanford University Press, 2015.

2. Jean-Luc Nancy, *Etre singulier pluriel,* Paris: Galilée, 1996/2013, 62, 87.
3. Dork Zabunyan, "Révoltes arabes et images impersonnelles," *May* 9, 2012 (my translation), available online at mayrevue.com.
4. Jacques Rancière, *Dissensus: On Politics and Aesthetics,* London: Continuum, 2010, 85.
5. "[T]he people … is not composed of Persons, … is not the Democratic Majority but rather just the opposite, namely all of us—in other words, that which does not exist, given that it has better things to do, the poor people … ." Agustín García Calvo, *Análisis de la Sociedad del Bienestar,* Zamora: Editorial Lucina, 1995, cited after anonymous English translation available at sites.google .com/site/politicalreading/home/analysisofwelfaresociety, n.p. See also Agustín García Calvo, *Contra la paz, Contra la democracia,* Barcelona: Editorial Virus, 1993.
6. The point that these videos are uploaded as common property, in a moral if not a legal sense, was made by Rabih Mroué during the January 24, 2014, performance of *The Pixelated Revolution* at the Frascati Theater, Amsterdam, but does not figure in the version of the text published in Rabih Mroué, *Image(s), mon amour: Fabrications,* Madrid: CA2M, 2013, 378–93. A related but not identical point is made by the Egyptian video collective Mosireen in their text "Revolution Triptych": "The images are not ours, the images are the revolution's. / How dare we trade in images of resistance to a system that we would feed by selling them? / How dare we perpetuate the cycle of private property in a battle that calls for

the downfall of that very system? / How dare we profit from the mangled bodies, the cries of death of mothers who lost their children?" Mosireen, "Revolution Triptych," in Anthony Downey, ed., *Uncommon Grounds: New Media and Critical Practices in North Africa and the Middle East,* London: IB Tauris, 2014, 48.

7. Dork Zabunyan, *Passages de l'histoire,* Blou: Le Gac Press, 2013, 58 (my translation).

8. Comité invisible, *L'insurrection qui vient,* Paris: La Fabrique, 2007, 102–3, my translation. On the politics of anonymity more generally and the distinction between its strategic and experiential dimensions, see Erik Bordeleau, *Foucault anonymat,* Montréal: Le Quartanier, 2012.

9. See Giorgio Agamben, *L'Uso dei corpi: Homo Sacer, IV,* 2, Vicenza: Pozzi Neri, 2014, 333–51.

10. Mohammed A. Bamyeh, "Anarchist Method, Liberal Intention, Authoritarian Lesson: The Arab Spring between Three Enlightenments," *Constellations* 20: 2, 2013, 192.

11. Ibid., 191.

12. Ayman El-Desouky, *The Intellectual and the People in Egyptian Literature and Culture: Amāra and the 2011 Revolution,* Basingstoke: Palgrave Macmillan, 2014, ix–x, emphasis in original. This use of the term "resonance" to refer to emergent forms of collective subjectivity can be traced back through Alain Badiou (*The Rebirth of History: Times of Riots and Uprisings,* London: Verso, 2012, 108–9) to Jean-Marie Gleize, who was himself quoting the Invisible Committee: "revolutionary movements do not spread by contamination, but by resonance" (*Mise-au-point,* 2009, n.p., my translation). For further reflection on the many implications of this language, see Erik Bordeleau's discussion of the difference between "resonance communism" and "voluntaristic communism" in *Comment sauver le commun du communisme?* Montréal: Le Quartanier, 2014, 149–85. The question of musicality as both vehicle and metaphor for a performative politics is taken up in more detail in chapter 9.

13. El-Desouky, *The Intellectual and the People in Egyptian Literature and Culture,* 12.

14. Ibid, ix.

15. Mohammed A. Bamyeh, *Anarchy as Order: The History and Future of Civic Humanity,* Lanham, MD: Rowman & Littlefield, 2009.

16. Bamyeh, "Anarchist Method, Liberal Intention, Authoritarian Lesson," 199.

17. Kristin Ross, *Communal Luxury: The Political Imaginary of the Paris Commune,* London/New York: Verso, 2015, 29.

18. Marx in his correspondence with Vera Zasulich, quoted in Ibid., 83.
19. Sahar Keraitim and Samia Mehrez, "Mulid al-Tahrir: Semiotics of a Revolution," in Samia Mehrez, ed., *Translating Egypt's Revolution: The Language of Tahrir*, Cairo: AUC Press, 2012, 30–32.
20. Jonathan Littell, *Carnets de Homs*, Paris: Gallimard, 2012, 26 (my translation).
21. Keraitim and Mehrez, "Mulid al-Tahrir," 31. On the Egyptian revolution as *mulid*, the *mulid* as desire "to transcend the 'bounded self,'" and the oral culture of Sufism as more persistent and enduring than the textual culture of other forms of Islam, see also Caroline Rooney, "Sufi Springs: Air on an Oud String," *CounterText* 1: 1, 2015, 52–54. The *dhikr* form of the early Syrian demonstrations can be admirably seen and heard in Talal Derki's film *Return to Homs* (2013). I discuss the *mulid* as a metaphor for the revolution, and for revolutionary video, in more detail in chapter 9.
22. El-Desouky, *The Intellectual and the People in Egyptian Literature and Culture*, x.
23. Bamyeh, "Anarchist Method, Liberal Intention, Authoritarian Lesson," 191.
24. This "weak" use of the term "vernacular video" is widespread in those works on the early years of YouTube that defined initial (Western) academic understandings of the platform, such as Jean Burgess and Joshua Green, *YouTube: Online Video and Participatory Culture*, Cambridge: Polity, 2009, or Michael Strangelove, *Watching YouTube: Extraordinary Videos by Ordinary People*, Toronto: University of Toronto Press, 2010.
25. It is interesting to note that Thompson's celebrated 1971 essay on the moral economy of the English crowd, which significantly influenced Illich's thinking on the vernacular, has also played an important role in the rescue of the Arab crowd from Orientalist mythology and its reinstatement as a rational agent of historical change by scholars such as Hugh Roberts, Edmund Burke III, and Larbi Sadiki. This genealogy is traced in Andrea Khalil, "The Political Crowd: Theorizing Popular Revolt in North Africa," *Contemporary Islam* 6, 2012, 45–65.
26. Ivan Illich, *Shadow Work,* Salem and London: Marion Boyars, 1981, 27–51. I discuss the contemporary relevance of Illich's account of the ideology of "mother tongue" as a tool of political surveillance and control in greater depth in "The Revolution *Will* Be Uploaded: Vernacular Video and the Arab Spring," *Culture Unbound* 6, 2014, 406–14.
27. Agamben, *L'Uso dei corpi*, 273–80.
28. Ibid., 333–51.

29. Giorgio Agamben, "For a Theory of Destituent Power," *Chronos*, 2013 (available online at chronosmag.eu). Illich's most important investigation into the radical diversity of vernacular forms-of-life can be found in his *Gender*, New York: Pantheon Books, 1982.

30. I take it as axiomatic that the online and the offline are thoroughly *enmeshed* and that both are thoroughly physical *and* virtual processes. Nathan Jurgenson, in particular, has developed this analysis in "When Atoms Meet Bits: Social Media, the Mobile Web and Augmented Revolution," *Future Internet* 4: 1, 2012, 83–91. On the ways in which the virtual is always already embedded in our everyday, predigital lives, see Serge Tisseron, *Du livre et des écrans, plaidoyer pour une indispensable complémentarité*, Paris: Editions Manucius, 2013.

31. Zeynep Gambetti, "Occupy Gezi as Politics of the Body," *Jadaliyya*, July 9, 2013 (available online at jadaliyya.com).

32. Ulrike Lune Riboni, "Filmer et rendre visible les quartiers populaires dans la Tunisie en révolution," *Sciences de la société 94*, 2015, 121–36; "Représentations mobilisatrices et stratégies visuelles pour convaincre et fédérer dans les productions vidéo de la Tunisie en révolution," in Bénédicte Rochet, Ludo Bettens, et al., eds., *Quand l'image (dé)mobilise. Iconographie et mouvements sociaux au XXe siècle*, Namur: Presses Universitaires de Namur, 2015, 95–110; "Filmer et partager la révolution en Tunisie et en Egypte: représentations collectives et inscriptions individuelles dans la révolte," *Anthropologie et Sociétés* 40: 1, 2016, 51–69. Cécile Boëx, "Montrer, dire et lutter par l'image: Les usages de la vidéo dans la révolution en Syrie," *Vacarme* 61, Autumn 2012, 118–31; "La grammaire iconographique de la révolte en Syrie: Usages, techniques et supports," *Cultures & Conflicts* 91–92, 2013, 65–80; "La vidéo comme outil de publicisation et de coordination de l'action collective et de la lutte armée dans la révolte en Syrie," in François Burgat and Paolo Bruni, eds., *Pas de Printemps pour la Syrie: Acteurs et défis de la crise 2011–2013*, Paris: La Découverte, 2013, 172–84. Donatella Della Ratta, *Shooting a Revolution: Visual Media and Warfare in Syria*, London: Pluto Press, 2018. Alisa Lebow, *Filming Revolution: A Meta-Documentary about Filmmaking in Egypt since the Revolution*, Stanford, CA: Stanford University Press, 2018, filmingrevolution.org.

33. For more information and to view the film, go to theuprising.be.

34. In 2016–17, I worked as a researcher with the Resistance-by-Recording project hosted by the Department of Media Studies, Stockholm University, and the Department of Cultural Anthropology and Development Sociology, Leiden University, with Kari Andén-Papadopoulos and Mark Westmoreland. While my work on

the project did include helping to conduct extended ethnographic interviews with video activists from Egypt, Syria, and Palestine, the insights gained there mainly concerned other struggles or other moments and came too late to influence the argument of this book.

35. Michel Foucault, "Réponse au Cercle d'épistémologie," *Cahiers pour l'Analyse* 9, 1968, 9–40; *L'Archeologie du Savoir*, Paris: Gallimard, 1969. Jacques Derrida, *Mal d'Archive: Une Impression Freudienne*, Paris: Editions Galilée, 1995. For an interesting overview of the subsequent debates, presented by someone who is herself a working archivist, see Marlene Manoff, "Theories of the Archive from Across the Disciplines," *portal: Libraries and the Academy* 4: 1, 2004, 9–25.

36. The most visible exception to this rule has been the autonomous region of Rojava in north-east Syria—a radical experiment in libertarian socialism involving around two million people, many but not all of them Kurdish—that, as I write these lines in late 2019, has been abandoned by its Western allies in the war against IS, and is now being targeted for destruction by the Turkish state.

37. Zabunyan, *Passages de l'histoire*, 51, 54–55 (my translation).

38. Tahar Chikhaoui, "La rampe s'est déplacée," africine.org, 2012 (my translation).

39. This should not be taken to imply that the deliberate archiving of vernacular video is a pointless task: far from it, especially given the privatized infrastructure in which most such videos remain stranded. For two remarkable examples of what can be achieved in this domain, see the 858 hours (and growing) of video from the archive of the Mosireen video collective in Egypt made available at 858.ma and the bak.ma online digital media archive of Turkish social movements, which was born out of Occupy Gezi. (*Bakma* is Turkish for "don't look," an instruction often issued by police to the Gezi protesters.)

40. The use of the term "anarchive" may be rare, but I certainly cannot claim it is original. Recent examples include a Russian web archive of anarchist literature (now defunct), a "digital archive on contemporary art" curated by Anne-Marie Duguet, a poetry collection by Stephen Collis, an essay by Alanna Thain on "anarchival" cinema, and "The Anarchivist Manifesto" of the Australian art collective Soda_Jerk, which itself takes the form of a cut-up essay, published in *INCITE: Journal of Experimental Media* 6, 2016.

41. I date this phenomenon to the start of 2011 as YouTube was banned in Tunisia throughout the winter of 2010–11, and it was only really with the Egyptian revolution commencing on January 25, 2011, that YouTube became a fully integrated part of Arab revolutionary cyberspace. Tunisian revolutionaries had instead been

posting their videos to their Facebook accounts, where they circulated in a related but somewhat different way. See Riboni, "Filmer et rendre visible" for more information. On zones of offensive opacity, see Tiqqun, "Comment faire?" *Tiqqun* 2, 2001, 278–87.

1. A Happy Man

1. This is an allusion to the evening of January 13, when President Zineddine Ben Ali's third televised speech was followed by a report showing the "rejoicing crowds" that had invaded the roads in their cars to celebrate the reforms he had announced. It was rapidly uncovered that not only were the people in the cars paid to make this demonstration of support, but the cars had also been hired especially for the occasion.

2. An alternative take of this scene (see vimeo.com/channels/the peoplearenot, video 1.1) makes it evident that the street is not as deserted as it might appear to us from the high-angle shot that defines this particular video. Still, for the purposes of the present analysis, the people who matter are those we can or cannot see in these shots, not those that would have been visible had the camerawoman run downstairs and out into the night. I return to the significance of this alternate take in chapter 2.

3. It is probably not a coincidence that the woman who says this phrase shifts from French—the former colonial language and that of certain elite sectors of education and society in Tunisia to this day—to Arabic at just the moment when she moves from positioning herself outside the event, in incredulous admiration for the reciter's bravery (as if it was an act she could not herself imagine emulating), to implicitly participating in his recital by invoking an absent multitude that is the very core of the "people" whom the reciter seeks to conjure into existence.

4. Abdennacer Aouini is identified in the titles given to a number of the YouTube re-ups of the two videos that immortalize his performance. He has since continued (as one might imagine) to be a thorn in the side of successive postrevolutionary governments (see his "official" Facebook page). My account of the Tunisian revolution draws on Abdelwahab Meddeb, *Printemps de Tunis: La métamorphose de l'Histoire*, Paris: Albin Michel, 2011; Jocelyne Dahklia, *Tunisie: Le pays sans bruit*, Arles: Actes Sud, 2011; and Pierre Puchot, *Tunisie: Une révolution arabe*, Paris: Galaade, 2011, as well as on contemporary journalistic and social media accounts, in particular those posted at the collective blog nawaat.org.

5. As far as I know, there are two videos of this scene: the one discussed here and the shorter alternate take referred to in note 2. Talking to friends from across the Arab region at the time of the event, I gained the impression that most of them knew this event from the alternative, ground-level clip and that they knew it because they had seen it on Al Jazeera and not because they had come across it on the web. For example, when Rached Ghannouchi, co-founder of the Islamist opposition movement Ennahda, was confronted with these images during an interview with the satellite TV channel Al Hiwar a few days later (see vimeo.com/channels /thepeoplearenot, video 1.2), it was the alternative, street-level take that was shown him. It is interesting to contrast Ghannouchi's tears, which manage to seem both spontaneous and completely inauthentic, with those we hear but do not see the three women shed in the clip discussed here.

6. Elias Canetti, *Crowds and Power*, Harmondsworth: Penguin, 1973, 47–54. Andrea Khalil has used Canetti's terminology, including "invisible" and "double crowds" (such as the living and the dead), to describe the importance of the felt presence of the martyrs for revolutionary and rebellious crowds in Algeria, Tunisia, and Libya: "The crowd testified that those invisible 'others,' whether the dead, imprisoned, impoverished, or exiled, were, despite state repression, already part of the subjective constitution; subjects are multitudes of others." Interestingly, one of the other "invisible" crowds she mentions is the "virtual" crowd that can be found on the Internet. Perhaps, when we watch this video from Tunisia, we are in fact watching it from a point of view that is not unlike the point of view of the dead? See Andrea Khalil, *Crowds and Politics in North Africa: Tunisia, Algeria and Libya*, London and New York: Routledge, 2014, 3, 13.

7. This video should be compared with the series of nocturnal videos from the Iranian Green Movement known to English-language netizens as The Rooftop Suite, available at mightierthan.com. These videos have since been quoted in many films, including David Dusa's fiction feature *Fleurs du mal* (2010), Bani Khoshnoudi's *The Silent Majority Speaks* (2014), and the anonymous documentary *Fragments d'une révolution* (2011). A study of the similarities and differences between them could provide the basis for a first measure of how the Green Movement both did and did not prepare the path for the Arab revolutions. For an extended interpretation of the Iranian videos that relates them to Giorgio Agamben's notion of rendering politics "inoperative," see Setrag Manoukian, "Where Is This Place? Crowds, Audio-vision, and Poetry in Postelection Iran," *Public Culture* 22: 2, 2010, 237–63.

8. For a skeptical take on how far even the Tunisian revolution was able to go in removing the apparatus of the Ben Ali regime, see Gilbert Achcar, *Le peuple veut: Une exploration radicale du soulèvement arabe*, Arles: Actes Sud / Sindbad, 2013, 15–21, and Khalil, *Crowds and Politics in North Africa*, 62–65.

9. For another eloquent example of how the Arab revolutions represented an occasion and a catalyst for various complex forms of rebellion against familial structures of authority, in particular on the part of young women, and with the camera as a privileged vector of such conflicts, see Sara Ishaq's moving portrait of her Yemeni family during 2011, *The Mulberry House* (2013).

10. Deleuze suggests two parallel sources for the phrase "the people are missing," starting with Klee's Jena Lecture of January 26, 1924, where it appears as "Wir haben noch nicht diese letzte Kraft, denn: uns trägt kein Volk" (in Paul Findlay's English translation: "We still lack the ultimate power, for: the people are not with us"). He also traces it to two texts by Kafka (a diary entry and a letter to Max Brod) where the words in question do not appear as such, but which appear to have played an essential role in prompting Deleuze's use of the phrase, both in *Cinéma 2* and in *Qu'est-ce que la philosophie?* (co-written with Félix Guattari in 1991). See Gilles Deleuze, *Cinéma 2: L'Image-Temps*, Paris: Editions de Minuit, 1985, 282–83.

11. Jacques Rancière, "D'une image à l'autre? Deleuze et les âges du cinéma," in *La fable cinématographique*, Paris: Le Seuil, 2001, 145–63.

12. The first words of the first volume are: "This study is not a history of the cinema. It is a taxonomy, an essay in classifying images and signs." Gilles Deleuze, *Cinéma 1: L'Image-Mouvement*, Paris: Editions de Minuit, 1983, 7 (my translation).

13. Dork Zabunyan, *Les cinémas de Gilles Deleuze*, Montrouge: Bayard, 2011, passim, and especially 34–82 and 161–78. On Deleuze's postwar caesura as a crisis in the concept of history itself, see Paola Maratti, *Gilles Deleuze: Cinema and Philosophy*, Baltimore, MD: Johns Hopkins University Press, 2008, 64–65.

14. Gilles Deleuze, "Qu'est-ce que l'acte de création?" in *Deux régimes de fous*, Paris: Editions de Minuit, 2003, 302 (my translation and emphasis).

15. "So in the end, this is the infinite reservoir on which the fireflies draw: their withdrawal, in so far as it is not a retreat but 'a diagonal force'; their clandestine community of 'scraps of humanity,' these signals that they give off intermittently; their essential freedom of movement; their faculty to make desire appear as the very paragon of that which is indestructible ... " Georges

Didi-Huberman, *Survivance des lucioles*, Paris: Editions de Minuit, 2009, 132–33 (my translation). For Pasolini, the disappearance of the fireflies—which for him, in 1975, seemed inevitable, and which for Didi-Huberman is never decided once and for all, and thus "depends on us"—was a metaphor for the "anthropological catastrophe" that had overtaken the people of Italy (epitomized by the subproletariat of the Roman *borgate* whom he had known in his youth), and who, like the fireflies who had fallen victim to the destruction of their natural habitats, seemed to be vanishing as their vernacular culture was bulldozed to make way for the mass-individualistic consumer society. Pier Paolo Pasolini, "L'articolo delle lucciole," in *Scritti corsari*, Milano: Garzanti, 2001, 128–34.

16. Cf. the alternate take of this scene cited above, in which the camera never once tilts up to see if anyone is watching from the "balcony."

17. This is the burden of Tariq Téguïa's feature film *Révolution Zendj* (2013), in which an Algerian journalist named after the great Arab chronicler (Ibn) Battuta travels through Lebanon to Iraq in search of traces of the revolt of the black slaves (Zanj) who, in the ninth century CE, had overthrown their masters and established a short-lived free city. Just before the end of the film, Battuta finally arrives at the supposed site of the city of Zanj in the marshes of Shatt al-Arab. He is accompanied by a local guide whose face is largely concealed behind a scarf that protects it from the wind and from others' eyes. Battuta looks down into the shallow water in which they are standing. When told that this is the place, he exclaims irritably: "But there is nothing here!" as if he had expected the marshes to be littered with random fragments of archeological importance. In response to his somewhat obtuse remark, his guide loosens his scarf so as to reveal the black skin of his face. Smiling at the startled Battuta, he tells him simply: "*We* are still here." While Jacques Rancière has questioned how successful Téguïa's film is in relating the individual to the collective, in this sequence it declares with almost overwhelming directness that Battuta's search is simultaneously successful and completely pointless. You do not have to look for the people, because they are always already there. Or to put it in slightly more Deleuzian terms: it was the intellectuals and artists who had gone missing, not the people. See Jacques Rancière, "Le reste, c'est à vous de l'inventer," interview with Cyril Béghin and Dork Zabunyan, *Cahiers du cinéma* 709, March 2015, 87.

2. Video as Performance

1. Samia Mehrez, "Translating Revolution: An Open Text," in Samia Mehrez, ed., *Translating Egypt's Revolution: The Language of Tahrir*, Cairo: AUC Press, 2012, 13, emphasis in original.

2. The term *al-nizam* could potentially also benefit from a similar questioning, as Mehrez suggests. Hamid Dabashi in particular has claimed that "[t]his demand for the dominant 'regime' to be brought down is a reference not only to political action but, even more radically, to the mode of knowledge production about 'the Middle East,' 'North Africa,' 'the Arab and Muslim world,' 'The West and the Rest,' or any other categorical remnant of a colonial imagination (Orientalism) that still preempts the liberation of these societies in an open-ended dynamic. The challenge the Egyptians faced in getting rid of a tyrant by camping in their Tahrir Square for eighteen days, with only one word (*Arhil* [sic], 'Go!') hanging on banners over their heads, will resonate for a very long time, calling also for the rest of the world to alter the regime of knowledge that has hitherto both been enabling and blinded us to world historic events." Hamid Dabashi, *The Arab Spring: The End of Postcolonialism*, London and New York: Zed Books, 2012, 2. This call for the bringing down of the dominant mode of knowledge production should be related to the emergence of the people's own modes of knowledge production during these revolutions, as analyzed in the case of Egypt by Ayman El-Desouky.

3. Niloofar Haeri, "Arabs Need to Find Their Tongue," *Guardian*, June 14, 2003.

4. Mehrez, "Translating Revolution," 14. On the question of whether "public space" is itself the most appropriate term for what is at stake in the context of these revolutions, see the extended discussion in chapter 7.

5. Mimetic in the sense elaborated by Michael Taussig, *Mimesis and Alterity: A Particular History of the Senses*, New York and London: Routledge, 1993.

6. Elliott Colla, "The People Want," *Middle East Report* 263, 2012 (available online at merip.org).

7. Judith Butler, *Notes Toward a Performative Theory of Assembly*, Cambridge, MA: Harvard University Press, 2015, 175. While Butler refers most frequently to the formula "we, the people," her argument is specifically prefaced with a reference to Tahrir Square as emblematic of exactly the kind of gathering of bodies and voices she wishes to analyze.

8. Ibid., 176.

9. Judith Butler, "'Nous, le peuple: réflexions sur la liberté de réunion," in Alain Badiou et al., *Qu'est-ce qu'un peuple?* Paris: La Fabrique, 2013, 59 (my translation). While parts of this text recur in Butler's 2015 monograph, this particular formulation exists only in this French-language publication that precedes it.

10. Butler, *Notes Toward a Performative Theory of Assembly*, 156–57, emphasis in original.

11. Hannah Arendt, *The Human Condition*, Chicago: University of Chicago Press, 1958.

12. For Agamben's attitude to Arendt on this point, see *inter alia* his discussion of classical and modern attitudes to slavery in *L'Uso dei corpi: Homo Sacer, IV, 2*, Vicenza: Pozzi Neri, 2014, 40–46. The relationship between Agamben's thinking about "bare life" and Butler's exploration of "precarious life" is too complex to go into here, though it seems clear that Agamben writes out of, and for, a more radically disruptive relationship to our existing political dispensation than does Butler. I touch on this issue again in chapter 4, where I consider the relationship between Butler's discussion of "constituent power" and Agamben's call for a "destituent power."

13. For an analogous critique of Arendt's separation of *bios* and *zoē*, see Jacques Rancière, *Dissensus: On Politics and Aesthetics*, London: Continuum, 2010, 29–30. In "The Revolution Will Be Uploaded: Vernacular Video and the Arab Spring" (*Culture Unbound* 6, 2014), I offered a summary of Butler's work on the people as performance that effectively elided the whole dimension of her thinking that represents a critique and a revision of Arendt's disembodied masculinist vision of the public realm. Here, I hope I give a more complex and more accurate reading of her ideas as expressed in *Notes Toward a Performative Theory of Assembly*, though it is arguably a moot point whether Butler's position is as distinct from that of Arendt as she herself seems to believe it to be. For a more complex appreciation of the "substantive" and "procedural" conceptions of "the public" that coexist in Arendt's thought, see Seyla Benhabib, "Feminist Theory and Hannah Arendt's Concept of Public Space," *History of the Human Sciences* 6: 2, 1993, 97–114.

14. In her discussion of the Tunisian revolution, Andrea Khalil makes the related but somewhat more ambitious claim that all the words spoken by the crowd *as* the people (*ex cathedra*, so to speak) were speech acts that had the power to enact what they declared: "The revolutionary crowd used illocutionary language, or speech acts, to remove the political leader by linguistically claiming political authority for itself. The utterances of the crowd—'*dégage*' and '*al sulta al shaab*'—were speech acts. As they were uttered in unison,

they enacted what they said as they were spoken. The words themselves tore down the government as they were shouted by the masses. The fact of saying '*al sulta al shaab*' enacted the reality that the people were now in power, because the government had prohibited exclamation of these words." Khalil's analysis ignores the bodily dimension identified by Butler and does not dwell on the people as *itself* a performative event. See Andrea Khalil, *Crowds and Politics in North Africa: Tunisia, Algeria and Libya*, London and New York: Routledge, 2014, 56.

15. Judith Butler, "Bodies in Alliance and the Politics of the Street," eipcp.net, 2011.

16. Ibid.

17. Ibid.

3. Seeing as the People

1. Ulrike Lune Riboni, "Filmer et partager la révolution en Tunisie et en Égypte: représentations collectives et inscriptions individuelles dans la révolte," *Anthropologie et Sociétés* 40: 1, 2016, 51–69.

2. I understand "mimesis" here in a sense close to that which William Mazzarella finds in Canetti's concept of "transformation," that is, as a form of imitation that enables and is enabled by a self-reflexive distance from both oneself and others: "Humans, Canetti argues, share their mimetic ability with other animals. But, unlike the others, humans imitate self-reflexively. Human imitation is thus, in a crucial sense, *mediate* in that it involves self-consciousness and self-distance as well as an exquisite, fully sensory attunement to the other. Canetti thus locates the kind of critical distance that is usually contrasted with mimetic merger right at the heart of human mimesis ... Situated at once within and without the mimetic act, human beings make it transformative and creative. Its particular enjoyment and immanent potential arises out of the interplay between sensuous reflex and conscious reflection ... Canetti takes us a long way from classic crowd theory's zero-sum drama of mimesis versus reason; in his vision, mimesis is creative and liberatory because of, rather than in spite of, its natural conditioning." William Mazzarella, "The Myth of the Multitude, or, Who's Afraid of the Crowd?" *Critical Inquiry* 36, Summer 2010, 719–20 (emphasis in original). Of course, whether it is indeed only humans who are able to imitate in this way remains a moot point.

3. Following Mark Paterson and J. J. Gibson, I take the "haptic" to include not only the cutaneous sense of touch but also "a range

of internally felt bodily states which functions as part of a larger haptic perceptual system." Mark Paterson, "Haptic Geographies: Ethnography, Haptic Knowledges and Sensuous Dispositions," *Progress in Human Geography* 33: 6, 2009, 769, referring to J. J. Gibson, *The Senses Considered as Perceptual Systems*, Boston, MA: Houghton Mifflin, 1966. These additional internal senses include kinesthesia (the sense of movement), proprioception (the sense of bodily position), and the vestibular system (the sense of balance). My understanding of the role of the somatic senses in human life is informed in particular by the work of Maxine Sheets-Johnstone; see for example "Bodily Resonance," in Helena De Preester, ed., *Moving Imagination: Explorations of Gesture and Inner Movement*, Amsterdam: John Benjamins, 2013, 19–36. In this book, I refer to these perceptual sequences as "tactile–kinesthetic" and reserve the term "haptic" specifically for forms of "haptic visuality" as that term has been elaborated by Laura Marks, especially in her *Touch: Sensuous Theory and Multisensory Media*, Minneapolis: University of Minnesota Press, 2002. Marks identifies haptic images as those that appeal to our somatic senses in part by frustrating our desire for representations of an optically legible world located at a safe distance from the viewer. For a longer historical perspective that locates a haptic regime of vision as the earliest of four scopic regimes, extending from the pre-Socratics to Ptolemy of Alexandria, where each layer subsists in various forms beneath and within the regimes that succeed it, see Ivan Illich, "Guarding the Eye in the Age of Show" (2001), available online at davidtinapple.com. Somewhat surprisingly, Marks denies the relevance of haptic visuality to elaborating a deeper understanding of the mobile phone videos that emerged from the Arab revolutions in her recent essay "Arab Glitch"; see Anthony Downey, ed., *Uncommon Grounds: New Media and Critical Practices in North Africa and the Middle East*, London: IB Tauris, 2014, 257–71. On the possibility of a haptic *aurality*, see Lisa Coulthard, "Dirty Sound: Haptic Noise in New Extremism," in Carol Vernallis, Amy Herzog, and John Richardson, eds., *The Oxford Handbook of Sound and Image in Digital Media*, Oxford: Oxford University Press, 2013, 115–26. The YouTube videos discussed here could be seen as approaching the intensity Coulthard attributes to the overloaded profusion made possible by Dolby surround sound through the opposite tactic—a radical (and largely involuntary) impoverishment of their material, rather like that produced by the in-built GoPro microphones that provide the basis for the soundtrack of Lucien Castaing-Taylor and Véréna Paravel's *Leviathan* (2012).

4. Riboni, "Filmer et partager la révolution en Tunisie et en Égypte," 57.

5. The allusion is to a celebrated sequence that edits together a series of shots from May 1968 in Paris, the Soviet invasion of Prague, and the 1973 coup d'état in Chile. The standard interpretation of this passage is as a refusal (or disavowal) on the part of Marker of any form of special (magical, revelatory) attunement between the camera and world history. As Cyril Béghin puts it, "the question is inserted between shots, in large white letters, and at first it seems to be leading us towards the mystery of an affective capacity specific to images themselves: as if they trembled with a kind of foreknowledge, faced with the imminence of an essential event. But before long, the question has been answered in such a way as to reduce this sudden ontological inflation to a technical matter—if the images shake, it is simply because the hand that held the camera was shaking." Béghin, however, is well aware of the characteristically ambivalent nature of Marker's gambit here—his sly delight in having his cake, while denying that "cake" even exists: "Editing together the fable of a man who trembles beside these trembling images does nothing, however, to reduce the initial effect they have had on me, the viewer, to neutralise the original mystery which they created by themselves, alone. The trembling man trembles precisely because something in him has been pushed out of balance; and these images shake for the same reason, while the fable only pretends to rationalise them." "Des images en sursis. *L'Ambassade*, de Chris Marker," *Théorème* 6, 2002, 159–60 (my translation).

6. The most obvious, and violent, disjunction we encounter is that our vestibular system is operational on one side of the recording–projection assemblage only. In everyday life, running down a street does *not* lead to sea-sickness, but watching a film made in the same circumstances often will, because absent the perceptual system operations which "smooth out" our everyday perceptions in line with our prior conception of how our body *should* and (in the standard case) does move through space, we are confronted with a series of abrupt discontinuities on an image-by-image basis which we have no way to knit back together again. The physiological–kinesthetic violence of watching, say, Jonas Mekas's *Reminiscences of a Journey to Lithuania* (1972), or Jonathan Nossiter's *Mondovino* (2004), or Lars von Trier's *Breaking the Waves* (1996), or many of the YouTube videos considered in this book, is in itself proof that we experience the world in which we live not so much through our real empirical body, as through a virtual body which we project into it and which presents the world to us as (among other things) relatively continuous and relatively coherent. There is no body that is *only* a body.

7. For notable exceptions to this rule, see the works by Zabunyan, Riboni, Boëx, and Della Ratta listed in note 33 to the Introduction; see also Stefan Tarnowski, "What Have We Been Watching? What Have We Been Watching?" May 5, 2017, available online at bidayyat.org.

8. See Toby Jones, "A Revolution Paused in Bahrain," *Middle East Research and Information Project*, February 23, 2011, available online at merip.org; and Samia Errazzouki, "Behind the Bahraini Revolution: An Interview with Maryam Al-Khawaja," *Jadaliyya*, September 11, 2014, available online at jadaliyya.com.

9. A *matam* is a Shia congregation hall.

10. See vimeo.com/channels/thepeoplearenot, video 3.

11. Physicians for Human Rights described the massive (and often lethal) use of tear gas by the Bahraini authorities during the first fifteen months of the uprising as "unprecedented in the 100-year history of tear gas use against civilians throughout the world"; *Weaponizing Tear Gas: Bahrain's Unprecedented Use of Toxic Chemical Agents against Civilians,* Cambridge, MA, and Washington, DC: Physicians for Human Rights, August 2012. During the first fifteen months of the uprising, tear gas was by far the principal cause of death, accounting for 40 percent of all fatalities (see bahrainvisualized.com). Concerns extend beyond immediate casualties to the long-term health consequences for residents of villages that have been systematically blanketed with tear gas (both CS and CR) night after night in what appears to have been a deliberate and systematic attempt to drive a wedge between those who had joined the protests and those who had not; see Gregg Carlstrom, "In the Kingdom of Tear Gas," *Middle East Research and Information Project*, April 13, 2012, available online at merip.org. For the history of a weapon that is, in the words of one early proponent, "admirably suited to the purpose of isolating the individual from the mob spirit," see Anna Feigenbaum, *Tear Gas: From the Battlefields of World War I to the Streets of Today*, London and New York: Verso Books, 2017.

12. Comment left by user raphion88. Comments have subsequently been disabled for this video.

13. All timings given in the text refer to positions within the video concerned, expressed as minutes and seconds (mm:ss) starting from 0:00.

14. Gilles Deleuze, *Francis Bacon: Logique de la Sensation,* Paris: Editions de la Difference, 1981, 99, cited in Pascal Bonitzer, *Le champ aveugle: Essais sur le réalisme au cinema*, Paris: Petite bibliothèque des Cahiers du cinema, 1999/1982, 28.

15. Judith Butler, *Notes Toward a Performative Theory of Assembly,*

Cambridge, MA: Harvard University Press, 2015, 163.

16. Marks, *Touch*, 6, 97, 109.

17. Bodil Marie Stavning Thomsen, "Participatory Citizenship in a War Zone—on Activist Strategies in a Documentary Film and on the Internet," *Conjunctions. Transdisciplinary Journal of Cultural Participation* 1: 1, 2014, 7.

18. Paterson, "Haptic Geographies," 780.

19. Jean-Luc Nancy, *Etre singulier pluriel*, Paris: Galilée, 1996/2013, 87 (my translation).

20. Butler, *Notes Toward a Performative Theory of Assembly*, 151.

21. James Scott, *Seeing like a State; How Certain Schemes to Improve the Human Condition Have Failed*, New Haven and London: Yale University Press, 1998.

22. Jacques Rancière, *Dissensus: On Politics and Aesthetics*, London: Continuum, 2010, 35–37.

4. What Day Is It?

1. The Arabic *allahu akbar* is often rendered in English as a straight-forward exclamation of praise, "God is great!" Yet it can be translated with equal accuracy as "God is greater (than X)!"—that is, in this case, as a way of telling the powerful and presumptuous that their fall is preordained and possibly imminent. I believe that the second interpretation is the more appropriate at many points in the vernacular anarchive, including here.

2. *Hajj*: A respectful term for an older man; literally, one who has made the pilgrimage to Mecca.

3. *Takbir* is a ritual invocation, inviting those who hear it to respond, *Allahu akbar.*

4. Mohammed A. Bamyeh, "Anarchist Method, Liberal Intention, Authoritarian Lesson: The Arab Spring between Three Enlightenments," *Constellations* 20: 2, 2013, 190.

5. Ibid., 191.

6. Andrea Khalil, *Crowds and Politics in North Africa: Tunisia, Algeria and Libya*, London and New York: Routledge, 2014, 26.

7. Bodil Marie Stavning Thomsen, "Participatory Citizenship in a War Zone—on Activist Strategies in a Documentary Film and on the Internet," *Conjunctions. Transdisciplinary Journal of Cultural Participation* 1: 1, 2014, 7.

8. On the practice of naming Fridays in Syria, see Joshua Landis, "The Names of the Revolution," December 14, 2013, available online at joshualandis.com/blog/. For the Arab League observers

mission of December 2011, and the revolutionaries' perspective on it, see Layla Al-Zubaidi, "In the Suburbs of Damascus," *Jadaliyya*, January 17, 2012, available online at jadaliyya.com, and Jean-Pierre Filiu, *Le nouveau Moyen-Orient: Les peuples à l'heure de la Révolution syrienne*, Paris: Fayard, 2013, 187–97.

9. On the way in which Syrian revolutionary video was organized and even institutionalized and the conventions that emerged from this process, see Cécile Boëx, "La vidéo comme outil de publicisation et de coordination de l'action collective et de la lutte armée dans la révolte en Syrie," in François Burgat and Paolo Bruni, eds., *Pas de Printemps pour la Syrie: Acteurs et défis de la crise 2011–2013*, Paris: La Découverte, 2013, 172–84, and Filiu, *Le nouveau Moyen-Orient*, 176. Jonathan Littell frequently comments on the ways in which the Free Syrian Army shaped the communication of the revolution, in close cooperation with local communities and coordinating committees, throughout his *Carnets de Homs,* Paris: Gallimard, 2012.

10. Compare the use of the *hors-champ* to dramatize the "presence" of the martyrs in the video from Tunisia discussed in chapter 1.

11. Keith Johnstone, *Impro for Storytellers*, New York: Routledge, 1999, 232–33.

12. See vimeo.com/channels/thepeoplearenot, video 4.1.

13. Judith Butler, "'Nous, le peuple': réflexions sur la liberté de réunion," in Alain Badiou et al., *Qu'est-ce qu'un peuple?* Paris: La Fabrique, 2013, 60–61 (my translation and emphasis).

14. Filiu, *Le nouveau Moyen-Orient*, 163.

15. On the relationship between form-of-life and rhythm, see Giorgio Agamben, *L'Uso dei corpi: Homo Sacer, IV, 2,* Vicenza: Pozzi Neri, 2014, 223–26.

16. Mohammed A. Bamyeh, "Arab Revolutions and the Making of a New Patriotism," *Orient* III, 2011, 10.

17. Mohammed A. Bamyeh, "Anarchist Philosophy, Civic Traditions and the Culture of Arab Revolutions," *Middle East Journal of Culture and Communication* 5, 2012, 32–33 (my emphasis).

18. Mathijs Van de Sande, "The Prefigurative Politics of Tahrir Square —An Alternative Perspective on the 2011 Revolutions," *Res Publica* 19: 3, 2013, 223–39.

19. "But it turns out that the people, as it is nothing more than a negation (that which is not composed of Persons, or that which is not the Democratic Majority but rather just the opposite, namely all of us—in other words, that which does not exist, given that it has better things to do, the poor people), does inevitably say 'NO' and nothing but 'NO': that this is not what life was like, that that is not how it used to be, that we do not believe, my Lord, that I

do not believe, and that I do not forget the cereals and how good they tasted, even though I must swallow, like Iriarte's donkey, the straw that they feed me; and so on, following the whole string of 'NOES' that every now and then sprout from people's hearts in daily life (from their hearts, we must underscore, which are not to be confounded with the little soul, milady, that you keep in your cupboard, as that one would never say 'NO')." Agustín García Calvo, *Análisis de la Sociedad del Bienestar*, Zamora: Editorial Lucina, 1995, cited after anonymous English translation available online at sites.google.com/site/politicalreading/home/analysisofwelfaresociety, n.p.

20. Giorgio Agamben, "Elements for a Theory of Destituent Power," translated by Stephanie Wakefield, *Environment and Planning. Society and Space: D* 32: 1, 2014, 70.

21. Mohammed A. Bamyeh, *Of Death and Dominion. The Existential Foundation of Governance*, Evanston, IL: Northwestern University Press, 2007, 106.

22. Agamben, "Elements for a Theory of Destituent Power," 73, emphasis in original; Mohammed A. Bamyeh, *Anarchy as Order: The History and Future of Civic Humanity,* Lanham, MD: Rowman & Littlefield, 2009, passim and especially 216–18.

23. Agamben, "Elements for a Theory of Destituent Power," 72.

24. Comité invisible, *A nos amis,* Paris: La Fabrique, 2014, 78–79 (my translation, emphasis in original).

25. The nondialogue between Agamben and Butler that runs through Butler's recent work on popular assembly is perhaps most poignantly encapsulated in Butler's use of the word *destitution* in a sense directly opposite to that in which Agamben employs *destituent*, that is, to describe a kind of involuntary impoverishment of the person brought about by the violence of the State or of the market. By focusing on "bare life" (a juridical fiction, with real effects) and ignoring the imperative existence of "forms-of-life" (an ontological claim about the basic concrete-relational structure of reality), Butler constructs (and then rejects) a version of Agamben from which all margin for political resistance has been removed.

26. Agustín García Calvo, *Análisis de la Sociedad del Bienestar,* n.p.

5. The Death of Ali Talha

1. Cited by Jaime Semprun, *Apologie pour l'insurrection algérienne,* Paris: Encylopédie des nuisances, 2001, 10 (my translation).

2. The complexity of the (very serious) game being played here with

language should not be underestimated. During a public debate at Lussas (France) in August 2013, Tariq Téguïa proposed that this slogan actually meant the opposite of what it seems literally to say: it is an assertion of vitality, not of resignation. Or as Agustín García Calvo's rousing conclusion to his *Analysis of the Welfare Society* has it: "The last and only genuine revolution is that of the dead who refuse to be dead." *Análisis de la Sociedad del Bienestar*, Zamora: Editorial Lucina, 1995, cited after anonymous English translation available online at sites.google.com/site/politicalreading/home/analysisofwelfaresociety, n.p.

3. On conventional images of Islamic martyrdom, see Jennifer Malkowski, *Dying in Full Detail: Mortality and Digital Documentary*, Durham, NC: Duke University Press, 2012, 190–91, and David Cook, *Martyrdom in Islam*, Cambridge: Cambridge University Press, 2007, 118–19.

4. This video has since been deleted from YouTube. A copy can be viewed at vimeo.com/channels/thepeoplearenot, video 5.1.

5. For a nondiscursive exploration of this tension between the determination to document suffering and death on the one hand and the abstract quality of the resulting images on the other, see Birgit Hein's short film based on YouTube videos from Libya and Syria, *Abstrakter Film* (2013).

6. This effect of "seeing beyond death" is also closely related to the overcompressed and distorted audio that accompanies it. For some thoughts on compression as disfiguration and its ability to conjure "ghosts," see chapter 10, and also Peter Snowdon, "Distorting the Pain of Others," *In Media Res*, April 4, 2014, available online at mediacommons.futureofthebook.org.

7. Rabih Mroué, "The Pixelated Revolution," *Image(s), mon amour. Fabrications*, Madrid: CA2M, 2013, 386–87.

8. Ulrike Lune Riboni, "Filmer et partager la révolution en Tunisie et en Égypte: représentations collectives et inscriptions individuelles dans la révolte," *Anthropologie et Sociétés* 40: 1, 2016, 56.

9. Jean-Pierre Beauviala and Jean-Luc Godard, "Genesis of a Camera," *Camera Obscura* 5: 13–14, 1985, 163–93. Cf. Anne-Marie Duguet, *Vidéo, La mémoire au poing*, Paris: Hachette, 1981. It should be remembered that the Paluche was not just a miniscule lens-box more or less the size and shape of a microphone, but also a cable that linked it to a recorder that had to be carried (strapped around the waist or some other way). Interestingly, Sony's attempt to reinvent that configuration in 2013 with its "lens-style cameras"—the QX10 and QX100—fell on stony ground, partly because the concept of physically separating the lens from the recording media appears to have been widely misunderstood.

10. See in particular the discussion of Lars Klevberg's *Syrian Hero Boy* in Stefan Tarnowski, "What Have We Been Watching? What Have We Been Watching?" May 5, 2017, available online at bidayyat .org.

11. Ernesto Carmona, "Murió el asesino de periodista argentino-sueco Leonardo Henrichsen," *El Observatodo*, January 23, 2008. Busta-mante died in prison in 2007 while still awaiting trial.

12. Video uploaded by thesyrianinterpreter on May 25, 2011, subse-quently deleted from YouTube. To view an archived copy, go to vimeo.com/channels/thepeoplearenot, video 5.2.

13. My understanding of the Tripoli protests of February 2011 was informed by the diary of Sandra James, a British woman who had lived in Libya for over twenty years and whose Libyan husband and two eldest sons took part in (and survived) the February 25 march. Her account was published as "Tripoli under Siege: A Mother's Account, Part 1," *Shabab Libya*, February 19, 2012, and was formerly available online at shabablibya.org (as of this writing, the website was no longer accessible). I have also con-sulted the information and videos assembled by the *New York Times*' blog, "The Lede," in the immediate aftermath of the event, and by John Liebhardt at Global Voices Online.

14. The date and place of the death of Ali Mohammed Talha, along with his full name and age, were confirmed by information pub-lished at atayamnal7lwa.net, as part of a forum discussion that has since been deleted.

15. All the accounts I have consulted place the massacre of Febru-ary 25 on Aradah Road, near to the Al-Hany crossroads—that is, several kilometers from the sea front. If it really is the sea we can see in this video, then it must have been filmed on one of the arteries running through the neighborhood perpendicular to the general east–west direction of the march, connecting Aradah Road with the coast.

16. Overall, this video can be divided into seven distinct movements (four "forward" and three "backward"): 0:00–2:19: first advance; 2:19–2:41: first retreat and regroup; 2:41–3:08: second advance; 3:08–3:35: second retreat and regroup; 3:35–4:12: third advance (to recover Ali Talha's body); 4:12–4:37: third retreat (with Ali Talha's body); 4:37–5:15: the cameraman alone moves forward against the flow of the people immediately around him, retracing the trail of blood the martyr's passage has left on the ground.

17. Judith Butler, *Notes Toward a Performative Theory of Assembly*, Cambridge, MA: Harvard University Press, 2015, 149.

18. Dork Zabunyan, *Passages de l'histoire*, Blou: Le Gac Press, 2013, 52 (my translation).

19. Ibid. (my translation).
20. Mohammed A. Bamyeh, *Of Death and Dominion: The Existential Foundation of Governance*, Evanston, IL: Northwestern University Press, 2007, 10, 4, 15–16.
21. Elias Canetti, *Crowds and Power*, Harmondsworth: Penguin, 1973, 19, 83. For a different interpretation of the universality of death as that which legitimized privilege in Renaissance Europe (as depicted in images of a thoroughly aristocratic heaven), see Ivan Illich, *Limits to Medicine. Medical Nemesis: The Expropriation of Health*, Harmondsworth: Penguin, 1977, 194.
22. Canetti, *Crowds and Power*, 84.
23. Bamyeh, *Of Death and Dominion*, 43.
24. Mohammed A. Bamyeh, "Arab Revolutions and the Making of a New Patriotism," *Orient* III, 2011, 9.
25. García Calvo, *Análisis de la Sociedad del Bienestar*, n.p.
26. Hamid Dabashi, *The Arab Spring: The End of Postcolonialism*, London and New York: Zed Books, 2012, ix, emphasis in original. The reference is to Hamid Dabashi, *Corpus Anarchicum: Political Protest, Suicidal Violence, and the Making of the Posthuman Body*, New York: Palgrave Macmillan, 2012.
27. Bamyeh, "Arab Revolutions and the Making of a New Patriotism," 9.
28. Comité invisible, *A nos amis*, Paris: La Fabrique, 2014, 41 (my translation, emphasis in original). Alexandros Grigoropoulos was killed by police in the Exarchia district of Athens on December 6, 2008. Mark Duggan was shot dead by police in the Tottenham district of North London on August 4, 2011. Massinissa Guermah was arrested by gendarmes on April 18, 2001 in Béni Douala, in the province of Tizi Ouzou, and died two days later of wounds sustained while in custody. Like Mohammed Bouazizi, each of these young men's deaths sparked a visceral and also deeply *political* response that resonated far beyond their immediate communities. Guermah's death was the direct trigger for the Algerian insurrection of 2001.
29. Leo Tolstoy, *War and Peace*, translated by Rosemary Edmonds, London: Penguin Classics, 1982, 326.
30. For an extended discussion of the impulse to film the "bloodlines" left by the martyrs of these revolutions, see Peter Snowdon, "The Proper Name of Our Dispossession: Notes on Filming the Blood of the Martyrs of the Arab Revolutions," in Stella Bruzzi and Berenike Jung, eds., *Beyond the Rhetoric of Pain*, New York: Routledge, 2019, 120–36.
31. Ivan Illich, *Gender*, New York: Pantheon Books, 1982, 111, referring to E. P. Thompson, "The Moral Economy of the English Crowd in the Eighteenth Century," *Past and Present* 50: 1, 1971, 76–136.

6. The Filmmaker as Amanuensis

1. *Shabab*, "youths."

2. Ahdaf Soueif, *Cairo: Memoir of a City Transformed*, London: Bloomsbury, 2014, 121–22.

3. The 2014 edition of Soueif's memoir republishes with a different subtitle the original 2012 text (completed in late 2011) almost in its entirety, with only the epilogue of the first edition omitted. The later edition adds two new sections written in 2012 and 2013, as well as an updated preface and a chronology of Egyptian history. References here are given to the 2014 edition, but I retain the title of the original 2012 edition, which seems to me more eloquent.

4. Ayman El-Desouky, *The Intellectual and the People in Egyptian Literature and Culture: Amāra and the 2011 Revolution*, Basingstoke: Palgrave Macmillan, 2014, 78.

5. Ibid., 73.

6. Soueif, *Cairo*, 4.

7. "Police": the Arabic word used here is *hakouma*, which means literally "government."

8. He seems to have misspoken: 10 Egyptian pounds is a very low price for a kilo of meat, though it would appear he means that the price is too expensive.

9. See, for instance, the striking shot beginning at 1:09 in Jasmina Metwaly and Philip Rizk's video, *Cairo Intifada*, which follows a march that set out from the neighborhood of Imbaba, also on the west bank of the Nile, on January 28, 2011, available online at vimeo .com/19513814.

10. The fact that the cameraperson here is a man may also influence Leila's manner and behavior. The filmer's gender is clearly established by the form of the Arabic pronoun "you" that Leila uses to address him in her opening speech.

11. This elegance might be compared to Brian Henderson's description of Fellini's tracking shots: "Fellini's camera *affects* his characters, calls them into life or bestows life upon them ... Fellini's tracks are frequently subjective—in the sense that the camera eye is a character's eye. In *8 1/2* the reactions of characters to the camera are their reaction to Guido; the pain we feel when we see them is Guido's pain. Because subjective, Fellini's tracks are most often in medium close or closeup range, sometimes with only faces coming into view." Brian Henderson, "Toward a Non-Bourgeois Camera Style," *Film Quarterly* 24: 2, 1970, 3.

12. To say that the way in which Leila makes the camera submit to her address is not "physical" is, of course, to accept for the sake

of simplicity a highly restricted and overly positivist conception of physicality and embodiment.

13. I am using the term "representation" here in a way that supposes that the political, sociological, and aesthetic senses of the term are to some extent continuous, even as their domains of application and the mechanisms/procedures they deploy remain distinct. For more on this matter, see the discussion in the conclusion.

14. It tells us something, perhaps, about the nature of both individuality and spectatorship, that the individual spectator is ultimately idealized here in the figure of the president, to whom Leila's final tirades are explicitly addressed.

15. A good example of such a character-driven documentary is Jehane Noujaim's Oscar-nominated 2013 film about the Egyptian revolution, *The Square*. For an even-handed discussion of the film, see Yasmine El-Rashidi, "What We Learned in Tahrir," *NYRBlog*, December 11, 2013, available online at nybooks.com/blogs /nyrblog/.

16. On "encounter" as a form of generative (and thus, nonrepresentational) film practice, see Mark R. Westmoreland, "Mish Mabsoota: On Teaching with a Camera in Revolutionary Cairo," *Journal of Aesthetics and Culture* 7, 2015. On generative seriality as characteristic of performative assembly, see Judith Butler, *Notes Toward a Performative Theory of Assembly*, Cambridge, MA: Harvard University Press, 2015, 166, 178. On transformation, see the discussion of Canetti and Mazzarella's conception of mimesis in chapter 3.

17. "They [Perrault, Rouch] have to become others, along with their characters, at the same time as their characters must themselves become other than they are." Gilles Deleuze, *Cinéma 2: L'Image-Temps*, Paris: Editions de Minuit, 1985, 199 (my translation).

18. In his discussion of the way in which certain cinematic practices of the 1960s—principally the Third Cinema of Sembene, Rocha, Güney and Chahine, on the one hand, and the direct cinema of Perrault and Rouch on the other—seem to be trying to invent a people who do not yet exist, Gilles Deleuze relates these attempts to the mode of the time-image which he defines as "serial." By this, he means not merely any kind of sequence, but a sequence that tends to a limit without ever reaching it. The characteristic of such a series is that it cannot be encapsulated in any single image, whether it be an image of the collective or of some individual or group held to represent the collective without remainder. The intervals between the members of such a series are not arithmetic, but irrational (in the mathematical sense of the term), and the limit toward which it tends is always immanent and always out of

reach (Ibid., 202). On the mathematical basis for Deleuze's think-ing here, see David Rodowick, *Gilles Deleuze's Time Machine*, Durham, NC: Duke University Press, 1997, 139ff. On the series as intimately connected with the need to generate "intercessors," see "Les intercesseurs" in Gilles Deleuze, *Pourparlers*, Paris: Editions de Minuit, 1990, 165–84. On the relation between becoming-other and serial temporality, see Dork Zabunyan, *Gilles Deleuze. Voir, parler, penser au risque du cinema*, Paris: Presses Sorbonne Nou-velle, 2005, 253–61. My emphasis here on the alternation between the people as series and the people as (provisionally) unified pres-ence could be seen as consistent with Didi-Huberman's proposal that the mode of the people's existence is, essentially, as intermit-tence (compare to the discussion in chapter 1).

19. Michael Renov, "Domestic Ethnography and the Approach: Text, the Internet, and the Construction of the 'Other' Self," in Jane M. Gaines and Michael Renov, eds., *Collecting Visible Evidence*, Minneapolis: University of Minnesota Press, 1999, 152.

20. David MacDougall, *Transcultural Cinema*, edited by Lucien Taylor, Princeton: Princeton University Press, 1998, 157, 163.

21. There is not space here to catalog and classify all the many online videos from the Arab revolutions in which the filmer is explicitly instructed to film by someone who is present to the camera, but not filming themselves. The simplest case, perhaps, is exemplified by a video shot on Tahrir Square on January 26, 2011, which shows, from the inside, a group of demonstrators being kettled by the police. At 3:04, a woman in a state of high emotion instructs the filmer to "Film this farce!" (see vimeo.com/channels/thepeople arenot, video 6.1). Countless more examples could be listed, from different countries across the region, where the instruction to "Film!" plays a more or less prominent role in the rhetoric of the clip. I single out this video here partly because it was uploaded by (and almost certainly filmed by) the same YouTube user (Freedom Revolution25) as the video discussed in detail in the previous section of this chapter.

22. On democracy as the authority of anyone, see Jacques Rancière, *La haine de la démocratie*, Paris: La Fabrique, 2005, 56.

23. Rodrigo Nunes, *Organisation of the Organisationless. Collective Action after Networks*, Luneburg and London: Post-Media Lab/ Mute Books, 2014, 33.

24. On practical authority, see Mohammed A. Bamyeh, *Anarchy as Order: The History and Future of Civic Humanity*, Lanham, MD: Rowman & Littlefield, 2009, 27–28 (echoing Bakunin).

25. Compare, for instance, Paulo Gerbaudo's detailed description of three contemporary social movements (the Egyptian revolution,

15-M, and Occupy Wall Street) in terms of "choreography," "liquid organizing," and "dialogical leadership." Gerbaudo's ethnographic work is invaluable, but his interpretation is more rigidly binary than is perhaps necessary and possibly leads him to overemphasize top–down organizational aspects of these movements in reaction. As Nunes says, "The point is not to abandon horizontality, prefiguration and other ideas, which are worthy ones even if their use might be only regulative, but to get rid of precisely the binary scheme by which to criticise or relativise one thing is necessarily to slip into its opposite. It is a matter of opening the space between the two that makes it possible for something, being both to some extent, to be neither. Or rather, to show that the space is already there and has always been, that these mixed states are in fact the only ones that actually exist, and that we stop ourselves from fully understanding what it is that we are doing when we try to shoehorn it into such either/or oppositions." Nunes, *Organisation of the Organisationless*, 12–13.

26. On the Zapatistas and representation, see Simon Tormey, "'Not in My Name': Deleuze, Zapatismo and the Critique of Representation," *Parliamentary Affairs* 59, 2006, 1–17. Nunes explicitly makes the link between his analysis of contemporary social movements and Zapatista practice: "distributed leadership can be said to offer a concrete instantiation of the Zapatista motto of *mandar obedeciendo*: 'to rule by obeying.'" Nunes, *Organisation of the Organisationless*, 40.

27. Madiha Doss, "Des écrivains publics à 'Ataba," *Égypte/Monde arabe Première série* 14, 1993, online, n.p.

28. The term *amāra* as used by El-Desouky is strictly untranslatable: the conventional English equivalent is "token of authority." See further the detailed discussion in chapter 8.

29. El-Desouky, *The Intellectual and the People in Egyptian Literature and Culture*, 107, vii. On the need for some concrete practice of solidarity as the basis for any collective (and thus revolutionary) subject, see also Eric Bordeleau's decisive distinction between a "communism of resonance" and a "communism of the will" in *Comment sauver le commun du communisme?* Montréal: Le Quartanier, 2014.

30. There is also an act of disobedience hidden within this video, and not a negligible one. For, at least as far as we know, the filmer never made any effort to send it to President Mubarak so that he could hear what Leila had to tell him. At least Soueif did finally write her book and publish it in English, thus accomplishing the task that had been laid upon her: "Be our voice abroad." The filmer, instead, would seem to have kept this video on his flash card or his

hard drive until one year later, by which time Mubarak had been deposed and was, at least temporarily, in prison, and the demands which it contained were no longer within his power to grant. This failure to obey does not directly undermine the argument advanced here, though it does complicate it. On one level, one might wonder to what extent Leila's demand to convey her words to the president is a rhetorical set-up, a way of endorsing preemptively the importance of what she has to say, rather than a realistic expectation. On another level, one might argue that the obedience that these videos owe is by its very nature an obedience *to the people themselves* and that it only obtains among them and between them. To obey Leila by sending the video to Mubarak would be in this sense to step outside the circle of obedience, by including within the community that obedience defines the figure who is the crystallization of its opposite, who is disobedience incarnate. This may sound like special pleading, but I believe it is consonant with the general sense that infused the Egyptian revolution, that it was Mubarak who had disobeyed God and disowned his own people and *not* the people who were disobeying him.

7. The Party of the Couch

1. Ulrike Lune Riboni, "Filmer et partager la révolution en Tunisie et en Égypte: Représentations collectives et inscriptions individuelles dans la révolte," *Anthropologie et Sociétés* 40: 1, 2016, 61 (my translation).

2. The larger problem with many of these films is their commitment to "character" per se. By adopting the standard modes of narration associated with the "character-driven documentary"—that is, by relying on a small number of characters to "represent" the larger political situation and by using their psychological evolution over time as the main structuring device of the film, through which larger and more public histories are condensed and made accessible—these films tend to produce forms and representational strategies which, whatever their virtues, can only appear as reactionary in relation to the distributed, "leaderful" nature of the revolutions they seek to address. As the Egyptian filmmaker Philip Rizk says, the character-driven documentary inevitably "falsifies reality" where reality is noncentralized and leaderless. See, Philip Rizk, "2011 Is Not 1968: An Open Letter from Egypt," *Roar Magazine*, January 25, 2014, available online at roarmag.org.

3. This position is made explicit in Mosireen's "Revolution Triptych,"

one of the few programmatic statements they have signed collectively, as well as in the writings of collective member Philip Rizk. See Mosireen, "Revolution Triptych" in Anthony Downey, ed., *Uncommon Grounds. New Media and Critical Practices in North Africa and the Middle East,* London: IB Tauris, 2014, 47–52; and Rizk, "2011 Is Not 1968." The work of Mosireen provides part of the context for Jehane Noujaim's *The Square* (discussed above)—her protagonist Khalid Abdalla was one of the collective's founding members. For a fictional working through of the collective's experience from yet another point of view, see Omar Robert Hamilton's novel *The City Always Wins*, London: Faber, 2017.

4. Mosireen Collective, *The Martyrs: Toussi,* 6:38–7:01, youtube .com/watch?v=Xz3Rg_heqAg. Mohamed Abdel Nabi Abdel Rahim Mselhi, popularly known as Toussi, was martyred in Tahrir Square on November 20, 2011, when his skull was fractured by the security forces.

5. Abounaddara defines itself as "a collective of self-taught and volunteer filmmakers involved in emergency cinema" (see vimeo.com /user6924378). For an extended introduction to its work, see Stefan Tarnowski and Victoria Lupton's 2016 conversation with Charif Kiwan, "Abou Naddara, Artisans of Cinema," documented at vimeo.com/162813412.

6. vimeo.com/52215527.

7. For an analogous argument rethinking the home as a profoundly political space, see Ruthie Ginsburg's essay on Palestinian women's videos of resistance, "Gendered Visual Activism: Documenting Human Rights Abuse from the Private Sphere," *Current Sociology* 66: 1, 2018, 38–55.

8. Jacques Rancière, "Ten Theses on Politics," *Theory & Event* 5: 3, 2001, n.p., paragraph 4.

9. Shahd Wari, *Palestinian Berlin: Perceptions and Use of Public Space,* Berlin: LIT Verlag, 2017, 115 and 128–29. On the complexity of translating "public" and "private" into Arabic, see also Farha Ghannam, *Remaking the Modern: Space, Relocation and the Politics of Identity in a Global Cairo,* Berkeley: University of California Press, 2002, 90–93, and 189 n.3.

10. James Scott, *Seeing like a State: How Certain Schemes to Improve the Human Condition Have Failed,* New Haven and London: Yale University Press, 1998, especially chapters 1, 2, and 4 and the introduction to part 3. I use the term "vernacular" here as roughly equivalent to Scott's intention in formulating his concept of "non-State space," though their ranges of application are not entirely identical.

11. Ghannam, *Remaking the Modern,* 79–82. As well as slightly altering

her transliteration, I have avoided Ghannam's alternative translations of *ulfa* and *lamma* as, respectively, "homogeneous" and "heterogeneous," since the nonrelational, abstract nature of these concepts seems to me inappropriate to define vernacular practices. Indeed, one could argue that *ulfa* and *lamma* stand in fact for *two different ways of handling heterogeneity*.

12. Lawrence Rosen has objected to talking about the reclaiming of public space during the Arab Spring on the basis that in the Arab world there is no concept of public space—there is only private space, on the one hand, and state-controlled space on the other. As a result, he reads the occupations as a form of privatization of state-controlled space. This interpretation seems to me problematic on a number of levels. In particular, it discounts not only the performative power of revolutions to create new concepts and categories, but also the persistent relevance of precolonial conceptions of common and collective relationships to land and space; see Shahd Wari, *Palestinian Berlin*, 113–16, for a useful summary of the complexity of Ottoman conceptions of land tenure. In this sense, accounts of the occupations as the (re)claiming or (re)invention of *common* space(s), such as those given by David Harvey or Stavros Stavrides, probably come closer to what is at stake. See Lawrence Rosen, "A Guide to the 'Arab Street,'" *Anthropology Now* 3: 2, September 2011, 43–44.

13. Scott, for his part, sees an even greater commonality of spatial practices extending across premodern cities from (at least) the Middle East to northern Europe, as exemplified by his comparison of the mediaeval center of Bruges to an Arab medina: Scott, *Seeing like a State*, 53.

14. Timothy Mitchell, *Colonising Egypt*, Berkeley: University of California Press, 1988, 56.

15. Ibid., 54.

16. Compare Scott, *Seeing like a State*, 396 n.12, on how revolutions are characterized by the reemergence of non-State spaces within even capital cities, as happened in the casbah of Algiers during the Algerian war of independence or the bazaar of Tehran during the revolution of 1979.

17. The reception room of an Arab house is in itself an example of how the interior/exterior status of space is constantly modulated in everyday practice: such rooms typically serve during the day as a space in which visitors, including relative strangers, can be more or less formally received, while at night they are converted into sleeping accommodation for the men of the family. See Ghannam, *Remaking the Modern*, 96–97, on the Egyptian *saala*, the Lebanese *maglis*, and the Yemeni *mafraj*.

18. See vimeo.com/channels/thepeoplearenot, video 7.1. On these home sit-in videos (including links to more examples), see Cécile Boëx, "La vidéo comme outil de publicisation et de coordination de l'action collective et de la lutte armée dans la révolte en Syrie," in François Burgat and Paolo Bruni, eds., *Pas de Printemps pour la Syrie. Acteurs et défis de la crise 2011–2013*, Paris: La Découverte, 2013, 172–84.

19. Mohammed A. Bamyeh, "Anarchist Method, Liberal Intention, Authoritarian Lesson: The Arab Spring between Three Enlightenments," *Constellations* 20: 2, 2013, 195.

20. Version screened at the cinema Les Trois Luxembourg, Paris, on February 11, 2012, as part of the festival Cinéma Tahrir.

21. See Ulrike Lune Riboni, *"Juste un peu de video." La vidéo partagée comme langage vernaculaire de la contestation: Tunisie 2008–2014*, doctoral thesis defended at the Université de Paris VIII, December 6, 2016, 239, where she confirms that she found no trace of such videos either online, or—significantly—in the personal offline collections of her informants.

22. Ibid., 195.

23. On the relationship between spatiality and ethics, see Comité invisible, *Maintenant*, Paris: La Fabrique, 2017, 62–64.

24. See vimeo.com/channels/thepeoplearenot, video 7.2. The original video that provoked those responses is discussed in some detail later in this chapter.

25. See vimeo.com/channels/thepeoplearenot, video 7.3

26. See vimeo.com/channels/thepeoplearenot, video 7.4.

27. Perhaps the most astonishing of these semiotic revolutions was the transformation of the Pearl Monument in Manama, Bahrain, erected in 1982 on the occasion of the third summit of the Gulf Cooperation Council, into a symbol of freedom and justice by the occupation that grew up around it. This shift in meaning was so successful that on March 18, 2011, the government demolished the monument, which had by then become irrevocably associated with the revolution. The irony of this reversal is all the greater when one thinks of the role the Gulf Cooperation Council's Peninsula Shield Force played in the brutal suppression of the Bahraini uprising that same month. See Amal Khalaf, "The Many Afterlives of Lulu," in Anthony Downey, ed., *Uncommon Grounds: New Media and Critical Practices in North Africa and the Middle East,* London: IB Tauris, 2014, 272–90, for a complex appreciation of the ironies surrounding this event, and Paul Ramirez Jonas, "Every Public Has a Form," unpublished keynote speech, *Open Engagement,* Portland State University, May 2012 (video accessible online at vimeo .com/43193508) for an eloquent homage to this moment when

"[t]he Bahraini protesters changed the text through performance. In turn, the state changed the reinterpreted monument through destruction." For a related interpretation of the transformation of Tahrir Square from a space deliberately designed to thwart community into a space that became the epitome of community, see Hamzamolnár, "When the Going Gets Tough ... ," in *Uncommon Grounds*, 137–38.

28. The independent journalist Mohamed Abdelfattah filmed some extraordinary footage of the invasion of State Security headquarters in Medinet Nasr on March 5, 2011 (see vimeo.com /channels/thepeoplearenot, video 7.4). His images seemed to show the revolutionaries taking control of one of the key institutional spaces of the regime, confiscating files and computer discs, as well as reveling in their transgressive discovery of this realm that had previously been entirely off-bounds to them, and lampooning its former occupants. Nevertheless, this video is just as significant for what it does not show. In particular, it does not reveal that on their exiting the building, the army, which had observed the whole operation, interposed itself and obliged the revolutionaries to hand over all the documents they had taken, in theory "for safekeeping," in reality never to be seen again. As Abdelfattah told me when I asked him about this a year after the events, "At the time I felt this was a great victory. But now, I feel that we were manipulated from beginning to end." Personal communication, Cairo, April 2012.

29. This ambivalence is very well captured in *Night Visitor: The Night of Counting the Years* (2011), Maha Maamoun's poetic found-footage video compiled from YouTube videos of revolutionaries invading the premises of State Security in a number of Egyptian cities (available online at vimeo.com/55608828).

30. Qur'an, 13:11.

31. Ulrike Lune Riboni, "Représentations mobilisatrices et stratégies visuelles pour convaincre et fédérer dans les productions vidéo de la Tunisie en revolution," in Bénédicte Rochet, Ludo Bettens, et al., eds., *Quand l'image (dé)mobilise. Iconographie et mouvements sociaux au XXe siècle*, Namur: Presses Universitaires de Namur, 2015, 106–7.

32. Jean Burgess and Joshua Green, *YouTube: Online Video and Participatory Culture*, Cambridge: Polity, 2009, 43.

33. The phrase "the vlog that helped spark the revolution" is part of the title under which Iyad El-Baghdadi uploaded the English-subtitled version of this vlog. Mahfouz made three vlogs during the eighteen days: they, and their effect on people, are well-described in Ashraf Khalil, *Liberation Square: Inside the Egyptian Revolution and the Rebirth of a Nation*, New York: St. Martin's Press, 2012.

On the Asmaa Mahfouz phenomenon, see also Melissa Wall and Sahar El-Zahed, "'I'll Be Waiting for You Guys': A YouTube Call to Action in the Egyptian Revolution," *International Journal of Communication* 5, 2011, 1333–43.

34. On the role of the Party of the Couch in the June 2013 demonstrations that triggered the ascension of President Sisi, see Ayman El-Desouky, *The Intellectual and the People in Egyptian Literature and Culture: Amāra and the 2011 Revolution*, Basingstoke: Palgrave Macmillan, 2014, 96. For an alternative take on the significance of *hizb al-kanaba* to that presented here, see Abdul Ilah Albayaty, "Is There a Couch Party in Egypt?" *Ahram Online*, Saturday, December 24, 2011, available online at english.ahram .org.eg.

35. Mobilization is a constant motive for video in revolutionary times. As Cécile Boëx says of the vernacular videos from Syria: "These short films are not just about capturing an event, they also construct their own formal propositions, sometimes comic, sometimes tragic, but always exhorting us not to remain mere spectators of the ongoing violence." Cécile Boëx, "Montrer, dire et lutter par l'image. Les usages de la vidéo dans la révolution en Syrie," *Vacarme* 61, Automne 2012, 118 (my translation). Or as the Egyptian video collective Mosireen put it, somewhat more bluntly: "We do not seek people's pity, we seek to drag you the viewer from your seat and into the street. / We do not seek to inform, we want you to question your apathy in the face of the killing, torture and exploitation that is forced upon us. / We do not ask for your charity, we do not ask for your prayers, we do not ask for words, but for bodies." "Revolution Triptych," in *Uncommon Grounds*, 48.

36. While I am thinking primarily of informal viewing on small screens, many larger scale projection formats were also mobilized throughout the region. On the street as a place of projection in Egypt, see Nina Grønlykke Mollerup and Sherief Gaber, "Making Media Public: On Revolutionary Street Screenings in Egypt," *International Journal of Communication* 9, 2015, 2903–21, and Mark R. Westmoreland, "Street Scenes: The Politics of Revolutionary Video in Egypt," *Visual Anthropology* 29, 2016, 243–62.

8. O Great Crowds, Join Us

1. For the general outline of these largely ignored and forgotten events, see Jaime Semprun, *Apologie pour l'insurrection algérienne*, Paris: Encylopédie des nuisances, 2001. Relying almost entirely

on reports in French-language newspapers, Semprun provides an account of the insurrection that takes at face value the role that the "traditional" Kabyle village councils (*aarouch*) attributed to themselves in the self-organizing dynamic. Other sources have suggested that the largely dormant *aarouch* were less an organic expression of the revolt than an artificial forum *deliberately* "revived" by the regime to undermine the grassroots organizing committees that had begun to emerge not only in villages, but also in universities and workplaces, and whose agenda was far more radical and threatening. For Semprun, one of the reasons the insurrection failed to become a revolution was that the *aarouch* were infiltrated and manipulated. Others argue that the *aarouch* were from the start the main vector of that infiltration. I am grateful to a number of Algerian friends (who prefer to remain anonymous) for these clarifications.

2. Elias Canetti, *Crowds and Power*, Harmondsworth: Penguin, 1973, 20.
3. For example, see vimeo.com/channels/thepeoplearenot, video 8.1.
4. vimeo.com/channels/thepeoplearenot, video 8.2.
5. For example, see vimeo.com/channels/thepeoplearenot, video 8.3.
6. See vimeo.com/channels/thepeoplearenot, video 8.4. For a detailed analysis of these acts of iconoclasm in Syria and their online extensions in terms of Kantorowicz's theory of the king's two bodies, see Cécile Boëx, "La grammaire iconographique de la révolte en Syrie: Usages, techniques et supports," *Cultures & Conflicts* 91–92, 2013, 76–80.
7. One Paris-based Algerian friend reported that, during an extended visit to the capital Algiers in the summer of 2011, people would repeatedly tell him: "If only we'd had Internet in 2001, we would have finished with this regime once and for all." Perhaps what matters about this statement is not whether it is true or not, or even whether people really believed it to be true, but the simple fact that making it had become such a plausible and common conversational gambit. It is also significant that this statement was made in Arabic to an Arabic-speaking Algerian, contrary to the propaganda of both the regime and certain "opposition" political parties that had tried to brand the insurrection as an ethnic separatist rebellion by the Berber-speaking "minority." The experience of the 2001 insurrection would seem to contradict Andrea Khalil's assertion that it was "[t]he violence of the 1990s in Algeria … [that] prevented [the country's citizens] from rising in a collective political crowd revolt" during the Arab revolutions of 2010 onward. Her account of recent Algerian politics entirely ignores the events of 2001, and she even asserts that "[s]ince the later 1980s, the Algerian population has

refrained from forming into large, heterogeneous political crowds
… Crowds in Algeria have been small and their demands have
remained specific and pecuniary": see Andrea Khalil, *Crowds and
Politics in North Africa: Tunisia, Algeria and Libya*, London and
New York: Routledge, 2014, 71. This is a strange way to dismiss
a revolt which on June 14, 2001, had mobilized many hundreds
of thousands of people from across the country to march on the
capital and whose key demands included "a State that would guar-
antee all socio-economic rights and all democratic freedoms" and
"the effective subordination of all the executive functions of the
State, as well as all the security forces, to authorities that have been
democratically elected." As Semprun remarks, this was tantamount
to setting as the movement's principal goal "the dismantling … of
the only part of the Algerian state that was still effectively func-
tional"; Semprun, *Apologie pour l'insurrection algérienne*, 19 (my
translation). For a similar sentiment in Tunisia (that the revolt in
the mining area of Gafsa in 2008 could have become a real rev-
olution if amplified by images and the Internet), see Ulrike Lune
Riboni, "Représentations mobilisatrices et stratégies visuelles pour
convaincre et fédérer dans les productions vidéo de la Tunisie en
revolution," in Bénédicte Rochet, Ludo Bettens, et al., eds., *Quand
l'image (dé)mobilise: Iconographie et mouvements sociaux au XXe
siècle*, Namur: Presses Universitaires de Namur, 2015, 95.

8. Judith Butler, "Bodies in Alliance and the Politics of the Street,"
eipcp.net, 2011.

9. Agustín García Calvo, *Análisis de la Sociedad del Bienestar*,
Zamora: Editorial Lucina, 1995, cited after anonymous English
translation available at politicalreading.neocities.org/welfare-
society.html, n.p.

10. The filmer is in fact *on* the square but walking away from it, as
if intending to take one of the roads leading out of the square to
go and bring more people. Al-Gezaer Square is the location of an
important mosque (whose arcades are visible on the left), which
was formerly the Roman Catholic cathedral.

11. Stefano Savona, Laurent Jeanpierre, and Dork Zabunyan, "Voir la
revolution," *Cahiers du cinema* 675, 2012, 76–81.

12. The hybrid practices by which different groups within the Arab
region continue to negotiate the arrival of the personal computer,
its networks, and devices and the impact these may have had on
video production and distribution deserve a separate study. Jennifer
Peterson's discussion of the lengths to which Egyptian music fans
have been prepared to go to make peer-to-peer file-sharing a reality
—"the practice of transferring files by removing and re-installing
hard drives is highly common"—give some sense of the questions

that might, by analogy, be explored. See "Sampling Folklore: The 'Re-popularization' of Sufi Inshad in Egyptian Dance Music," *Arab Media & Society* 4, Winter 2008, 7.

13. On the need not simply to refer to "networks" in an arm-waving way, but rather to describe and define the specific types of linkage that operates around each individual node, see Ben Anderson and Paul Harrison, "The Promise of Non-Representational Theories," in Ben Anderson and Paul Harrison, eds., *Taking-Place: Non-Representational Theories and Geography,* Farnham: Ashgate, 2010, especially 16. I read the works by Paolo Gerbaudo and Rodrigo Nunes discussed below as attempts to explore precisely these kinds of question in relation to the field of "networked" social movements, though without specific reference to the work done within those networks by video *as* video.

14. Ayman El-Desouky, *The Intellectual and the People in Egyptian Literature and Culture: Amāra and the 2011 Revolution*, Basingstoke: Palgrave Macmillan, 2014, passim, and especially 29–37. On the relationship between *amāra* and the South African concept of *unhu*, for instance, see Caroline Rooney, "Egyptian Literary Culture and Egyptian Modernity: Introduction," *Journal of Postcolonial Writing* 47: 4, 2011, 369–76.

15. Yusuf Idris, "The Chair Carrier," in Denys Johnson–Davies, ed., *The Essential Yusuf Idris. Masterpieces of the Egyptian Short Story,* Cairo: AUC Press, 2009, 177–82.

16. El-Desouky, *The Intellectual and the People in Egyptian Literature and Culture,* 33–34.

17. Ibid., 12, 80, 107.

18. Butler touches briefly on this question but does not seem to see the need for trust to be grounded in anything prior to the physical gathering of bodies or in anything more concrete than the demand for "new forms of solidarity on and off the street": see Judith Butler, *Notes Toward a Performative Theory of Assembly,* Cambridge, MA: Harvard University Press, 2015, 186–87.

19. Compare Mohammed Bamyeh's interpretation of the anarchist basis of civic traditions in "Anarchist Philosophy, Civic Traditions and the Culture of Arab Revolutions," *Middle East Journal of Culture and Communication* 5, 2012, 38.

20. Rooney, "Egyptian Literary Culture and Egyptian Modernity," 372.

21. See, for example, Giorgio Agamben, *L'Uso dei corpi: Homo Sacer,* IV, 2, Vicenza: Pozzi Neri, 2014., passim.

22. See further my discussion of the vernacular in Peter Snowdon, "The Revolution Will Be Uploaded: Vernacular Video and the Arab Spring," *Culture Unbound* 6, 2014, 408–9.

23. El-Desouky, *The Intellectual and the People in Egyptian Literature and Culture*, 33, 36.
24. Idris, "The Chair Carrier," 181.
25. Compare this anecdote told about the Scottish psychiatrist R. D. Laing: "While still in Chicago, Laing was invited by some doctors to examine a young girl diagnosed as schizophrenic. The girl was locked into a padded cell in a special hospital, and sat there naked. She usually spent the whole day rocking to and fro. The doctors asked Laing for his opinion. What would he do about her? Unexpectedly, Laing stripped off naked himself and entered her cell. There he sat with her, rocking in time to her rhythm. After about twenty minutes she started speaking, something she had not done for several months. The doctors were amazed. 'Did it never occur to you to do that?' Laing commented to them later, with feigned innocence." John Clay, *R.D. Laing. A Divided Self: A Biography*, London: Hodder and Staughton, 1996, 170–71.
26. Frantz Fanon, *The Wretched of the Earth,* translated by Constance Farrington, New York: Grove Press, 1963, 224.
27. Mohammed A. Bamyeh, "On Humanizing Abstractions: The Path beyond Fanon," *Theory, Culture & Society* 27: 7–8, 2010, 60–61.
28. El-Desouky, *The Intellectual and the People in Egyptian Literature and Culture*, 12 (my emphasis).
29. Giorgio Agamben, "What Is a Destituent Power?" translated by Stephanie Wakefield, *Environment and Planning. Society and Space: D* 32: 1, 2014, 73, 72.

9. The Mulid and the Network

1. Sahar Keraitim and Samia Mehrez, "Mulid al-Tahrir: Semiotics of a Revolution," in Samia Mehrez, ed., *Translating Egypt's Revolution: The Language of Tahrir*, Cairo: AUC Press, 2012, 45.
2. Much of the literature on this subject is ephemeral or narrowly focused. An important exhibition, "Creative Dissent: Arts of the Arab World Uprisings," curated in 2013 by Christiane Gruber and Nama Khalil for the Arab American National Museum in Dearborn, Michigan, gave a sense of the range and power of vernacular creativity expressed all across the region during these revolutions.
3. vimeo.com/channels/thepeoplearenot, video 9.1.
4. vimeo.com/channels/thepeoplearenot, video 9.2.
5. vimeo.com/channels/thepeoplearenot, video 9.3.
6. vimeo.com/channels/thepeoplearenot, video 9.4.
7. The role and visibility of women in these revolutions should help overturn certain Orientalist assumptions about the automatic and

comprehensive subjection of women in Arab societies. But that does not mean that Arab women are necessarily happy with their position in everyday life, in postrevolutionary politics, or even in the liberated spaces of the revolutionary moment itself. There is a large and growing literature on this subject, and the political importance of these issues can hardly be understated for the future of these revolutions as a whole. To cite only two examples, Jessica Winegar has questioned the power of the eighteen days of the Egyptian revolution to interrupt everyday patterns of discrimination in "The Privilege of Revolution: Gender, Class, Space, and Affect in Egypt," *American Ethnologist* 39: 1, 2012, 67–70, while Andrea Khalil has documented how women participating in the revolution in Eastern Libya encountered obstacles located neither in tribal tradition nor in the dynamics of the revolutionary moment itself—the revolution in Benghazi was *started* and sustained throughout by women's independent action—but rather in the postrevolutionary return to "normality," where normality takes the form of institutionalized politics and bureaucratic state structures; *Crowds and Politics in North Africa: Tunisia, Algeria and Libya*, London and New York: Routledge, 2014, 96–105.

8. vimeo.com/channels/thepeoplearenot, video 9.

9. vimeo.com/channels/thepeoplearenot, video 9.5. For more information, see Nahrain Al-Mousawi, "A Poetry of Resistance: The Disappearance of Ayat al-Qormezi in Bahrain's 'Hidden History,'" *Jadaliyya*, June 14, 2011, available online at jadaliyya.com.

10. On the way in which the Syrian revolution, for one, catalyzed a wave of vernacular linguistic creativity, see Nassima Neggaz, "Syria's Arab Spring: Language Enrichment in the Midst of Revolution," *Language, Discourse & Society* 2: 2, 2013, 11–31.

11. Ayman El-Desouky, *The Intellectual and the People in Egyptian Literature and Culture: Amāra and the 2011 Revolution*, Basingstoke: Palgrave Macmillan, 2014, 95.

12. Ibid., 99.

13. vimeo.com/channels/thepeoplearenot, video 9.6. Compare the chants cited in Mahmoud Al-Wardani's novel of the bread riots, *Heads Ripe for Plucking*, translated by Hala Halim, Cairo: AUC Press, 2008, 17, 70. On the way the Tunisian revolution revived slogans and chants from the bread riots of the 1980s, see Ulrike Lune Riboni, "Filmer et partager la révolution en Tunisie et en Égypte: représentations collectives et inscriptions individuelles dans la révolte," *Anthropologie et Sociétés* 40: 1, 2016, 53. On the repurposing of chants from 1978–79 by the Iranian Green Movement of 2009, see Negar Mottahedeh, *#iranelection. Hashtag*

Solidarity and the Transformation of Online Life, Stanford, CA: Stanford University Press, 2015, 19, 23.

14. Jean-Luc Nancy, *A l'écoute*, Paris: Galilée, 2002.
15. Phil Weinrobe and Naeem Inayatullah, "A Medium of Others: Rhythmic Soundscapes as Critical Utopias," in M. I. Franklin, ed., *Resounding International Relations: On Music, Culture, and Politics*, New York: Palgrave Macmillan, 2005, 239.
16. Ibid., 242.
17. Ibid., 255.
18. Ibid., 239.
19. Ibid., 243–44.
20. Ali Jihad Racy, *Making Music in the Arab World: The Culture and Artistry of Tarab*, Cambridge: Cambridge University Press, 2003.
21. Samah Selim, *The Novel and the Rural Imaginary in Egypt, 1880–1985*, London and New York: Routledge, 2004, 178, referring to a celebrated scene in 'Abd al-Rahman al-Sharqawi's 1952 novel *El-Ard*.
22. Call and response patterns can also be found as a structuring device, a resonating form, in revolts and uprisings beyond the Arab region, too. Occupy Wall Street's invention of the "human mic" is only the most obvious example, though some of its effects may seem almost the *opposite* of those documented here. As Bernard E. Harcourt writes: "The 'human mic,' as a form of expression, communication, and amplification, has the effect of undermining leadership. It interrupts charisma. It's like live translation: the speaker can only utter five to eight words before having to shut up while the assembled masses repeat them. The effect is to defuse oratory momentum or to render it numbingly repetitive. The human mic also forces the assembled masses to utter words and arguments they may not agree with—which also has the effect of slowing down political momentum and undermining the consolidation of leadership. Somewhat prophetically, these creative measures reinforced the leaderless aspect of the movement itself." Bernard E. Harcourt, "Political Disobedience," in W. J. T. Mitchell, Bernard E. Harcourt, and Michael Taussig, *Occupy: Three Inquiries in Disobedience*, Chicago: University of Chicago Press, 2013, 59. As Judith Butler terms it, the human mic is more a "relay" than a response; see her *Notes Toward a Performative Theory of Assembly*, Cambridge, MA: Harvard University Press, 2015, 157. Indeed, it is hard to imagine a "leaderful" practice that might be so affectively *flat*. (For a more Dyonisiac vision of the mimetic musicality of Occupy, see Michael Taussig's essay in the co-authored volume *Occupy*.)

23. Nadia Yaqub, *Pens, Swords, and the Springs of Art: The Oral Poetry Dueling of Palestinian Weddings in the Galilee*, Leiden: Brill Academic Publishers, 2006.

24. Paul Gilroy, *The Black Atlantic: Modernity and Double-Consciousness*, Cambridge, MA: Harvard University Press, 1993, 79.

25. Ibid., 200. See Martin Stokes's generous but not uncritical comments in "Music and the Global Order," *American Review of Anthropology* 33, 2004, 59. The key to Gilroy's sense of antiphony would seem to lie in his lapidary reference to Sterling Stuckey's work on ring rituals in *Slave Culture: Nationalist Theory and the Foundations of Black America*, Oxford: Oxford University Press, 1987; see Gilroy, *The Black Atlantic*, 248 n.28.

26. John M. O'Connell, "An Ethnomusicological Approach to Music and Conflict," in John Morgan O'Connell and Salwa El-Shawan Castelo-Branco, eds., *Music and Conflict*, Urbana, Chicago, and Springfield: University of Illinois Press, 2010, summarizing Ali Jihad Racy, "Sound and Society: The Takht Music of Early-Twentieth Century Cairo," *Selected Reports in Ethnomusicology* VII, 1988, 139–70.

27. For a graphic yet also analytical video account of the massacre itself, see "The Maspero Massacre 9/10/11" by the Mosireen video collective, available at youtube.com/watch?v=00t-0NEwc3E. On the singular significance of Maspero in the litany of counterrevolutionary violence, see Sarah Carr, "Why Is Maspero Different?" *Mada Masr*, October 10, 2013, available online at madamasr .com. For a prescient discussion of the massacre as heralding "a move towards a more-or-less openly reactionary state modeled on Latin American dictatorships of the 1970s," see Sherif Younis, "The Maspero Massacre: The Military, the Media, and the 1952 Cairo Fire as Historical Blueprint," *Jadaliyya*, October 17, 2011, available online at jadaliyya.com.

28. This observation is perhaps particularly true of chanting led by and for the Ultras, who seem to have both their own specific rituals, and more importantly, their own particularly democratic ways of self-organizing such events, which doubtless testify to the unique character of their political culture. On the Ultras' role in the Egyptian revolution, see Robbert Woltering, "Unusual Suspects: 'Ultras' as Political Actors in the Egyptian Revolution," *Arab Studies Quarterly* 35: 3, 2013, 290–304, and Ronnie Close's film, *More Out of Curiosity* (2014). Ultras groups specifically (and football fans generally) are a widespread phenomenon throughout the Arab region and often played analogous roles in the different revolutions. See for example Andrea Khalil's description of the role

of Ultras in the Tunisian revolution, based on interviews with two leaders of Lem Mkashrine, the oldest Ultra group of the Espérance team based in the capital Tunis, in *Crowds and Politics in North Africa*, 11–13.

29. Anna Madoeuf, "Mulids of Cairo: Sufi Guilds, Popular Celebrations and the 'Roller-Coaster Landscape' of the Resignified City," in Diane Singerman and Paul Amar, eds., *Cairo Cosmopolitan: Politics, Culture and Urban Space in the New Globalized Middle East*, Cairo: AUC Press, 2006, 470–71.

30. Ibid., 477–78.

31. Ibid., 475.

32. Rodrigo Nunes, *Organisation of the Organisationless: Collective Action after Networks*, Luneburg and London: Post-Media Lab / Mute Books, 2014, 35.

33. vimeo.com/channels/thepeoplearenot, video 9.7.

34. Trying to reconstruct and reinterrogate the videos of October 9, 2012, some three years later when I first drafted this chapter demonstrated to me the highly ephemeral nature of the media assemblages created by activists as they upload their videos to YouTube and those videos are then processed and redistributed to those searching for them through the site's database architecture and algorithmic processes. Thus, searching for "Maspero October 2012" in both English and Arabic produced radically different results on October 10, 2012, and September 18, 2015. By the latter date, of the eight videos and video channels I found and noted for future reference in 2012, only two could initially be retrieved, directly (through keyword searches) or indirectly (through fifteen to twenty minutes of associative searching using YouTube's suggestions and other forms of lateral channel-hopping), of which one was a video published by the English-language news portal Ahram Online. While many videos of the massacre itself continued to surface, most of the videos of the anniversary march had since been submerged. However, an hour later, when I reloaded some of the pages I had found in 2012, the "suggestions" column began to refill with videos that were more closely related to the subject of my original search, rather than the miscellaneous news broadcasts on widely varying subjects that had originally manifested. This reflects the fact that the YouTube algorithm is not unresponsive to viewer behavior but is designed to be "trained" by persistent searching and clicking through to produce different kinds of assemblage, which are more closely aligned with (its interpretation of) the viewer's effective interests.

35. Comité invisible, *Maintenant*, Paris: La Fabrique, 2017, 136 (my translation, emphasis in original). The final word in this quotation

is an untranslatable pun on "middle" and "environment," in the sense of the medium in which one lives (*milieu*).

36. On the constraints that apply to all performativity due to our interdependency, and thus undermine any magical interpretation of its operation, see Butler, *Notes Toward a Performative Theory of Assembly*, 151–3.

37. On call and response as the underlying ethical form of our lives, see Ibid., 110. On the "network" as defined precisely by the *absence* of that "singular exercise" which opens given forms onto an unpredictable future, and thus translates them into forms-of-life, see Giorgio Agamben, *L'Uso dei corpi: Homo Sacer, IV, 2*, Vicenza: Pozzi Neri, 2014, 270–72.

38. Alexandra Juhasz, "Documentary on YouTube: The Failure of the Direct Cinema of the Slogan," in Thomas Austin and Wilma de Jong, eds., *Rethinking Documentary: New Perspectives, New Practices*, Milton Keynes: Open University Press, 2008, 310. "YouTube serves well the de-centering mandate of post-identity politics by creating a logic of dispersal and network. However, while there is unquestionably both freedom, and otherwise unavailable critical possibilities, offered by such fragmentations, YouTube limits our possibilities for radical comprehension by denying opportunities to re-link these peripherals in any rational or sustaining way. Collective knowledge is difficult to produce without a map, a structure, and an ethics … Because people consume media in isolation on YouTube, even if a documentary presents radical content, the viewing architecture maintains that viewers must keep this to themselves. In this way, even as the self may be changing because of the conditions of new media, the self is also consolidated … Like much new media, YouTube disturbs the public/private binary, opening up new possibilities for combinations inconceivable without the technology. Yet YouTube forecloses the construction of coherent communities and returns production, consumption, and meaning-making to the individual, re-establishing the reign of the self"; Ibid., 306–7. While arguably ethnocentric, this view is not without justification, despite its unilateral and impressionistic interpretation of the affordances of the database. It is interesting to ask how far works such as Olivia Rochette and Gerard-Jan Claes's *Because We Are Visual* (2010) or Nathalie Bookchin's *Testament* (2009–16) confirm Juhasz's vision or subvert it, precisely through the musicality they discover in/ impose upon the YouTube videos of everyday online life that they take as their raw material.

39. Lev Manovich, *The Language of New Media*, Cambridge, MA: The MIT Press, 2001, 219 et seq.

40. Molly Sauter, *The Coming Swarm: DDOS Actions, Hacktivism, and Civil Disobedience on the Internet*, New York and London: Bloomsbury Academic, 2014, 4.

41. Ibid., Preface, xiv.

42. Manovich, *The Language of New Media*, 219.

43. For the cattle-rustling analogy, see Gabriella Coleman, *Hacker, Hoaxer, Whistleblower, Spy: The Many Faces of Anonymous*, London and New York: Verso, 2014, 92.

44. Mohammed A. Bamyeh, *Anarchy as Order: The History and Future of Civic Humanity*, Lanham, MD: Rowman & Littlefield, 2009, 216–18; Hakim Bey, *T.A.Z.: The Temporary Autonomous Zone, Ontological Anarchy, Poetic Terrorism*, n.p.: The Anarchist Library, 1985; James Scott, *The Art of Not Being Governed: An Anarchist History of Upland Southeast Asia*, New Haven and London: Yale Unversity Press, 2009.

45. Madoeuf, "Mulids of Cairo," 465, 473, 466, 469.

46. El-Desouky, *The Intellectual and the People in Egyptian Literature and Culture*, 73f.

47. Anna Madoeuf stresses the primarily tactile–haptic nature of the collectivity created by the *mulid*: "Cairo's mulid space–times are intermediary zones where contacts are made and practiced between people, but also between objects and positions. Because of this fact, it is appropriate to extend one's attention to places and individuals, towards objects, whether fixed or tended. Objects in these festival urban contexts are active, they move people, provide impulses to action. Innumerable worry beads wrapped around wrists are ceaselessly caressed; handles of teapots are gripped by men and women ceaselessly serving and offering tea to friends and passers-by; sides of women's dresses or headscarves are clutched by children who are either carried or walking on their own. In terms of the density of the crowd, imposed proximity is intense. But it is the consensus of those at the mulid to further intensify this density by holding each other close—arm-in-arm, or hand-in-hand, or embracing a comrade around the shoulder as they move around in groups of two, three, or in lines. Is contact with others reduced, attenuated, or enabled when one is submersed within this gender-mixed crowd? Squeezing the arm of one's family member or companion, is it a show for the others, against the vertigo experienced by the individual in the middle of the crowd? Or is this a paradoxical attempt to escape, by a demonstration of linkage, from the non-sense of being alone among a multitude of other beings? Or is this a way of integrating oneself into this collective gathering of bodies while affirming oneself through a concrete touching gesture?" "Mulids of Cairo," 481.

48. Maxine Sheets-Johnstone, "Bodily Resonance," in Helena De Preester, ed., *Moving Imagination: Explorations of Gesture and Inner Movement*, Amsterdam: John Benjamins, 2013, 31, citing texts by, respectively, Nina Bull and M. F. Washburn.
49. Andreas Treske, *The Inner Life of Video Spheres: Theory for the YouTube Generation*, Amsterdam: Institute of Network Cultures, 2013, passim.
50. Tiqqun, *How Is It to Be Done?* n.p.: The Inoperative Committee, 2008.
51. Comité invisible, *A nos amis,* Paris: La Fabrique, 2014, 195 (my translation).

10. The Last Broadcast

1. This is the flag of the Kingdom of Libya (1951–69) that was revived by the rebels during the revolution. Perhaps it is not entirely ironic that the framing preserves the red (which appears in the video as orange) for blood and the black for the dark days of oppression, while omitting the green of future agricultural prosperity intended by the original designers: see explanation at wikipedia.org.
2. On the relationship between digital compression and haptic visuality, see Laura Marks, *Touch: Sensuous Theory and Multisensory Media*, Minneapolis: University of Minnesota Press, 2002, 161–76. On the relationship between the haptic and intimate bodily processes/presences, including breathing, see Jennifer M. Barker, *The Tactile Eye: Touch and the Cinematic Experience,* Berkeley: University of California Press, 2009, and Davina Quinlivan, *The Place of Breath in Cinema*, Edinburgh: Edinburgh University Press, 2012.
3. On the failure of representation as a paradoxical way of figuring "the challenge to representation that reality delivers," compare Judith Butler, *Precarious Life: The Powers of Mourning and Violence*, London and New York: Verso, 2014, 146–67.
4. Marks, *Touch*, 1–20.
5. For more information on Mohammed Nabbous's life and work, see Andy Carvin, "He Didn't Lose the Battle: Remembering Mohamed Nabbous," *Medium*, March 19, 2015, available online, and also the memorial website at mohamednabbous.com.
6. On her main blog, motleynews.net, LLWProductions provides a lot of information about herself but not her name.
7. I have not been able to find an upload of the original video from Libya Al Hurra TV, but several videos from other sources

informing and/or commenting on Nabous's death include extracts from this video, from which it is evident that the original was of a much "higher quality" in terms of transparency and photographic "realism."

8. Marks, *Touch*, 91–110.

9. Hito Steyerl, "In Defense of the Poor Image," *e-flux journal* 10, 2009, available online at e-flux.com.

Conclusion

1. Hito Steyerl, "The Spam of the Earth: Withdrawal from Representation," *e-flux journal* 32, 2012, available online at eflux.com.

2. Ibid.

3. Ibid.

4. Ibid.

5. Ibid.

6. Jean-Luc Nancy, *Etre singulier pluriel*, Paris: Galilée, 1996/2013, 62 (my translation).

7. Mohammed A. Bamyeh, *Of Death and Dominion: The Existential Foundation of Governance*, Evanston, IL: Northwestern University Press, 2007, 37.

8. Tahar Chikhaoui, public debate with the author, Cinéma Le Gyptis, Marseille, France, May 10, 2015.

9. Dork Zabunyan, *Passages de l'histoire*, Blou: Le Gac Press, 2013, 72.

10. vimeo.com/channels/thepeoplearenot, video 11.1.

Still frame from video posted to YouTube in 2011 and subsequently deleted. To view, and for more information, go to vimeo.com/channels/thepeoplearenot, video 12.2.

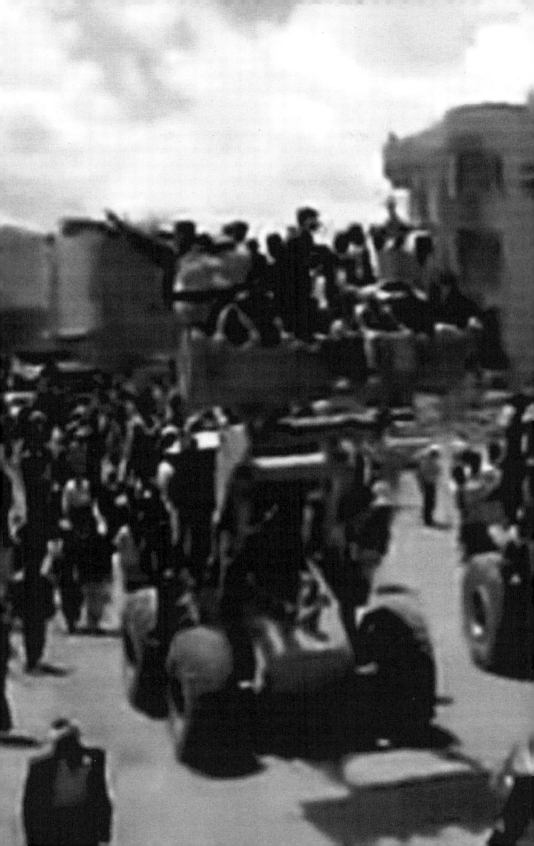

About the Author

Peter Snowdon is a filmmaker and writer. His feature-length found footage film *The Uprising*, which created an imaginary pan-Arab revolution out of YouTube videos from the Arab Spring, won the Opus Bonum Award for best world documentary on its début at the 2013 Jihlava International Documentary Film Festival. After teaching filmmaking at the University of the West of Scotland, and in the Visual Ethnography programme at Leiden University, he is currently Associate Researcher at MAD-PXL School of Art (Hasselt, Belgium).